The BEST
SpeCtRum 12
in Contemporay
Fantastic ART

edited by

Cathy Fenner & Arnie Fenner

UNDERWOOD BOOKS
Nevada City, CA • 2005

Chairman's Message

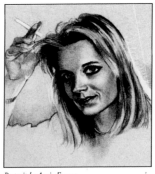

Portrait by Arnie Fenner

As I sit down to write the chairman's message this year we have just returned from seeing the last episode in the *Star Wars* prequel trilogy *Episode III: The Revenge of the Sith*. I have to admit that it was a strangely bittersweet moment for me. It doesn't seem possible that it has been 28 years since I was completely mesmerized by the first *Star Wars* movie in 1977. That film changed forever the way I thought about SF visually. At the tender age of 26 those images swirled around in my head for years; with each new episode the visuals just got better. I think it had a profound and lasting effect on a lot of people in the creative sector. I sometimes wonder what movies will have the same impact on the next generation of artists. Will it be the *Matrix* trilogy or perhaps *The Lord of the Rings* that the young artists will look back on fondly? I'm not going to get into all the discussions about the acting, the plot, or whether George Lucas gave us something we all deserved and looked forward to at the end after all those years or came up short. My feeling is that it will be strange to *not* have any *Star Wars* movies to look forward to anymore. In his recent *Rolling Stone* article "Darth & Me" director Kevin Smith wrote, "Thank Christ—we can all finally stop talking about fucking *Star Wars*." I think the point is we have to talk about NOT talking about it. The movies have been a part of all our lives for such a long time. It somehow makes us all feel a little older in a way—but I'm sure that something new and groundbreaking will come along to capture our collective imaginations. Maybe it will be a new vision by some artist that appears in *Spectrum*.

The 2005 *Spectrum* judging took place the final weekend in February. A blizzard on the east coast made travel to Kansas City interesting for several of the jurors. Happily, everyone arrived unscathed and pretty much on time. The judging was held at the Hyatt Regency Crown Center again this year. The room was set up with sixty tables which the jurors moved around, dropping a bean in an inverted cup for the art they thought exceptional: they had to evaluate a little over 4000 works this year (the art in the room was replaced five times through the day). Each judge surveyed the entries independently and discussions of the work during that phase of the voting was discouraged. When votes had been cast in the final category, art that had been indicated for award consideration (by a juror dropping a paperclip in the cup along with their voting bean—everything is strictly high-tech around here, you know) was brought back out for debate. As usual, there were a lot of lively discussions concerning the virtues of each piece, but a consensus was reached and awards were presented in each division.

Assisting Arnie and I this year in tabulating votes, setting and resetting the room, and keeping the proceedings moving along were Arlo Burnett, Terry Lee, Gillian Titus, Lucy Moreno and her daughter Lucy Moreno. Without the help of the people who give up their Saturday each year *Spectrum* would not be possible—there is no way Arnie and I could possibly do it all.

As with every previous volume of *Spectrum*, this book is only made possible by the active and continuing participation of the artists (both those selected for the book and of those that disappointingly were not), to the readers that purchase each edition, and the art directors who use it as a resource. This book, this on-going project belongs to all of you. To everyone we humbly extend our continued thanks for allowing us to be part of this community.

—Cathy Fenner/Show Co-Chairman

SPECTRUM 12: The Best in Contemporary Fantastic Art copyright © 2005 by Cathy Fenner and Arnie Fenner/Spectrum Design LLC. All Rights Reserved. Copyright under International and Pan-American Copyright Conventions. An Underwood Books edition by arrangement with the Spectrum directors. No part of this book may be reproduced, stored in a retrieval system or transmitted in any other form or by any means electronic (including Internet websites), mechanical, photocopying, recording, or otherwise, without prior permission of the editors and/or the proper copyright holders. While the editors have made every effort possible to publish full and correct credits for each work included in this volume, sometimes errors of omission or commission may occur. For this the editors are most regretful, but hereby must disclaim any liability.

Credited artworks on pages 80, 84, 94, 95 are ™ and copyright © 2004 & 2005 DC Comics. All Rights Reserved. Credited artworks on page 81 is © J.M. DeMatteis & Kent Williams. Credited artwork on pages 37 and 80 are copyright © and TM Lucasfilm Ltd. All Rights Reserved. Credited artworks on pages 108 and 109 are copyright © Playboy Enterprises, Inc. All Rights Reserved. Credit artworks on pages 136, 137, 153, 156, and 157 are © 2005 Twentieth Century Fox. All Rights Reserved. All other artworks are copyright © 2005 by the credited artists, their representative(s), and/or their respective copyright/trademark holders. All Rights Reserved. Nothing may be reprinted or used in any manner without the express permission of the copyright holder(s). Giger Introduction by Harlan Ellison. Copyright © 1990 and 2005 by The Kilimanjaro Corporation. Reprinted by arrangement with, and permission of, the Author and the Author's agent, Richard Curtis Associates, Inc., New York. All Rights Reserved. Harlan Ellison is a registered trademark of The Kilimanjaro Corporation.

CORRECTION: In the obituary notice for Erich Sokol in *Spectrum 11* he was described as being of Czech birth. Mr. Sokol was born in Austria.

Trade Softcover Edition ISBN 1-887424-94-6
Hardcover Edition ISBN 1-887424-95-4
10 9 8 7 6 5 4 3 2 1

Advisory Board: Rick Berry, Brom, Leo & Diane Dillon, Harlan Ellison, Irene Gallo, Bud Plant, Don Ivan Punchatz, Tim Underwood, Michael Whelan
Artists, art directors, and publishers interested in receiving entry information for the next Spectrum competition should send their name and address to:
Spectrum Design, P.O. Box 4422, Overland Park, KS 66204
Or visit the official website for information & printable PDF entry forms: **www.spectrumfantasticart.com**
Call For Entries posters (which contain complete rules, list of fees, and forms for participation) are mailed out in October each year.

Published by **UNDERWOOD BOOKS**, P.O. BOX 1919, NEVADA CITY, CA 95959
www.underwoodbooks.com
Tim Underwood/Publisher

Spectrum 12 Jury

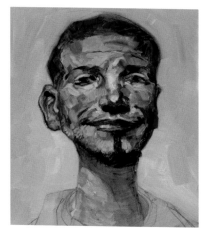

Jon Foster/artist

Irene Gallo/art director: Tor Books

Anita Kunz/artist

Karen Palinko/sculptor

David Stevenson/art director: Del Rey Books

William Stout/artist

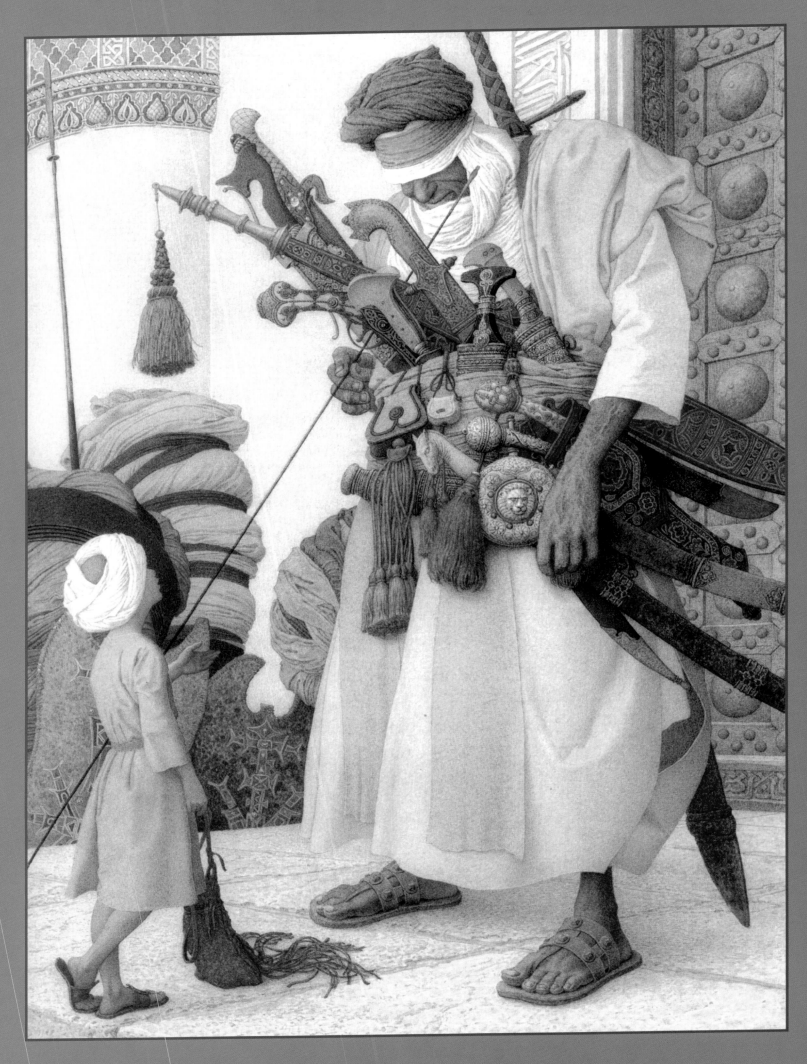

THE YEAR 2004 IN REVIEW

by Arnie Fenner

"If you haven't got anything good to say about anyone...come and sit by me."
—*Alice Roosevelt Longworth*

"It's too late [to stop the war]. I've already paid a month's rent on the battlefield!"
—*Rufus T. Firefly* [*Groucho Marx*], Duck Soup

Hmmm. When I look back at the events of the previous year the first word that comes to mind is "disparity."

The contrasts between the highs and lows seemed especially severe, the differences between good news and bad shockingly stark. The gap between the "haves" and "have nots", between the rich and the poor, widened alarmingly. The Presidential campaigns and election were as emotionally divisive as predicted (though comedians were united in making fun of candidate Howard Dean's primal scream while he was trying to rally the faithful after his defeat in the Iowa caucus). Oddly, voters seemed less concerned with war, the economy, security, or health-care insurance as they were with gay marriage, the display of the Ten Commandments in government buildings, and the revelation of Janet Jackson's pierced nipple (owww!) during the half-time show at the Super Bowl. (Her two second flash of boob cost CBS $500,000 in fines from the FCC and ultimately created a backlash against Jackson's new CD—as well as providing impetus for the opportunists to start attacking "inappropriate content" in all manner of media.) Pundits talked about the differences between "red states" and "blue states," but such observations were simplistic and the validity was questionable (let's face it: voting "against" a candidate is never as effective as getting out and voting "for" one). However, what readily became apparent throughout the year was that a new form of Puritanism had exerted itself, that intolerance, censorship and repression were the preferred reactions to those people, works, beliefs, and expressions of opinion that didn't toe the line. Hypocrisy—often preached from an evangelical or fundamentalist pulpit—was unfortunately common. The Far Right was as strident and as out-of-touch as the Far Left, leaving the vast majority of people—here and abroad—wondering who in government was left to represent *them*...

The occupation of Iraq became increasingly more deadly as American and allied troops fought

Above and facing page: *The latest in pop-diva Madonna's series of children's books published by Calloway featured a selection of stunning illustrations by Olga Dugina and Andrej Dugin.*

various militias and insurgents (didn't I say last year that winning the Peace wasn't going to be easy?). It didn't help matters when abuses of inmates by U.S. guards at the Abu Ghraib prison were revealed in a series of photographs shown on the evening news. In the meantime, al-Queda was behind the bombing of train stations in Madrid on March 11—effectively influencing the outcome of the Spanish elections and causing the withdrawal of that country's soldiers from Iraq. In a horrifying event (once again played out on television), over 1000 children and teachers were killed or wounded when Chechen guerrillas occupied a school in Beslan, Russia. Genocide haunted the Darfur region of Sudan, the North Koreans repeatedly rattled a nuclear saber, and AIDS continued to decimate the peoples of Africa. Hurricanes savaged the Caribbean, Florida and the Gulf Coast, and an earthquake the day after Christmas in the Indian ocean spawned a tsunami that devastated parts of Sumatra, Sri Lanka, and Thailand, causing the deaths of 300,000 people.

2004 was full of many sobering reminders of human frailty and mortality. Since contemporary art frequently reflects the present-day frame of mind, it's not surprising that modern fantasists often deal with dark themes.

On the flip side, of course, were much happier and amazing events... such as the successful flights of *SpaceShipOne* (piloted by Michael Melvill), the first manned civilian craft to travel to space. A pair of NASA Rovers landed on Mars and began remote-controlled explorations of the planet, while the Cassini-Huygens probe entered Saturn's orbit and began transmitting astounding photos back to Mission Control. At the end of '05 the Huygens probe will separate and descend to Titan, becoming the most distant landing ever made (at least by an Earthly spacecraft).

Chinese and American paleontologists announced the discovery of a tyrannosaur with

feathers (I'm hoping it was a newly discovered species rather than an indication that *all* T-Rexes were feathered—after *Jurassic Park*, it just wouldn't seem right) while a team of Australian and Indonesian scientists revealed the skeletal remains of a race of three-foot-tall prehistoric humans (quickly nicknamed "Hobbits"). While debates raged in the U.S. about the ethics of stem cell research, the South Koreans announced breakthroughs in their cloning experimentation which could (in theory, anyway) eventually help to treat any disease or ailment involving cell damage.

Funded by MicroSoft's Paul Allen, the Science Fiction Museum opened in downtown Seattle, Washington, to much acclaim. Co-located with Experience Music Project in the landmark Frank Gehry building at Seattle Center, the facility combines film props, books, magazines, art, and information into interactive environments, immersing visitors in SF's cultural influence and history. Meanwhile, on the opposite coast, the Museum of Modern Art returned to its $858 million reconstructed/renovated home in Manhattan, the National Museum of the American Indian opened in Washington D.C., and the National World War

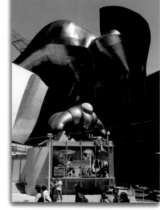

Part of the same building housing the Jimi Hendrix Experience, the exhibition space in Seattle's Science Fiction Museum was designed by Tim and Steve Kirk.

II Memorial was dedicated in the Capitol as well (I wish my dad, a member of the "greatest generation" and the recipient of three Bronze Stars for valor during the Battle of the Bulge, had lived long enough to be able to attend the celebration).

And, from an entertainment/arts standpoint, 2004 was trumpeted as the year in which "The Geeks Win!" Whether the proof was in *The Lord of the Rings: The Return of the King's* sweep of the Oscars (eleven statues, including one for Best Picture and another for a *really* crappy song), sales of $80 million for the video game *Halo 2* on it's first day of release, the mega-bestseller status of Stephen King's illustrated conclusion to his *Dark Tower* series, the manga-mania that swept the mass market, or the 100,000 people clogging the aisles (and clamoring over the full-size *Star Wars* X-Wing fighter) at the San Diego Comic-Con, I suppose depended on where your

interests lay. If anything, '04 could be described as the year of "more." More films, more games, more books; more acceptance of fantastic imagery by galleries and advertisers and publishers and auction houses and the public.

And, yes, more job outsourcing to foreign countries and more identity theft and more debt; more concerns about the economy and terrorism

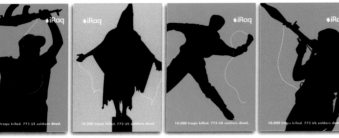

Regardless of whether you leaned left or leaned right in your feelings about the war, everyone had to give Forkscrew Graphics points for the wickedly clever political spin with their parody of Macintosh's very popular and attention-grabbing ads for the iPod. The posters are available for download at their website: http://www.forkscrew.com/

and Social Security and health insurance. More—God help us!—Paris Hilton simpering and Bono playing the another-rock-guy-as-diplomat game.

More of the good. More of the bad. More disparity.

What does my talking about "the bad" (or the seemingly unrelated "good" for that matter) have to do with fantastic art and artists (as Karen Haber gently chided me for in her positive *Locus* review of *Spectrum 11*)? Pretty much everything, I think. We don't live in a vacuum and a good way to understand why artists do what they do is to consider those real-world events affecting their lives. What is "going on" effectively influences content, directions, and quantity of the works that *are* created, as well as our access and reaction to that art.

When food producers experienced slumping sales because their products weren't carb-free (note to self: come up with a hare-brained diet plan and get rich) or when music companies had trouble competing with downloads and file swapping, that translated into fewer dollars for illustrators, package designers, and ad agencies. When a comics-based film shattered box-office records, opportunities opened up for other publishers and creators as producers sniffed around for a similar "hot" property (and started spending money for conceptual artists, spfx artists, and designers). Rising insurance costs, escalating fuel prices, the Ohio sniper (who was caught in Vegas, of all places), internet theft, a flat economy, and lack of consumer confidence all impacted artists as much as they affected businesses and the populace as a whole. New revelations in space exploration will change the way interplanetary landscapes are painted; Paleo discoveries demand some second thoughts as to the way dinosaurs will be depicted; new computer technology is translated rapidly to the arts. Events (including Janet's ta-ta) influence the types of works that are created, just as they affect the perceptions, tastes, and purchase decisions of the general public. *Everything's* connected: I'm just trying to make sense of it (which is hard enough) and help provide some perspective for readers today and for readers who might stumble across these books fifty years from now. Which, of course, is an expression of optimisim that there still *will* be readers in fifty years...

Advertising

Choices. In what to watch, what to read, how

to reach people: there's seemingly an infinite number of options, a wide array of venues and avenues to consider for advertisers trying to reach customers with their messages. But there are so many choices today, such splintering of the marketplace, that no single choice is the right one. (More about that later.) There are radio stations and cable stations and internet sites and magazines that cater to pretty much every niche interest you can imagine—and as such, there are progressively fewer "things" the majority of the population have in common. In television's early days, workers knew when there was a commercial break on Milton Berle's show because the city's water reservoir level dropped suddenly as everyone flushed their toilets at the same time. Now, a "hit" show has an audience of 17 million—which means that there are still, oh, 270 million people in this country *not* watching. A 30 second TV spot (or a print ad in, say, *The Saturday Evening Post*) used to be a sure path to success: with 200+ cable channels and DVR (which allows viewers to easily skip commercials) it's a challenge for advertisers to reach their target audiences, much less draw in new consumers. And though internet advertising has started to recover from the dotcom implosion, there was growing consumer alarm at the use of "adware" or "spyware" that some companies covertly loaded on browsers' computers when their sites were visited.

Product Placement in films and television shows was noticeably on the rise; advancements in cell phone technology created a new way to deliver visual promotions; CGI made elaborate productions (many featuring f&sf imagery) more cost-effective and common; characters from the movies *Spider-man 2* and *Shrek 2* were used to market all manner of goods and services. The plethora of genre films, of course, meant there was a mountain of "collateral" material created to promote them—some of it, amazingly, done in traditional mediums rather than in the now-standard Photoshop.

There was something of a cultural conflict caused by a Nike shoe ad starring NBA star LeBron James. In the spot James plays one-on-one with various Asian kung-fu masters and spirits (with nice special effects)—and whips them all (because he's got the right shoes, natch). Protests and charges of racism in China and Japan resulted in the ads being pulled.

I fuss every year about the anonymity of ad work—and it doesn't do me one bit of good. I'll simply say that I was able to spot some exceptional work through the year that (I think) were created by Bill Mayer, Mark Fredrickson, Brad Holland, Tim Bower...and a host of others.

Book

If it's a given that weird stuff *always* happens in the book industry, I think it safe to say that 2004 had even MORE (going back to what I said earlier) bizarre events, more screwball behaviors than "nor-

mal" (whatever that is). Needless to say, I alternated between being aghast and highly entertained.

I mean, really: how could you not be amused by writer Anne Rice's tirade at readers who dared criticize her latest book, *Blood Canticle,* on the Amazon.com website? (She ended her screed by giving her home address in New Orleans and promising refunds to the disgruntled.) Or bemused at Ray Bradbury's anger with film-maker Michael Moore for swiping the title of his classic science-fiction novel, *Fahrenheit 451,* without asking permission for Moore's movie, *Fahrenheit 9/11.* (I thought the umbrage was because of possible confusion the title might cause the new film adaptation/remake Mel Gibson was supposedly working on, but reportedly at least part of Bradbury's objection was due to the anti-government bent of Moore's movie.)

I'm still scratching my head over the report that *Kirkus Reviews*—which has long prided itself on being a sort of *Consumer Reports* for the book publishing industry, proclaiming its independence by refusing to accept advertising and which produced unbiased reviews that could generate or quash a new title's buzz—would start reviewing books in two of their new online publications for a fee ($350 to be reviewed in *Kirkus Discoveries*, $95 in *Kirkus Reports*). They weren't promising *good* reviews, mind, but still...it smacked of the days when Ted White was charging a "reading fee" to writers submitting their stories to *Amazing.*

And what about the scandal surrounding comic-book-writer-turned-anti-war-poster-designer Micah Wright's fake credentials? It turned out that

Donato Giancola painted this luminous ad for "The Bard's Tale," a computer strategy game released by Vivendi/Universal.

Wright had sold *You Back the Attack, We'll Bomb Who We Want!,* a book of re-touched WWII posters (the original messages had been cloned out and replaced with some occasionally clever anti-Bush copy), by claiming to be a disgruntled combat veteran, a former elite Army Ranger, no less. As such, he got a *lot* of interviews and media attention: what a unique marketing strategy! The only glitch was that he wasn't a vet, hadn't been a Ranger, and apparently hadn't even been in the military. Whoops. Perhaps what Mr. Wright failed to consider was the willingness of people to look into the records—prompted, at least in part, by the vitriol with which he'd answered his critics (including *real* Rangers) in various on-line forums. He allegedly confessed after the *Washington Post* (which had originally run a positive article about Wright and his book) informed him that it was going to expose his fraud (which it cheerfully did); though initially expressing remorse for the deception, Wright quickly reversed himself and ultimately claimed that he had just been testing the media's investigative abilities. Apparently chagrined at being duped, his publisher, Seven Stories Press, cancelled a second book and quickly stopped talking about the first.

Store sales were generally flat and growth was negligible at best. There were a record number of books published, but fewer customers were buying

them. Sellers went into the year with conservative expectations and they weren't surprised when they were met. A great deal of business was driven by a small number of *big* books, while backlist sales were in a slump. There seemed to be a wait-and-see attitude regarding the outcome of the presidential election; the possibility of a change in the White House while the occupation of Iraq dragged on, as well as the pressure caused by increased oil prices, had a cooling effect on customer confidence. In fact, it seemed that if people were buying anything in any quantity (other than manga, that is), they were picking up either partisan political tracts (left or right, didn't matter which) or something with a religious/spiritual spin. Whether about Islam, Christianity, or Judaism, mainstream or fringe, Religion has become the biggest growth genre in the publishing industry (fuelled, probably, by geopolitical uncertainty and an interest in fiction with a religious undercurrent). *The Da Vinci Code* was a sales phenomenon, Kabbalah tie-ins seemed to be everywhere (Kabbalah Power Drink, anyone?), and the apocalyptic *Left Behind* series dominated entire tables at Costco. Since my spot in Hell was reserved long ago, I don't spend a lot of time in that section of the bookstore...

Authors expressed alarm that the ease with which readers could find second-hand copies of their work (both on-line and increasingly in chain brick-and-mortar stores) shortened the shelf life of new books and deprived them of royalties; writers also lobbied Oprah Winfrey (whose cult, er, I mean *audience* dutifully turned any book she mentioned on her TV show into instant bestsellers) to stop dwelling on titles by dead authors and to please (pretty please, sugar on top) start recommending contemporary works to her "reading club." (I think Oprah said something like, "Let them eat cake...") And finally, it was interesting when Peter Olson, the CEO of Random House Inc. (the nation's largest publisher) announced the company's plans to sell books directly to consumers through its own website, prompting Stephen Riggio, the chief executive of Barnes & Noble, Inc. (the country's largest bookseller, natch), to respond that he was "deeply concerned" by Random House's plans to enter into his business—which in turn resulted in questions regarding B&N Publishing's ever-growing line of books and calendars that certainly compete with other publishers for space in their stores.

Whew! There was a *lot* of behind-the-scenes stuff, a lot of drama going on through the year that ultimately affected what you saw (and where you saw it) from your favorite publishers and creators. And what caught *my* attention these past twelve months?

Starting with single artist collections, my personal favorites included *Quantum Dreams: The Art of Stephan Martiniere* [Design Studio], a modest but dynamic gathering of some astonishing work; *Monstruo: The Art of Carlos Huante* [Design Studio], a great compilation of creatures that go bump in the night; *Grande Fanta* by Ashley Wood [IDW], which featured

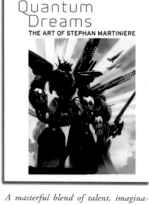

wonderfully manic and naughty paintings and drawings; *Amano First* by Yoshitaka Amano [Asahi Sonorama], slightly pricey for its size (70 pages), but still an arresting compilation of this Japanese master's recent works; *The Deceiving Eye: The Art of Richard Hescox* [Paper Tiger], a long-overdue examination of this popular painter's career; *Fantastic Art* by Luis Royo [NBM], a thorough overview of Royo's erotic fantasy canvases; *Joseph Clement Coll: A Legacy in Line* [Flesk Publications], simply the *best* book about the influential pen-and-ink artist ever done; and *Drew Struzan: Oeuvre* by Jessie and Amy Horsting [Dreamwave Productions], the much-delayed mammoth celebration of Struzan's paintings that just barely squeaked into stores before the publisher took a powder. (Another, smaller collection, *Movie Posters of Drew Struzan* [Running Press], was released almost simultaneously and was a resonably priced alternative for those on limited budgets.) *Freedom Fries* by Steve Brodner [Fantagraphics Books] was a brutally funny selection of his acid-pen political art (Dems and Reps received equal attention, though his portrait of Jesse Helms buying phone porn is a special hoot), *Chiodo Darkworks* [Verotik] included a nice group of Joe's darkly humorous pieces, and *Popaganda: The Art And Subversion Of Ron English* [Last Gasp] provided insight into the work of the seminal (and notorious) figure in the subvertising, or culture jamming movement, in which artists and activists subvert an existing advertisement to send out their own message or encourage free thought (which is a load of baloney, but it's a worthwhile book nonetheless.) *Olbinski Posters for Performing Arts* [Hudson Hills] was a luscious gathering of Rafal's allegorical paintings, *Wondertoonel* [Frye Art Museum] was the latest look at Mark Ryden's fabulously creepy panels, and *Howard Pyle: His Life—His Work* by Preston Davis [Oak Knoll] was the only place to find *every single piece* the "father of modern illustration" ever painted or drew...all printed the size of a postage stamp, mind you, but they're there, by golly! I enjoyed *Amazona* by Chris Achilléos [Titan], *As Dead As Leaves: The Art of Caniglia* [Shocklines], *The Paint In My Blood* by Alan M. Clark, *Dream: The Dark Erotic Photographic Visions of John Santerineross* [Attis Publishing], *The Book of Schuiten* by Francois Schuiten [NBM], *Kingsgate: The Art of Keith Parkinson* [SQP], *Tim Biskup's 100 Paintings* [Dark Horse], *Dumb Luck: The Art of Gary Baseman* [Chronicle], *The Art of Greg Horn* [Image] (which sold out its first printing in the blink of an eye), *From Pencils To Inks: The Art of Mark A. Nelson* [Thomas S. Baron], the slim but gorgeous *Donato Giancola: Recent and Selected Works* [self-published], and, for something *really* out of left field, *Simon Bisley's Illustrations From the Bible* [Heavy Metal Books] (I'm not kidding). Mary never looked so...bodacious. Mentioned without comment were

two books Cathy and I worked on: *Ilene Meyer: Paintings, Drawings, Perceptions* and *The Best of Gahan Wilson* [both from Underwood Books].

In the category of "anthology" art books, I was pleased with the latest installment of *Illustrators* (#45, edited by Jill Bossert) [Harper], with its typically grand selection of art by everyone under the sun; *Art Of Modern Rock: The Poster Explosion* by Paul Grushkin [Chronicle] which sported eye-popping samples by Glenn Barr, Coop, Ragnar, and a host of others; *Pop Surrealism: The Rise Of Underground Art* edited by Kirsten Anderson [Last Gasp], which included remarkable paintings by Robert Williams, Mark Ryden, and Todd Schorr; *100 Artists See Satan* edited by Mike McGee [Last Gasp], a tongue-in-cheek answer to all of the angels books on the market, featured some devilishly funny pieces by R. Crumb, and Rick Griffen; and the spiral-bound *The Illustrated World of Robert E. Howard* [Wandering Star], which boasted a prodigious batch of illustrations by Glen Orbik, Justin Sweet, Mark Schultz, Greg Manchess, and many more. *The Complete Cartoons of The New Yorker* edited by Robert Mankoff was, as the title implies, the definitive collection of yuks by a who's-who of contemporary cartoonists; *Vinyl Will Kill: An Inside Look At The Designer Toy Phenomenon* by Jeremy was an excellent primer on the current trend of artist-created figurines; *Hellboy: The Art of the Movie*

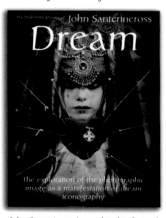

*John Santerineross' sequel to his first collection (*Fruit of the Secret God*), was provocative, disqueting, and darkly erotic, perfectly exhibiting his complicated method of "painting" with photography.*

edited by Peter Briggs included some monsterously good art by Mike Mignola, Wayne Barlowe, Nirazawa, and Katsuya Terada, among others; and *The Art of The Incredibles* by Mark Cotta Vaz was an entertaining exploration of the thought process behind the retro-chic animated classic. A pair of sweaty, guilty pleasures were *Men's Adventure Magazines* by Max Allan Collins, Rich Oberg, George Hagenauer, and Steven Heller and *Dian Hanson's The History of Men's Magazine: From 1900 to Post-WWII* [both available from Taschen]—trust me when I say that *all* of the art (including some stunning pieces by James Bama, Tom Lovell, and Mort Kuntsler) is "fantasy art." And you couldn't go wrong by picking up a copy of *The Art of Der Spiegel: Cover Illustrations Over Five Decades* as edited by Stefan Aust and Stefan Kiefer [teNeues]: it was crammed to the bursting point with many fantastic-themed works by the likes of Braldt Bralds, Kinuko Y. Craft, and Sebastian Krüger. Ballistic Publishing came on like gangbusters with *Exposé 1* (followed by #2 in pretty short order), edited by Mark Snoswell and Leonard Teo. Their boast that their books contained the "finest digital art in the known universe" was perhaps a bit presumtuous, but there *were* some exceptional pieces in the mix. They also published

A masterful blend of talent, imagination, and technical wizardry was on display in Stephan Martiniere's first art book. A second is in the works.

Best known for his creature designs for such films as Van Helsing *and* Hellboy, *Carlos Huante's first book featured a wonderfully disturbing array of drawings and paintings.*

the very worthwhile *The Art of Oddworld Inhabitants: The First Ten Years 1994-2004*, edited by Daniel Wade and Cathy Johnson, a nice history of the computer game company.

As I mentioned in last year's review, artists' self-published sketchbooks had started to appear with some regularity: a short time ago, Bill Stout was virtually the only one offering his own collections to convention crowds. Now? Hoo-boy! It's almost become a publishing category unto itself. Dave Stevens, Adam Hughes, Frank Cho, Mike Mignola, Jason Felix, Phil Noto, Mike Sutfin, and even Neal Adams all produced some especially fine booklets. (And, yes, Bill Stout was well-represented with his tenth convention sketchbook.)

Naturally, there were a number of nicely illustrated titles through the year. Of special note were the final installments in Stephen King's epic about Rowland the gunslinger, *Song of Susannah* illustrated by Darrel Anderson and *The Dark Tower* with art by Michael Whelan (who was the artist for the first book in the series, *The Gunslinger*, way back when) [both from Donald M. Grant Books]. Wandering Star's second Conan collection, *Conan of Cimmeria Vol. 2,* featured an arresting stack of beautiful work by Gary Gianni (easily some of the most authoritative REH-themed art ever published); *The Saint of Dragons* by Jason Hightman [Eos] included some nice paintings by Vince Natale; the prodigious talents of Leo and Diane Dillon were on display in *The People Could Fly: The Picture Book* by Virgiana Hamilton [Knopf]; *The Faery Reel: Tales from the Twilight Realm* edited by Ellen Datlow and Terri Windling [Viking] included a nice batch of drawings by Charles Vess; and Joe DeVito fulfilled a childhood dream and released his gorgeously illustrated authorized prequel to the classic film, *Kong: King of Skull Island* [DH Press]. *Tales From Shakespeare,*

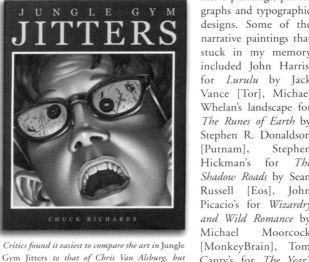

JUNGLE GYM JITTERS

CHUCK RICHARDS

Critics found it easiest to compare the art in Jungle Gym Jitters *to that of Chris Van Alsburg, but Chuck Richards' vision was very uniquely his own.*

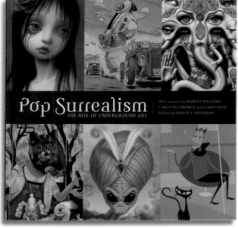

Pop Surrealism
THE RISE OF UNDERGROUND ART

With essays by ROBERT WILLIAMS, CARLO McCORMICK and LARRY REID
Edited by KIRSTEN ANDERSON

Kirsten Anderson's overview of the "outsider" art movement was the must-have book on the subject. If you're interested in finding out who is influencing the next generation of artists (and why), this is the place to start.

edited by Tina Packer [Scholastic], featured abbreviated versions (intended for younger readers) of ten classic plays stunningly illustrated by David Shannon, Barry Moser, the Dillons, and Mary Grandpré; *Jungle Gym Jitters,* written and illustrated by Chuck Richards [Walker], showcased some introcate and innovative (and fun!) drawings; *Boris*

and Bella by Carolyn Crimi [Hrcourt] boasted the sinisterly engaging art of Gris Grimly, and *Dragonology* by Ernest Drake [Candlewick] was an interactive delight (similar in conceit to Nick Bantock's *Griffin & Sabine*) with some great pieces by stalwarts Wayne Anderson and Douglas Carrel.

Book covers were all across the board, a mix of new works and stock art, graphic solutions and narrative paintings, photographs and typographic designs. Some of the narrative paintings that stuck in my memory included John Harris' for *Lurulu* by Jack Vance [Tor], Michael Whelan's landscape for *The Runes of Earth* by Stephen R. Donaldson [Putnam], Stephen Hickman's for *The Shadow Roads* by Sean Russell [Eos], John Picacio's for *Wizardry and Wild Romance* by Michael Moorcock [MonkeyBrain], Tom Canty's for *The Year's Best Fantasy & Horror* co-edited by Ellen Datlow, Kelly Link, and Gavin Grant [St. Martin's] (which always includes an invaluable year-end summary), Jody Lee's for *The Return of Nightfall* by Mickey Zucker Reichert [Daw], and John Jude Palencar's for *The Wild Reel* by Paul Brandon [Tor].

Everybody has their favorite place to shop for books. Borders, Barnes & Noble, Amazon.com and the locally owed Rainy Day Books generally get a goodly percentage of my paycheck. But (though I probably sound like a broken record here) for our "field," our area of interest, the *only* retailer with pert-near everything artsy is Bud Plant. I mean, you know he's got a leg up on the competition when he's got books the big chain bookstores have never even heard of. You can call a friendly member of his staff at 800-242-6642 for a catalog or visit his website at www.budplant.com. Bud also has a catalog of "adult" material (titled "Incorrigible") that my local postal workers apparently love to peruse—though tabbed shut top and bottom before it's sent out, my mailfolk carefully slit each catalog open for me before they deliver it. Isn't that thoughtful?

I also recommend that shoppers check out Greg Ketter's DreamHaven Books for new fiction and many collectible titles, including a line of their own dandy books: www.dreamhavenbooks.com/

Comics

Regardless of all the hoopla about graphic novels and and the manga invasion, and despite all the mainstream attention given such titles as *In the Shadow of No Towers* by Art Spiegelman or the astronomical boxoffice records set by *Spider-Man 2,* the comics industry was pretty much the same in 2004 as it was in '03 and '02. Circulations of traditional comics continued to slowly decline, prices continued to edge upwards, creators and companies fought like cats and dogs and kissed and made up, companies feuded with each other as well as with the fan press. The spectacular success of manga in the mass-channels and its popularity with female readers was largely lost on the greater part of the

comics field's direct market—reinforcing what most have known all along: girls generally think most comic shops are smelly and creepy and filled with leering weirdos. Women shop differently than men and if a business doesn't provide a comfortable environment for them...well, they drive down the street and happily spend their money at Borders (and pick up a latté while they're there).

Pulitzer Prize-winning novelist Michael Chabon noted in his keynote address at Comic-Con last year his belief that many of the industry's woes were due to an abandonment by the publishers of young readers—the audience comics were created for in the first place. Whether that's true—or whether the decline of monthly comics is simply due to evolutionary shifts in the culture or to increased prices—is open to debate. My feeling is that there have always been comics produced for children, but that at $3 or more a title they're not percieved as "cheap" entertainment anymore. A GN with more heft, more pages, and (let's face it) more of an air of legitimacy for another $10 or $15 still seems the better deal when compared to the monthly pamphlet. What's going to happen? I dunno.

The industry experienced some casualties among the publishers in '04. Both DreamWave and CrossGen went belly-up—and supposedly the latter set a record previously held by Tundra (a 1990s-era example of glorious failure) as being the comics publisher that lost the most amount of money before taking a dirt nap. And Todd McFarlane Productions (the comics arm, not the toy division) entered bankruptcy in an attempt to stave off the crippling effects of losing both the Tony Twist liable suit (the verdict in Twist's favor was reinstated on appeal) and the well-reported Neil Gaiman breach of contract/infringement case (which has been upheld in every appellate court). Todd's various *Spawn* comics continued to appear through the year,

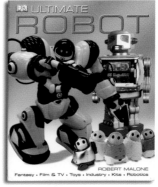

ULTIMATE ROBOT

ROBERT MALONE

Fantasy · Film & TV · Toys · Industry · Kits · Robotics

DK's Ultimate Robot *book by Robert Malone featured all manner of mechanical men, including some very nice portfolios of the art of Lawrence Northey, Eric Joyner, Calyton Bailey, and Grand Master Michael Whelan.*

but were no longer the independent sales powerhouse they once were.

Dark Horse continued to add diversity to their various product lines (with stationery, figurines, journals, etc.), formed a new imprint (DH Press), and aligned with PGW to distribute their graphic novels to the book trade. Guillermo del Toro's film adaptation of Mike Mignola's character made all things *Hellboy* a hot seller while the anticipation for the '05 release of Robert Rodriguez's take on Frank Miller's *Sin City* created a frenzy of interest in the repackaged compilations. Various *Star Wars* titles added to the anticipation for the final film in the series and *Conan* was resurrected in a big way, thanks to the scripts by Kurt Busiek and the wonderful art by Cary Nord and Tom Yeates (with the occasional equally effective fill-in by Greg Ruth). Other DH comics of note included the sardonic *The Goon* (written and illustrated by Eric Powell), Steve Rude's *The Moth* (written by Gary Martin), *Concrete: The Human Dilemma* (script and art by Paul Chadwick), and *Freaks of the Heartland* (witten

by Steve Niles with art by Greg Ruth). I also enjoyed editor Scott Allie's *The Dark Horse Book of Witchcraft*, which included some spooky work by Mike Mignola, Gary Gianni, and Scott Morse.

DC had another good year: not only did their books dominate the shelves in the mass-market, but from a creative standpoint they were firing on all eight cylinders. *DC: The New Frontier* by Darwyn Cooke was a retro-cool revisioning of many favorite characters, *Catwoman: When in Rome* by Tim Sale (written by Jeph Loeb) was an intriguing series, and Brad Meltzer's *Identity Crisis* mini-series (with art by Rags Morales and Michael Bair) was not without it's share of controversy (the plot revolved around an especially brutal crime). Kyle Baker and Scott Morse switched off illustrating the revived *Plastic Man*, Bruce Timm teamed with writer Paul

Artist Tim Sale was the subject of the first in a series of showcase comics that kicked-off in 2005. This page from his Catwoman story was playfully humorous and exhibited Sale's exceptional design skills.

Dini on the humorous mini-series *Batman: Harley & Ivy*, and Mark Chiarello kicked off his series spotlighting a single artist—*Solo*—with Tim Sale the focus of #1 and Richard Corben of #2. Corben was also in the forefront with his work in several issues of the relaunched *Swamp Thing*, Howard Chaykin gave a jolt to a reworking of *The Challengers of the Unknown*, P. Craig Russell teamed with writer Mike Carey on *Lucifer #50*, a reprinting of Kent Williams' *Blood: A Tale* included some new art, and Leinll Yu and Gerry Alanguilan beautifully illustrated Andy Hartnell's script for the *Batman/Danger Girl* one-shot. DC regularly had some of the best covers in comics with exceptional examples by James Jean, Adam Hughes, Tim Bradstreet, John Van Fleet, Brian Bolland, Christopher Moeller, Jae Lee, Mike Kaluta, Tara McPherson, Art Adams, and Alex Ross (and that's the *short* list!). Fans of the company's characters were eagerly looking forward to the release in 2005 of a new *Batman* film (and hoped it would make everyone forget about Halle Berry's Razzie Award-winning flop, *Catwoman*).

As noted elsewhere, *Spider-Man 2* broke a number of boxoffice records in '04—deservedly, since it featured an engaging script, a talented cast, sure-handed direction, and, yep, some rip-roaring action. It was a lot for Marvel's comics division to live up to. Stan Lee's breach of contract lawsuit, legal battles with licensor Sony for royalties, and the boxoffice failure of the *Punisher* film adaptation took a bit of the sheen off of what otherwise should've been a golden year. Though there wasn't a lot of subject variety in their line (superheroes are their stock and trade, True Believer), the company still published the bestselling monthly titles for the comics shops. If they seemed a bit behind when it came to exploiting the mass-market's interest in graphic novels or that they weren't able to noticeably capitalize upon the successes of their two *Spider-Man* and *X-Men* movies, it didn't seem to matter much to the fans who still proclaimed, "Make Mine Marvel!" with their purchases. Titles worthy of attention last year included *Daredevil* as written by Brian Michael Bendis and illustrated by

Alex Maleev, the *Secret Wars* series scripted again by Bendis with art by Gabriele Dell'Otto, and Robert Rodi's *Loki* mini-series, which featured nicely painted pages by Esad Ribic. Bill Sienkiewicz started a beautiful six-part *Black Widow* story (written by Richard K. Morgan) and Richard Corben illustrated Garth Ennis' one-shot *Punisher: The End*. The covers that caught my attention included those by Jo Chen, Mike Mayhew, Brandon Peterson (who also did a great job on the interiors of *Strange*), Greg Land, Brian Hitch, Andy Park, Frank Cho, and particularly the unparalleled *Punisher* pieces by Tim Bradstreet.

Perusing the offerings from some of the smaller presses revealed some outstanding material throughout the last twelve months. Recalcitant artist and self-publisher Dave Sim fulfilled his promise and brought his *Cerebus* saga to a satisfying conclusion after twenty-seven years of regular publication. Fantagraphics had a major sales breakthrough with the first volumes in their *The Complete Peanuts* library and Cartoon Books scored a success with their phonebook-sized b&w collection of the charming *Bone* by Jeff Smith (who sold color reprint rights to the series to Scholastic); IDW became *the* publisher of horror and alternative SF comics with titles like *Lore*, *PopBot*, *Silent Hill*, and various reprints and spin-offs of the phenomenally popular vampire story, *30 Days of Night* (Ashley Wood was IDW's cover artist of choice); Penny-Farthing Press sported some dandy paintings by Glen Orbik (*The Victorian*) and Stephan Martiniere (*Para*); and *Liberty Meadows* continued to perk along nicely at Image under the sure hand of Frank Cho. I enjoyed Neal Adams' *Monsters* [Vanguard], Mike Huddleston's and Phil Hester's *Deep Sleeper* [Image], Tommy Kovac's *Autumn* [Slave Labor], Christian Gossett's *Red Star* [Archangel]—and, of course, Chris Ware's stint on the alternative *McSweeney's Quarterly Concern Issue 13* [McSweeney's], was something of an event all on its lonesome.

Oh, and manga? There was a lot of it, both from publishers like Viz, TokyoPop, and Dark Horse, but also increasingly from non-comics publishers like Del Rey. Is it a fad that will fade or a trend we're likely to see become more pervasive in the future? I wish I knew.

There were a variety of how-to (draw, ink, color, write) books aimed at the comics field, a number of new examinations and poorly-researched encyclopedias (when *I* can spot errors, you *know* they're sloppy!), but with the exception of *The DC Comics Encyclopedia* edited by Phil Jimenez and Daniel Wallace [DK] (which was

Stuart Immonen and Laura Martin collaborated on this iconic cover for Ultimate Fantastic Four #7 *for Marvel. A FF4 film was scheduled for release in summer '05.*

pretty comprehensive) few seemed especially worthwhile. Similarly, I liked the idea behind many of the "treasury" hardback compilations brought out by most of the publishers, but simply didn't feel that the printing quality matched the (usually) $50 price tags attached. The one history that I found fascinating was *Men Of Tomorrow: Geeks, Gangsters, and the Birth of the Comic Book* by Gerard Jones [Basic Books]. Jones' fairly objective chronicle of the trials and tribulations of the fledgling industry's young writers and artists, most from working-class Jewish neighborhoods and many still teenaged, and the bosses who exploited them, has as its central figures Jerry Siegel and Joe Shuster, the creators of Superman. I'd heard all the stories about who did what to whom over the years, all of the charges and counter charges, but it was interesting to read a balanced account of not only the struggle over ownership of comics' most well-known character, but also the little-known history of the industry as a whole.

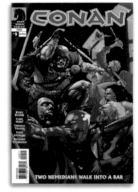

Dark Horse did Robert E. Howard proud with their relaunch of the Conan franchise. Leinil Francis Yu painted some very effective covers.

There were the typical mix of comics-related magazines published last year: *Wizard* (which continued to expand the number of conventions it sponsored around the country), *Alter Ego* (edited by former Marvel EIC and writer Roy Thomas), *Draw!*, *Back Issue*, *Comic Book Market-place*, and the increasingly irregular *Comic Book Artist*. The most interesting turn was *Comic Buyer's Guide* metamorphosis from a weekly tabloid to a monthly magazine, roughly similar in content to *Wizard*. Let's see if the newsstand's big enough for the both of them (I hope so).

Dimensional

If you collected statues or action figures or dimensional stuff—whether pop-culture or Fine Art in nature—2004 was jam-packed with temptations in every style and price.

A unique Japanese-inspired trend in the "alternative" market were "artist" toys, high-quality limited editions featuring creatures and oddball characters designed by the likes of Todd Schorr, Gary Baseman, Tim Biskup, and many others. An interesting wrinkle were the lines that were sold blind in blank boxes: what you got for your bucks was always a surprise.

If "bigger is better," Neca and Mezco proved it with the spot-on 18"-tall *Lord of the Rings* "Aragorn" and "Legolas" figures (complete with sound chips with movie dialogue) from the former and the equally sized movie "Hellboy" figure from the latter. Dark Horse, in partnership with Kotobukiya released a line of exquisitely detailed 12" *Star Wars* figures, which nicely complimented the *SW* statues and busts (based on the films *and* the animated Cartoon Network series), produced by Gentle Giant. Dark Horse also brought out a nice "Concrete" statue (designed by the character's creator, Paul Chadwick, and sculpted

by Gianfranco Grieco) as well as a whimsical "Hong Kong Hellboy" vinyl figure by Eric So.

And speaking of Hellboy, creator Mike Mignola and Randy Bowen collaborated on a museum-style bust that was available in painted resin or as a (tad more pricey) bronze. Guess what I bought? McFarlane released the first of their Conan toys, new additions to their spawn line, and a fairly accurate interpretation of H.R. Giger's "Li II." Palisades Toys offered a number of *Alien* figures and Kotobukiya expanded their line of statuettes based on the *Final Fantasy* video game heroes and monsters.

DC Direct produced a number of well-done collectibles through the year. Some stand-outs included John G. Mathews' "Fleischer Studios-Style Lois Lane" (a perfect interpretation), Tim Bruckner's "Superman" (based on Jim Lee's design) and "Wonder Woman" (designed by Adam Hughes), and Barsom's cute conjurer, "Zatanna" and lovely "Despair" mini-bust. Mr. Bruckner and Mr. Mathews shared sculpting responsibilities on the Jim Lee-designed "Batman: Hush" action figures and Mike Hill

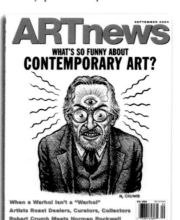

This classically-styled nymph (with her pet dragon) was designed by Julie Bell and Boris Vallejo for the Franklin Mint.

worked with Alex Ross to create the "Martian Manhunter" statue. DC Direct also released a plethora of other interesting 3D items for the collectors, including Batmobiles, marionettes, wall sculptures, and a host of other sweet items: the quality was consistently high.

Marvel's dimensional offerings continued to improve in quality. Elie Livingston's "Marvel Milestones: Spider-Man" and "Green Goblin" statues, Randy Bowen's "Punisher" and "Dr. Doom" busts, and Andy Bergholtz's "Thor, Circa 1602" maquette were especially noteworthy. Marvel also added Sideshow Collectibles as an official licensor: their first release ("Green Goblin," sculpted by Pablo Viggiano and Martin Canale) sold out its run virtually upon release.

Sideshow also continued to add to their other licensed figures, including superior figures based on the *Lord of the Rings* trilogy, the James Bond films, *Hellboy, Star Wars*, and the work of such artists as H.R. Giger, Wayne Barlowe, and Brian Froud.

The Franklin Mint produced some beautifully delicate porcelain figurines designed by Brom, highly detailed dragons designed by Michael Whelan, and some lovely faux-bronzes designed by Boris Vallejo and Julie Bell. The Bradford Exchange also had their own batch of *Lord of the Rings* and dragon collectibles (no designer names were obvious). Frazetta Prints

One of the best places to track the newest genre statues and garage kits was in the glossy magazine, Amazing Figure Modeler. *Information can be found at: www.amazingmodeler.com/*

released their own "Death Dealer III" statue (sculpted by Kevin Johnson) and Mr. Dandy produced some devilishly cute "Sikk At the Circus" figures by James Hakola (I liked "Snockers The Drunk-Ast Clown"), Majestic Studios produced the "Sea Monkeys Action Figures" (which looked like the happy creatures in the comic book ads—instead of the crappy brine shrimp that arrived in the mail after you'd sent them your allowance and waited for weeks on end for them to arrive only to feel gypped and ripped-off...not that I'm bitter), and Dynamic Forces continued to release the life-sized superhero and villain busts that just gave me the willy's—I can imagine a roomful of them being the focal point in a Wes Craven horror movie.

I saw a number of worthwhile Fine Art pieces that fit nicely into the fantastic art arena. Here are a list of creator websites I happened across which contain some incredibly nice work:
Mark Newman www.marknewmansculpture.com/
Lawrence Northey www.robotart.net/
Sandra Lira www.sculptor.net/
Thomas Kuebler www.tskuebler.com/
Clayton Bailey www.claytonbailey.com/
Christian Ristow www.christianristow.com/
Go. Look. Well, go on.

Editorial

Like everything else in 2004, the editorial arena had its high and low points. Newspapers continued to suffer declines in readerships that made it tough to justify their advertising fees. At the same time, the conservative tenor in the country resulted in complaints regarding objectivity and balance— and editorial cartoonists were usually the main targets for reader rancor. The magazine racks at the bookstores were just as jammed-full of titles as ever (if not more so) at the same time that ad revenues were generally flat and circulations continued to slide—in other words, more product appealing to more diverse interests, but fewer readers overall. Are the "free" internet-only magazines to blame? Is all of the POD casting and web blogging and instant messaging giving everyone the opportunity to spout whatever pops into their heads without having to read or listen? Is it the fault of a corporate culture which, rather than doing one thing well, feels compelled to increase profit through product saturation? Or are people simply less literate, less interested, less willing to spend the time or money on reading material when it's much easier to surf through 200 cable channels and be spoon-fed information? Are we living in a time when everyone suffers from ADHD? Maybe. Or maybe it's that all these choices, all this diversity, all the options, all of these fringe and niche markets that spring up or get identified simply frag-

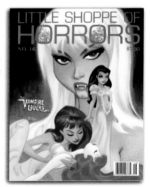

Robert Crumb continued to reluctently find himself lauded for his revelence, edge, and importance to the contemporary art world, as in this cover article in ARTnews. *Much to his embarrassment, naturally.*

ment society, essentially dividing us into clubs or cliques with fewer and fewer instances of commonality. Good God! Real Life is starting to mimic High School!! Freaks, geeks, jocks, and creeps!!!

The genre fiction magazines used to be the focal point for SF fans: it was pretty safe to assume that if you were interested in the field, you read *Astounding* or *The Magazine of Fantasy & Science Fiction.* You *knew* the writers, you knew the artists, you knew your fellow afficionados. Now in the U.S., there are something like forty fiction magazines (some more regular and with larger circulations than others, granted, but not by much these days), an equal number devoted to genre games and media, and even more "mainstream" titles that routinely included fantasy and SF fiction, features, and art within their pages.

Amazing Stories reappeared (as it turned out, briefly) in '04, sporting a slicker, more media savvy appearance, but plenty of fiction and color art as well. *Realms of Fantasy* was the genre magazine with the most visual punch, featuring some striking story illustrations and some terrific artist profiles/ portfolios (Dan Horne's featured an especially good selection). *Analog* and *The Magazine of F&SF* particularly sported some nice covers, while *Isaac Asimov's,* for the most part, didn't. Titles devoted to horror and goth-style entertainment like *Rue Morgue, Dark Realms,* and *Cemetery Dance* included some suitably moody works (including a Bernie Wrightson zombie cover on an issue of the latter). The thing about working "in" the genre magazine field is that the compensation is relatively modest: even when *Asimov's* was hot stuff with a circulation floating around 100,000, they paid less than half for a cover than what the same artist could get doing the same sort of job for a paperback publisher. Prices in the field haven't gotten any better.

Bless Richard Klemensen, he's kept the light burning in the window for Hammer Films with his slick fanzine (which he started publishing in 1972), Little Shoppe of Horrors. *His latest issue (#16) featured this peachy cover by Bruce Timm. Visit Richard's website for more info: www.littleshoppeofhorrors.com/*

Whereas commission fees held pretty steady in the mainstream, thankfully (and even increased in some spots). There were terrific fantasy-flavored pieces in *Playboy* (by the likes of Kent Williams and Phil Hale, thank you very much) and *National Geographic* (including some stunning John Jude Palencars) and *Time* and *Scientific American* and *Discover*—pretty regularly, I might add. *Juxtapoz,* for all intent and purpose, is a genre art magazine: considering that every issue is full of gleefully subversive works featuring monsters, robots, flying saucers, and well-endowed devil girls, how could you consider it anything *but*?

Dan Zimmer's *Illustration* continued to pro-

vide insightful examinations of both the famous and the obscure—and he promised to do the same for contemporary artists with a new publication, *Illustration '05* promised for, appropriately, 2005. Jim Vadeboncoeur, Jr. sadly decided to put his very-worthwhile *ImageS* on hiatus while he devoted his attention to other publishing ventures—let's hope he brings it back in '05.

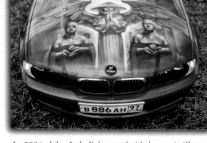

In 2004, John Jude Palencar decided to quit illustration and become a custom car painter...no, not really. When he found this picture of a Russian fan's car on the web his immediate reaction to me was, "What kind of person would do that to a BMW?!?"

The trade magazine for the f&sf field is the perineal Hugo Award-winner, *Locus*. Even though editor/publisher Charles Brown growls at me whenever I try to convince him to devote some space to film news or comics, it really *is* the only place to find out all of the who, what, when, and where—all of the facts, figures, and politely worded dirt—of the industry. Information about sample issues or subscriptions can be found at their website (as expertly run by Mark R. Kelly): www.locusmag.com/

Institutional

This question comes up periodically: what do we mean by the "institutional" category. Our standard reply is, "everything not covered by the other six." Greeting cards, prints and posters (for sale or promotion, but not used primarily for advertising), conceptual art for films, TV, or theatrical productions, calendars, collectibles, website graphics, self-promotional mailers, gallery work, and pretty much everything else that doesn't conveniently fit into one of the other sections we've established. (If a hundred concept pieces—or web graphics or role-playing game artworks—were selected by the jury, we'd set up a separate category or categories and awards. As it is, the Institutional melting-pot seems to work best so far.)

Tons of things went on throughout the year (some of which won't be apparent until '05—such as Dave McKean's collaboration with Neil Gaiman on the film *MirrorMask* or Dave's set design work for a broadway play, *Lestat, The Vampire: The Musical*). While recognizing the nuanced differences (as well as many of the similarities), I tend to blithely ignore the whole debate between "illustration" and "fine art"—semantics were never my strong suit—and prefer to wander around treating all art and artists equally.

One of the saddest events of 2004 was the theft of Edvard Munch's iconic painting, "The Scream" (also known as "The Cry") and "Madonna" in broad daylight from the Oslo, Norway, Munch Museum. Easily two of the world's most famous artworks, the theory was that both were impossible to see and that the thieves would try to negotiate a ransom for their return. As I write

"Cyber Manga Barbie 2" was an interactive work by airbrush artist Alexander Hansen using nude model Tamara Dupuis as his canvas. (Photo by Norm Edwards, hair stylist Alain Larivée, make-up by Anne-Marie D'ostie.) See more at www.alexmurals.com/

this, the paintings are still missing.

Conversely, the funniest thing I heard about last year were the criticisms leveled at the folks at David & Goliath for their various "Boys Are Stupid" products—which girls tended to love, for obvious reasons. It seemed that their catch phrase of, "Boys are stupid: let's throw rocks at them" with a cartoon kid running away, was just too *mean* for these politically correct times and might actually *encourage* someone to *hurt* children and D&G had better sanitize their stuff or there might be boycotts, goshdarrnit.

sigh

People are stupid: let's throw rocks at them.

There were more Fine Art shows than you could shake a stick at, including *100 Artists See Satan* (the spin-off book was noted earlier) at the Grand Central Art Center in Santa Ana, CA; *Beautiful Losers: Contemporary Art and Street Culture* at the Yerba Buena Center of the Arts in San Francisco; *Wondertoonel: Paintings by Mark Ryden* at the Frye Art Museum in Seattle; David Hochbaum's *Sky Is the Messenger* at the Metalstone Gallery in New York, and *Age of Aquarius: Summer Solstice Group Show* at the Copro Nason Gallery in Cuver City, CA (which included some outstanding pieces by Glenn Barr, Joe Vaux, and Sas Christian, among many other notables).

As mentioned earlier in this essay, Dark Horse expanded their product line to include such things as journals, stationery, and drink coasters. Some of the artists they tapped for these new offerings included Brom, Coop, Shag, Bob Eggleton, Simon Thorpe, and Roman Dirge.

Dynamic Forces produced several nice lithographs featuring the Marvel Universe heroes and villains by Alex Ross (whose work could also be found on a *Superman & Lois Lane* Christmas collector's plate for DC Direct).

There was another nice batch of calendars to decorate the walls. High points included those published by Ronnie Sellers (Kinuko Craft, Michael Whelan, Keith Parkinson), Tidemark (Mike Mignola's *Hellboy*, Brom, Frank Frazetta, Ciruelo), Welcome Books (*Mythology: The DC Comics Art of Alex Ross*), Heavy Metal (Luis Royo, *The Art of Heavy Metal*), and Andrews McMeel (Tony Diterlizzi's *Spiderwick*, a beautiful *Harry Potter* with all-new art by Mary Grand Pré, and, naturally, various *Far Side* formats by Gary Larson).

The fantasy roleplaying game market (estimated to be something like an $25 million domestic retail market) was weak in 2004, with sales down 15-20% from '03: the video game market, on the flip side, is the entertainment juggernaut, generating more profit than the film industry. Naturally, both employ a tremendous number of artists and designers—but since the company is the "author" of

the material (work for hire), good luck figuring out who is doing all of the marvelous graphics.

There were many, *many* prints and lithographs produced last year, everything from etchings, to giclees, to silkscreens and everything in between. I'm always impressed with the various outsider offerings from Pressure Printing (by the likes of Coop and Dave Cooper), eagerly anticipate releases from the Greenwich Workshop (Gustafson,

I was sad when I learned of the suicide of New Zealand-born artist Martin Emond (who often signed his pieces and was known to his friends as "Marty Fuck") in California in 2004. Perhaps best known for his comics work for Verotik (who had also published a book of his paintings several years back) and DC, Emond's art was simultaneously edgy and charming

Bama, Christianson, Blackshear, Dos Santos—what more can you ask for?), and was pretty excited by Tin Man Alley's "Otaku" portfolio by Detroit's Glenn Barr. Many artists publish their own limited editions, and I would encourage people to google their favorites on the internet and see what might be available.

Of course, if you collect originals you can check with your favorite artist to see what's available. Or you can visit a reputable dealer such as:
Worlds of Wonder: www.wow-art.com/
Illustration House: www.illustrationhouse.com/
Heritage Galleries: www.heritagecomics.com/
Graphic Collectibles: www.graphiccollectibles.com/

Requiem

In '04 we bid farewell to these talented creatives:
Raymond Bayless [b. 1920] artist
Simon Combes [b. 1940] artist
Martin Emond [b. 1970] artist
Harry Hargreaves [b. 1922] cartoonist/illustrator
Mel Hunter [b. 1929] astronomical artist
Harry Lampert [b. 1916] comic artist
Bernard Lansky [b. 1924] cartoonist
John Parr Miller [b. 1913] artist/animator
Irv Novick [b 1916] comic artist
Bill Oakley [b. 1975] comic lettering artist
Julie Schwartz [b. 1915] DC Comics editor
James Simpkins [b.1911] cartoonist
Norman Thelwell [b. 1920] cartoonist
Frank Thomas [b. 1912] animator †

Grand Master Award
H.R.GIGER

born February 5, 1940 / Chur, Switzerland

by Harlan Ellison®

"Real art," Susan Sontag said, "has the capacity to make us nervous."

If that were the *only* criterion for judging Art, then we would have to deny the validation of posterity's attentions to Degas, Botticelli, Tintoretto, Norman Rockwell, and most of the work of Michelangelo. They startle and pleasure us, they compel and arrest us, but they definitely do not make us nervous. Rather, they bring us balm and succor.

Van Gogh makes us nervous. We vibrate to Munch's *The Cry*. We eye Henri Rousseau's lush, dangerous jungles with trepidation: what salivating Fury watches us from that foliage? Picasso, Brueghel the Younger (called "Hell Brueghel"), Mark Rothko...they cause a twitch, run the arpeggios, tilt the museum gallery's floor.

Bosch, *sui generis*, scares the crap out of us.

Fortunately, one critic's set of measurements is another's fit of giggles. That's what makes horse races; and it's what sends prices whistling skyward at Sotheby's.

But if the power to unsettle bulks large as a quality in art as scarce (and as logical) as explanations why chinless nebbishes take up AK-47s and blow away random groups of innocents, then H. R. Giger produces Art—without question—and he casts an ominous shadow that any contemporary art critic using the "nervousness yardstick" must take into account.

For Giger, surrealist as direct lineal descendant of Dali and Bosch and Ernst, is as reassuring, as succoring, as the contemplation of root canal surgery; and his work leaves in its emotional wake the sensory equivalent of biting down on tinfoil. His is an *oeuvre* produced by scraping fingernails across a blackboard.

Most strongly put, he is our latter-day Hieronymus Bosch, the Dutch fabulist come again, demonic and erotic, exalting the more Baudelairean elements of the dark human psyche and affirming our now almost totally committed embrace with rust, stainless steel, the malevolent servomechanism, and the inescapability of clockwork destiny. He is Bosch adamantine.

It has been suggested—with sincerity—that one might as properly pay attention to the "terrible beauty" one finds in Giger's images. Rather than dwell on the obsessive ontogenetic and phylogenetic messages Giger begins with, programs through, and phosphorescently polishes to perfection. I think such nakedly obvious

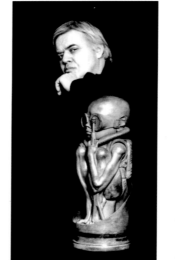

ABOVE: *H.R. Giger, 2002.* FACING PAGE: Li II, *200cm x 140cm, 1974.*
Copyright © by H.R. Giger. All Rights Reserved.

apologia show disrespect for Giger and his vision.

The possibility that "terrible beauty" in Giger's bio-mechanical world exists, seems obvious. Yes, there is that frightening clarity one can throw into the mix called beauty. There is a "terrible beauty" in watching a horned owl swoop down to snare a fieldmouse. There is a "terrible beauty" in contemplating the philosophical extrapolations of the demented *Übermensch* concept. "Terrible beauty" in the radioactive sculpture raised in the stratosphere above Hiroshima. Hell, there's a "terrible beauty" in the purple coils of visceral material spilling out of the belly of a trench warrior, in the thundering landslide that buries an Icelandic village, the systematic ballet of a thresher shark's attack. Terribly beautiful, each in its own way.

But when we fall back from academic foolishness, we are forced, as always, to deal with the pragmatic realities of the mimetic universe; and then we can no longer indulge ourselves in the disingenuous apologia of abstract expressionism, of wooly-minded postmodern deconstructionist criticism.

At that point, after the playing around, we begin kicking about through the cinders. And we have to recognize the savaged carcass, the run amuck philosophical undercurrent of Naziism, psychopathic, self-validating fundamentalist religions; the mutant Japanese children and fish born blind; the dead soldier who was someone's lover, the suffocation of hundreds under a mountain's burial shroud, the gobbets of bloody meat floating in the water.

"Terrible beauty" is used, if I may demur, by those whose unexplicated guilt at enjoyment of the frightening compels them to proffer *ex post facto* rationalizations for the "worth" of the dangerous material. They know in some secret chamber of the heart or mind that to acknowledge one's fascination with the corrupt, the depraved, the terrifying, will put them beyond the pale, exclude them from the congress of Proper Men and Women. Have we not Wilde and Crowley and Rimbaud and all the rest to offer example?

It used to be the case, back in the Thirties and Forties, for those who read novels and magazines of fantasy and extrapolation to champion them on the basis of how prescient such stories could be. "Look," their apologists would whoopdedoo, "we predicted the submarine, and waldo armatures, and night baseball, and the microchip." But that was hooey. There were a

Essay copyright © The Kilimanjaro Corporation.

12 *Spectrum Twelve*

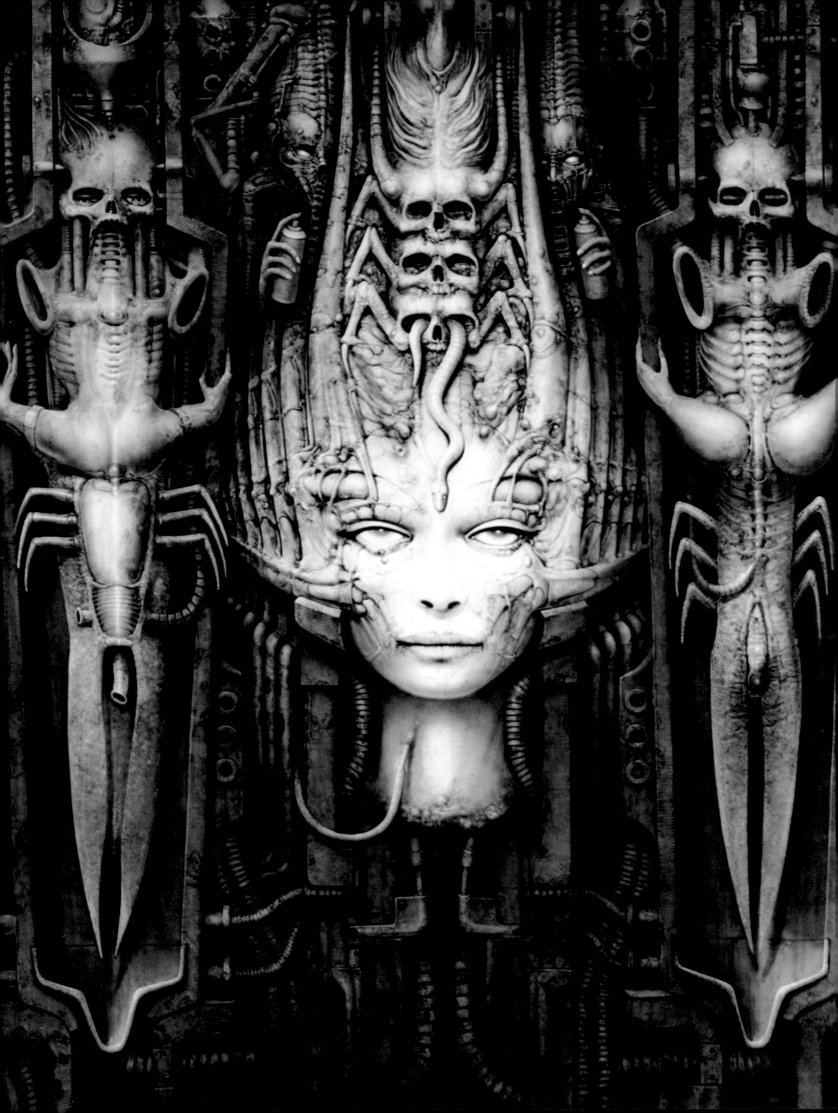

thousand different writers, all predicting like mad things, extrapolating this, extrapolating that, aiming a rock-salt-laden scattergun at the entire range of possible scientific advance. Of *course* some of them hit it right. But more went as far off the mark as "less insightful" observers; that is to say, the average man or woman in the street. We are forever getting tabloid-level essays on how smart these "dreamers" were. Of more interest, I suggest, would be a book that examines the million predictions that *didn't* come true, or happened in entirely different ways.

But that is digression. The point to which I return is this: cobbling up bogus, but socially acceptable, reasons for the existence of Art does the art in question a greater disservice than we can know. It's like ex-Governor George Wallace babbling about "states' rights" when what he was really talking about was "let's keep the niggers in chains." If fantasy and speculative fiction ever did really crystal-ball a technological advance, it was lagniappe. It wasn't what the fiction was trying to do principally, nor what it was *intended* to do; and it's a sidebar having nothing to do with its artistic value.

And so it is with Giger.

Those who try to play at the game of "terrible beauty" ignore the obvious reasons Giger does what he does.

The man is trying to unnerve us.

And *that*, in and of itself, is a noble, worthy artistic endeavor. He isn't trying to quell our jangled sensibilities, nor is he trying to lull us with restatements of the naturalistic *status quo*. For pete's sake, just *look* at what he shows us, *look* at the iconographic choices he makes.

He gives us elements of the shark, the spider, the scorpion; insects, worms, crocodiles; teeth, crushing limbs, ichor-slick coils; wombs, razors; surfaces across and down which we'd slide, unable to get a handhold; bottomless depths, malevolent eyes, the death rictus and the sybaritic leer.

This man *knows* what we fear. And he shows it to us again and again. Don't bother me with this "terrible beauty" nonsense. That's for parvenus, for diddlers. Giger is working with primal

materials, and his mission is to stand our hair on end. To unnerve us.

Look: Nietzsche said, "Gaze not overlong into the abyss, lest the abyss gaze into thee." And Allen Tate, no doubt harkening to Nietzsche's warning, wrote, "Civilization is an agreement to ignore The Abyss."

Okay, then, if that's so, then what value do we place on the dangerous artist who works *only* at the edge of that abyss, who forces us to confront our primal fears painting after painting? How important, how *valuable* is the artist who says, "I know you fled the warm salt seas to escape the jaws and teeth of the shark, so let me remind you of that horror!"

How valuable? Not for me to say. Fortunately, Time and the Judgment of Posterity handle that for me.

All I can say now, as page after page of Giger's biomechanics challenge your ability to handle the unthinkable, is this:

There is already a plethora that spends its time telling us how secure and swell everything is. There will always be mediocre men and women who gravitate to the Better Business Bureau and the Establishment of Safe Ideas. Boosters and flag-wavers; pollyannas and con-artists; those who lie without knowing they lie because they cannot face the truth, and those with vested interests who lie because it is in their best interests. And the artists will continue to be called depraved, decadent, obscene, disgusting, troublesome, unnerving.

Ah. Yes, precisely the point.

The great French novelist Colette, whom some say is the most incisive observer of the human condition in the history of literature, wrote, "Look for a long time at what pleases you; and longer still at what pains you."

That, I submit, is the answer. To what question? To the question of Giger. He is both question and answer.

Enigma and revelation.

Starting place and final resting place.

He is here to make you twitch. Honor that.

Previous Grand Master Award Recipients

Frank Frazetta
1995

Don Ivan Punchatz
1996

Leo & Diane Dillon
1997

James Bama
1998

John Berkey
1999

Alan Lee
2000

Jean Giraud
2001

Kinuko Y. Craft
2002

Michael Wm. Kaluta
2003

Michael Whelan
2004

the Show

Spectrum 12 "Call For Entries" poster by
GREG SPALENKA

artist: **Brom**

art director: Brom *client:* Abrams Books *title:* Jack *medium:* Oil

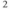
1
artist: **David Ho**
art director: Infected Mushroom
client: BNE Records
title: IM The Supervisor
medium: Digital
size: 7"x7"

2
artist: **Juan Manuel Fuentes del Ama**
client: Galeria Heller-Catalogo
title: The Spacial Traveller
 and His Apprentice
medium: Oil on canvas
size: 73cmx92cm

3
artist: **Anita Kunz**
client: Directory of Illustration
title: Self-portrait
medium: Mixed
size: 12"x14"

4
artist: **Anita Kunz**
art director: John English
client: The Illustration Academy
title: Juggler
medium: Mixed
size: 20"x30"

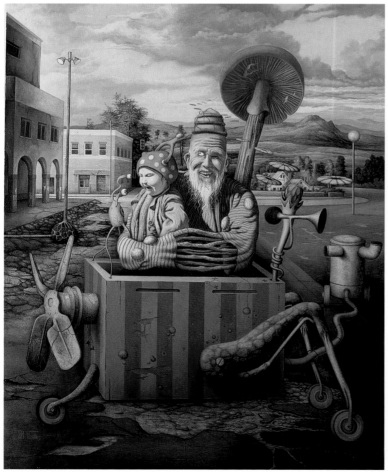

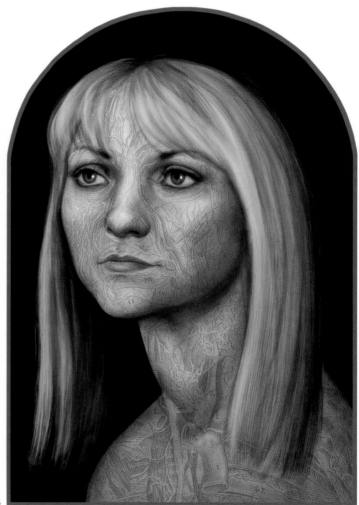

4

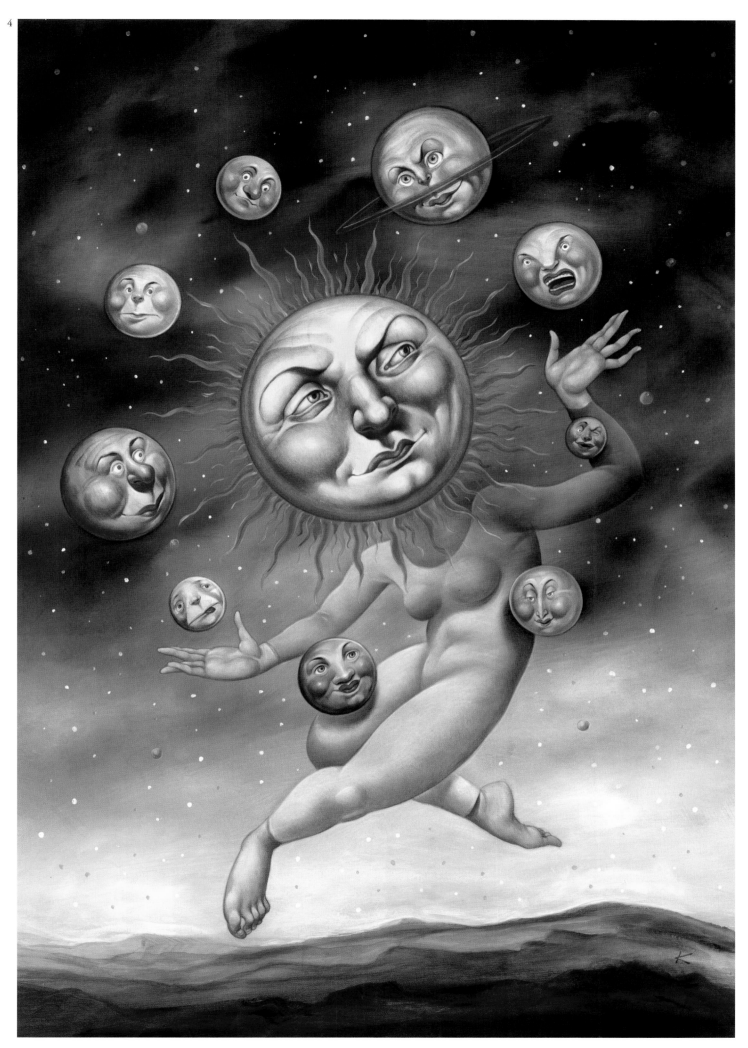

1
artist: **Wes Benscoter**
client: Ubi Soft
title: Shadowbane 3
medium: Digital
size: 10^1/2"x13^1/2"

2
artist: **Will Bullas**
art director: Dick Reno
client: Chateau Lafayett Reneau
title: Well-Chilled Whites...
medium: Watercolor
size: 7"x9"

3
artist: **Scott Anderson**
art director: Albert Ihde
designer: Scott Anderson
client: Ensemble Theater
title: All In the Timing
medium: Oil on board
size: 14"x22"

4
artist: **Matt Cavotta**
art director: Mark Painter
client: Wizards of the Coast
title: Unleash the Power of Ass
medium: Digital
size: 12^1/2"x16"

5
artist: **Raymond Swanland**
art director: Lorne Lanning
designer: Raymond Swanland &
 Silvio Aebischer
client: Oddworld Inhabitants
title: Oddworld Stranger's Wrath
 Army–Stranger
medium: Digital
size: 17"x6"

6
artist: **Raymond Swanland**
art director: Lorne Lanning
designer: Raymond Swanland &
 Silvio Aebischer
client: Oddworld Inhabitants
title: Oddworld Stranger's Wrath
 Army–Sekto
medium: Digital
size: 17"x6"

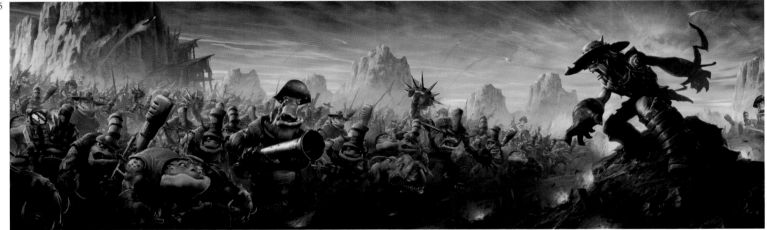

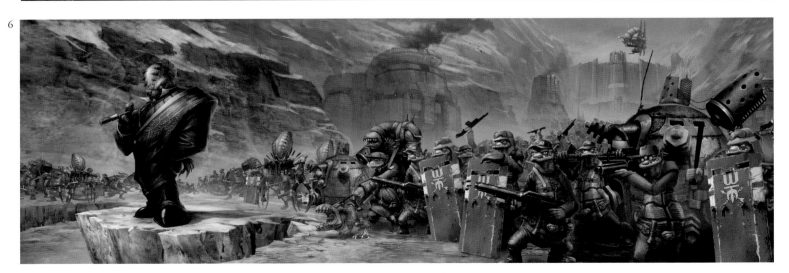

1

artist: **Ragnar**
art director: Ragnar
client: Baby Tattoo Books
title: Izzy's Very Important Job
medium: Digital
size: 11"x17"

2

artist: **Joel Parod**
art director: John Wallace & Diana Lynn
designer: Joel Parod
client: Urth Mother Music
title: Daydreams & Lullabies
medium: Oil on canvas
size: 36"x18"

3

artist: **Ragnar**
art director: Ragnar
client: Baby Tattoo Books
title: Got Your Nose
medium: Digital
size: 11"x17"

4

artist: **Raúl Cruz**
client: Sci-Fi & Toy Convention
title: A Robot's Inner Child
medium: Digital
size: 20"x28"

5

artist: **Dave Sheppard**
art director: Barb Daniel
designer: Dave Sheppard
client: Writers in Woody Paint Festival
title: A Reader in Woody Point
medium: Oil on canvas
size: 16"x20"

6

artist: **Katherine Jones**
client: The Cadies of Witchery Tours
title: Nodrog
medium: Oil
size: 8"x11"

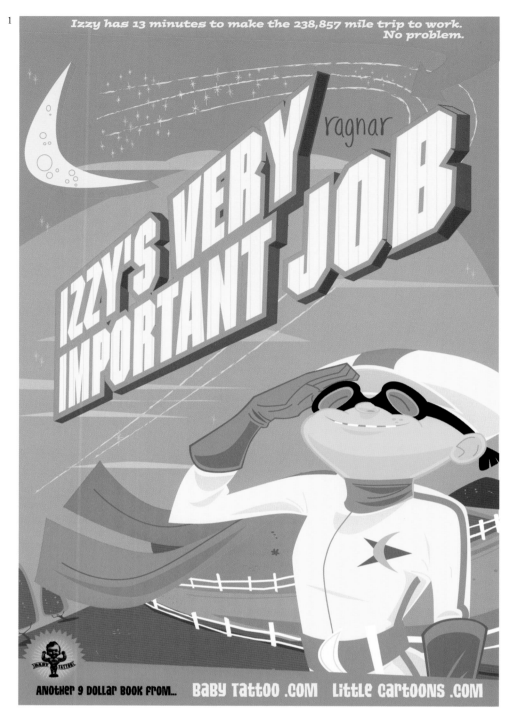

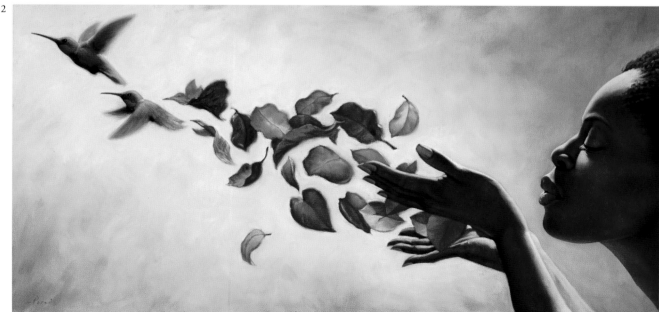

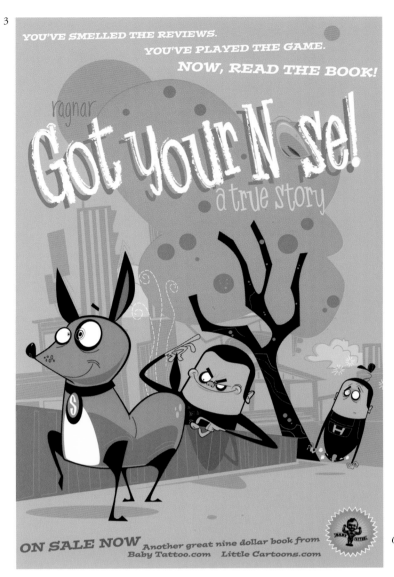

1
artist: **Justin Sweet**
art director: Mike Styskal
client: Ride Snowboards
medium: Watercolor

2
artist: **Todd Lockwood**
art director: Melissa Rapier
client: Wizards of the Coast
title: Bar Fight!
medium: Digital
size: 20"x11"

3
artist: **Cory & Catska Ench**
art director: Gordon Van Gelder
client: Magazine of Fantasy &
 Science Fiction
title: The Tribes of Bela
medium: Digital
size: 6³/4"x9¹/4"

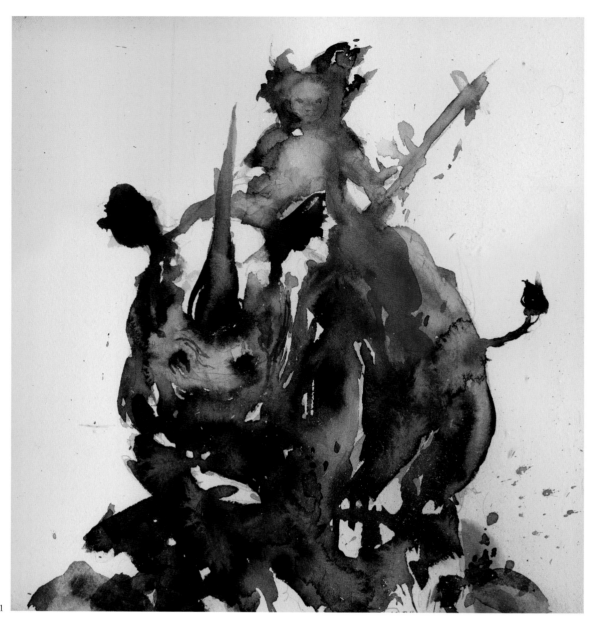

1

2

3

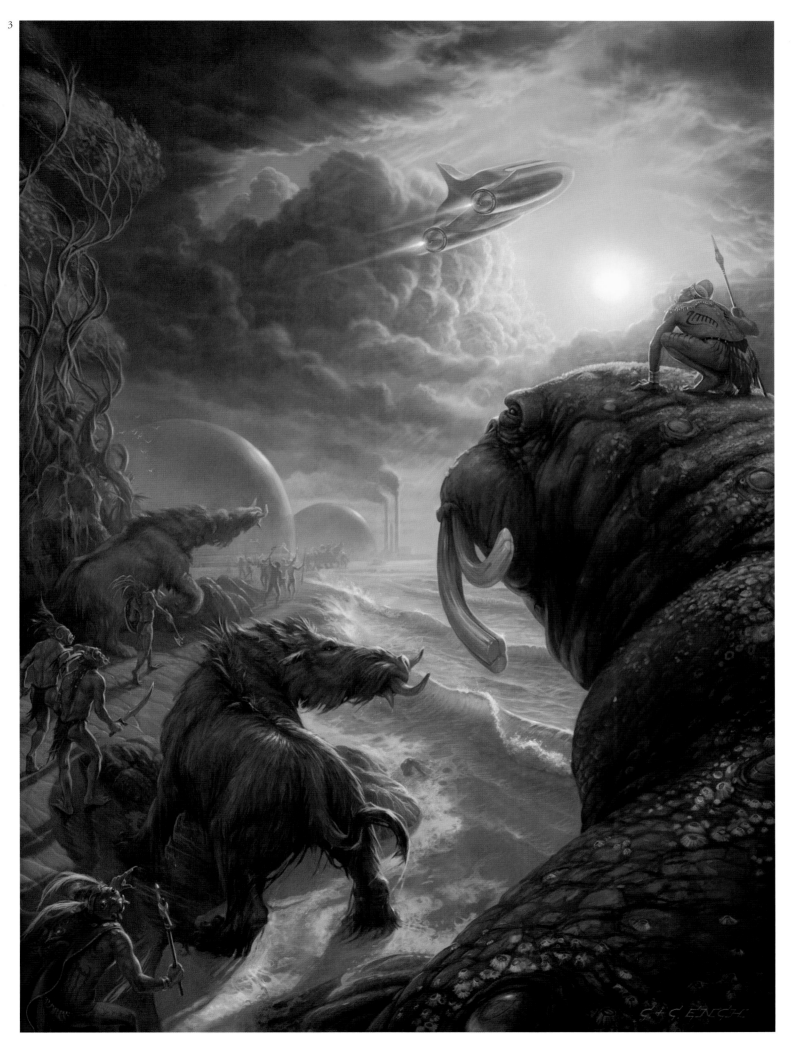

BOOK
Gold Award

artist: Brad Holland

art director: Irene Gallo *client:* Tor Books *title:* Outside the Dog Museum *medium:* Acrylic

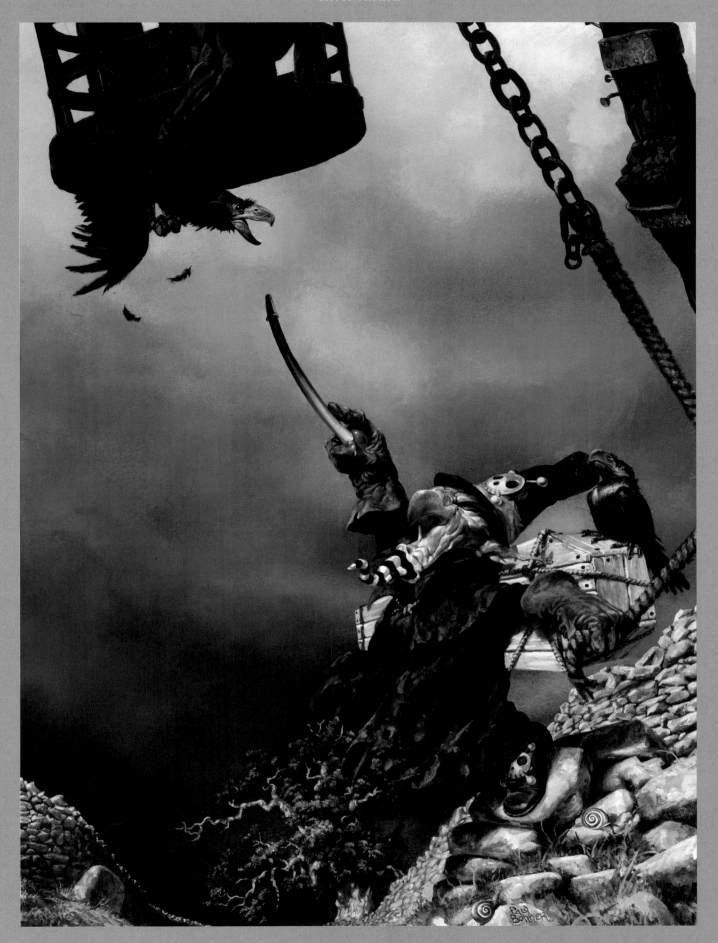

artist: **Paul Bonner**

art director: Jean Bev *client:* Rackham *medium:* Watercolor *size:* 28cm x 39cm

1
artist: **John Jude Palencar**
art director: Irene Gallo
client: Tor Books
title: Trader
medium: Acrylic
size: 27"x29"

2
artist: **Cheryl Griesbach/Stanley Martucci**
art director: Sarah Delson
client: St. Martins Press
title: Darwin's Wink
medium: Oil on paper
size: 24"x36"

3
artist: **Daniel Dos Santos**
art director: Irene Gallo
client: Tor Books
title: Alosha 2
medium: Oil on board
size: 20"x30"

4
artist: **Daniel Dos Santos**
art director: Irene Gallo
client: Tor Books
title: The Silver May Tarnish
medium: Oil on board
size: 30"x40"

1

2

3

4

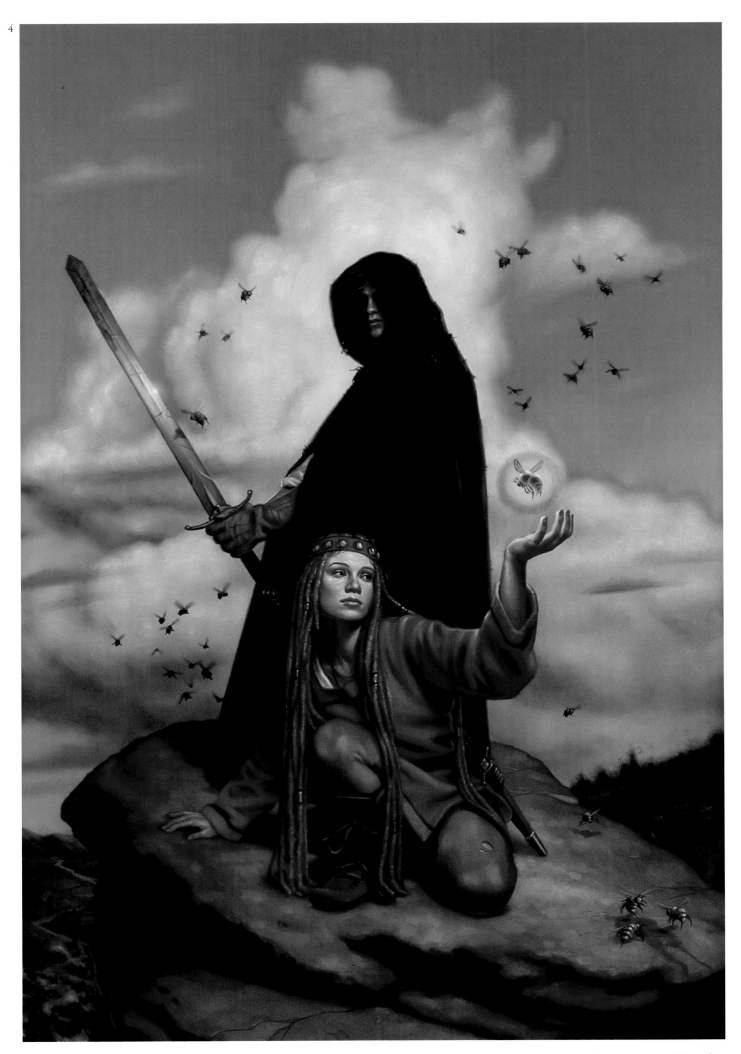

1
artist: **Michael Whelan**
art director: Robert K. Wiener
client: Donald M. Grant Publishers
title: The Artist
medium: Oil on panel *size:* 18"x28"

2
artist: **Michael Whelan**
art director: Robert K. Wiener
client: Donald M. Grant Publishers
title: "He Reached For It Again..."
medium: Oil on panel *size:* 18"x28"

3
artist: **Michael Whelan**
art director: Robert K. Wiener
client: Donald M. Grant Publishers
title: Ka-Tet
medium: Oil on panel *size:* 18"x28"

4
artist: **Michael Whelan**
art director: Robert K. Wiener
client: Donald M. Grant Publishers
title: Crimson King
medium: Oil on panel *size:* 18"x28"

4

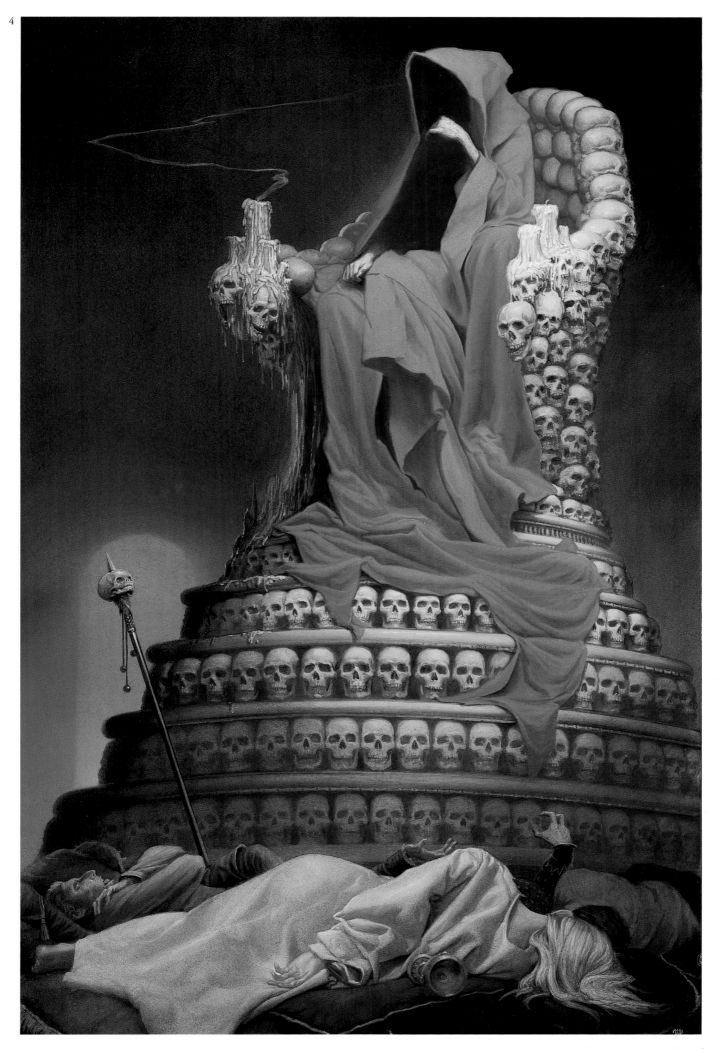

1
artist: **Bryn Barnard**
art director: Isabel Warren-Lynch
client: Crown Books
title: Outbreak
medium: Oil on panel
size: 60"x30"

2
artist: **Matthew Mitchell**
art director: Rich Thomas
client: White Wolf Publishing
title: Mage Boston
medium: Oil
size: 50"x40"

3
artist: **Jeremy Geddes**
client: Lothian Books
title: The Mystery of Eilean Mor
medium: Oil
size: 1818cm x 915cm

4
artist: **Brad Holland**
art director: Irene Gallo
client: Tor Books
title: Christmas Stars
medium: Acrylic

5
artist: **Lee Moyer**
art director: Andrew Migliore
designer: Lee Moyer
client: Night Shade Books
title: H.P. Lovecraft: The Lurker in
 the Lobby
medium: Mixed
size: 12"x18"

6
artist: **Francis Tsai**
title: Machineflesh: Reluctant God
medium: Digital
size: 16"x10"

1

2

3

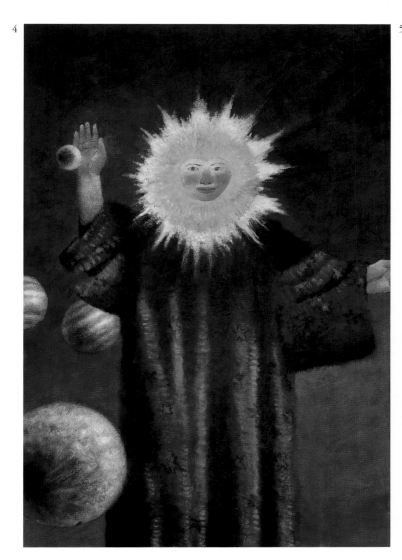

1
artist: **Carlos Huante**
client: Monstruo: The Art of Carlos Huante
title: Vices
medium: Mixed/digital

2
artist: **Carlos Huante**
client: Monstruo: The Art of Carlos Huante
title: Tierra Mia
medium: Mixed/digital

3
artist: **Brom**
art director: Brom
client: Abrams Books
title: The Plucker
medium: Oil

4
artist: **Vince Natale**
art director: Michael Storrings
client: St. Martins Press
title: The Bitten
medium: Oil
size: 13"x18"

1

2
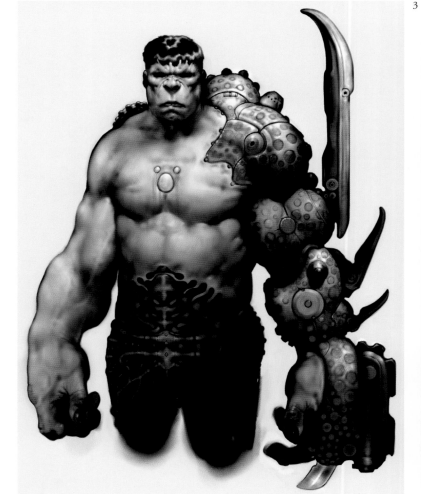

3
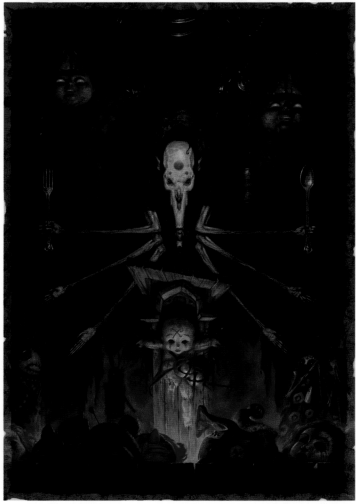

4

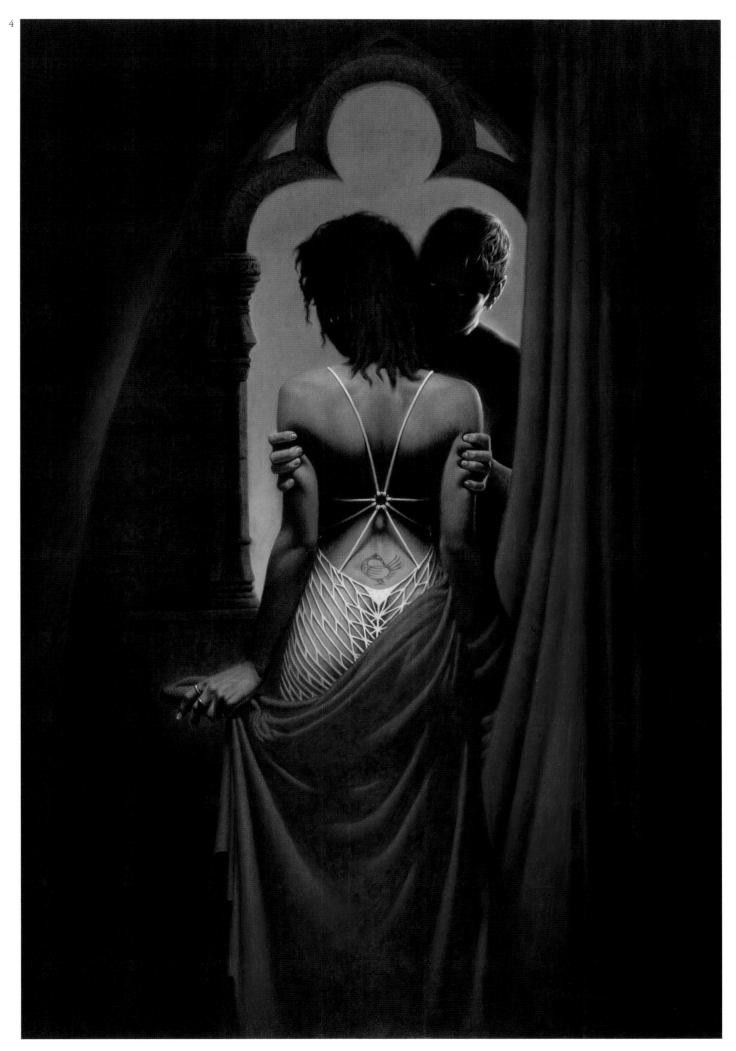

1
artist: **Oliver Scholl**
art director: Oliver Scholl
designer: Oliver Scholl
client: Wilhelm Heyne Verlag,
　　　Muenchen Random
　　　House GmbH
title: Die Laengste Nacht
medium: Digital
size: 29cm x 22cm

2
artist: **Viktor Koen**
art director: Viktor Koen
client: Graphopress/
　　　Attic Child Press
title: Page 84: Plug in the
　　　Quest for Mug
medium: Digital
size: 17"x9$^{3}/_{8}$"

3
artist: **Ron Miller**
art director: Janet Vicario
client: Workman Publishing
title: The Grand Tour
medium: Digital
size: 22"x8$^{1}/_{2}$"

4
artist: **Fred Gambino**
art director: Judy Murello
client: Berkley Books
title: Old Twentieth
medium: Digital

5
artist: **Dave Seeley**
art director: Dave Stevenson
client: DelRey Books
title: Star Wars: Healer (Pieta)
medium: Oil on digital
　　　background
size: 24"x40"

6
artist: **Stephan Martiniere**
art director: Benedicte
　　　Lombardo
client: Univers Poche
title: Skinner
medium: Digital

7
artist: **Manchu**
client: ISF Editions
title: La Harpe des Etoiles
medium: Acrylic
size: 50cm x 65cm

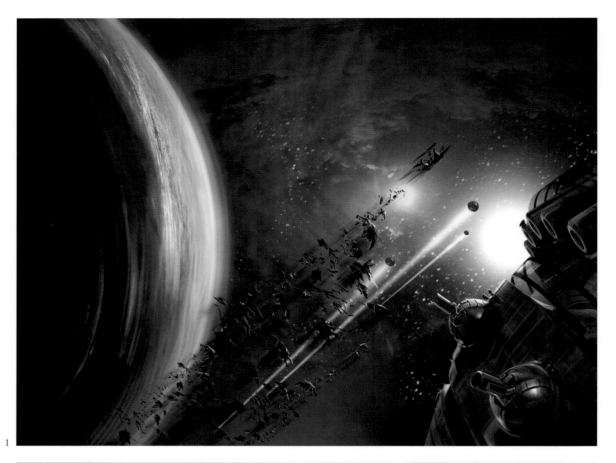

1

2

3

4

5

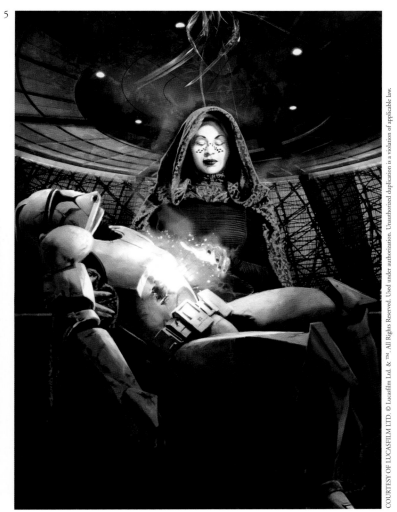

COURTESY OF LUCASFILM LTD. © Lucasfilm Ltd. & ™. All Rights Reserved. Used under authorization. Unauthorized duplication is a violation of applicable law.

6

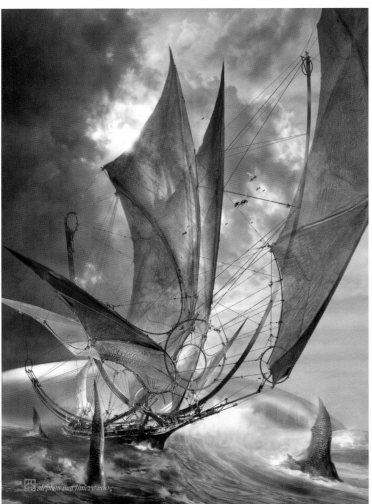

7

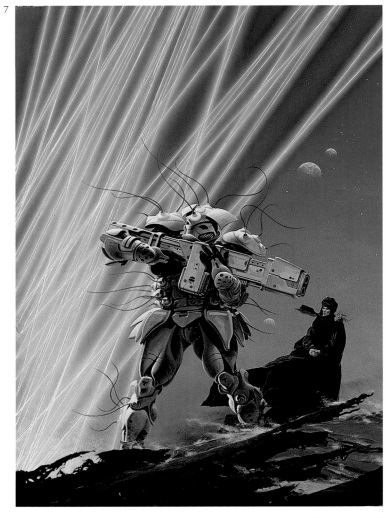

1
artist: **Richard Sardinha**
art director: Mike Chaney
client: Necromancer Games
title: Mesopotamia
medium: Oil
size: 24"x18"

2
artist: **Victoria Francés**
art director: Victoria Francés
client: Norma Editorial
title: Diabulus (Favole Vol. 2)
medium: Color pencil
size: 12"x16"

3
artist: **Melvyn Grant**
art director: Melvyn Grant
client: The Art Book
title: The Nubian Princess
medium: Digital
size: 21"x31"

4
artist: **Mark Zug**
art director: Matt Adelsperger
client: Wizards of the Coast
title: Crimson Blade
medium: Oil
size: 13"x16"

1
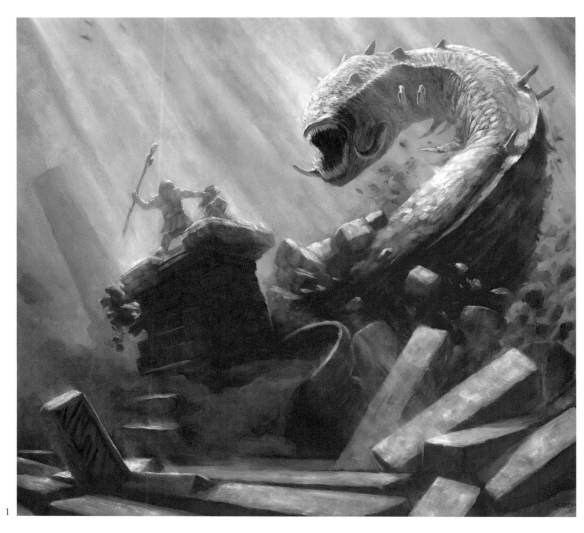

2
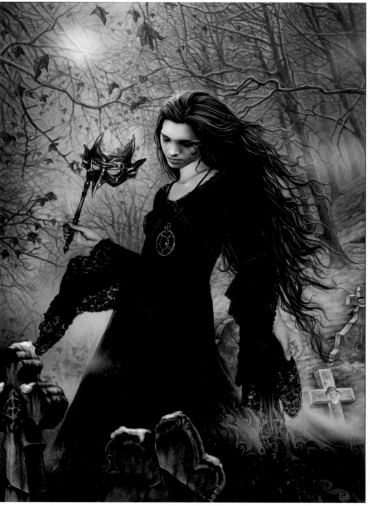

3
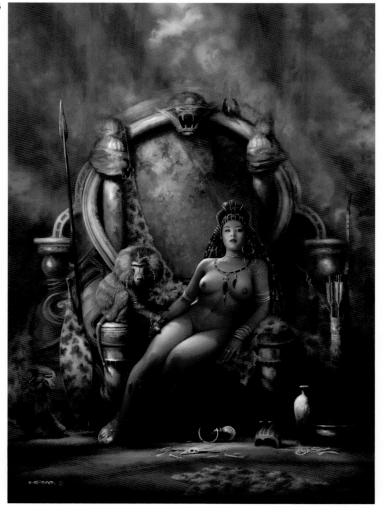

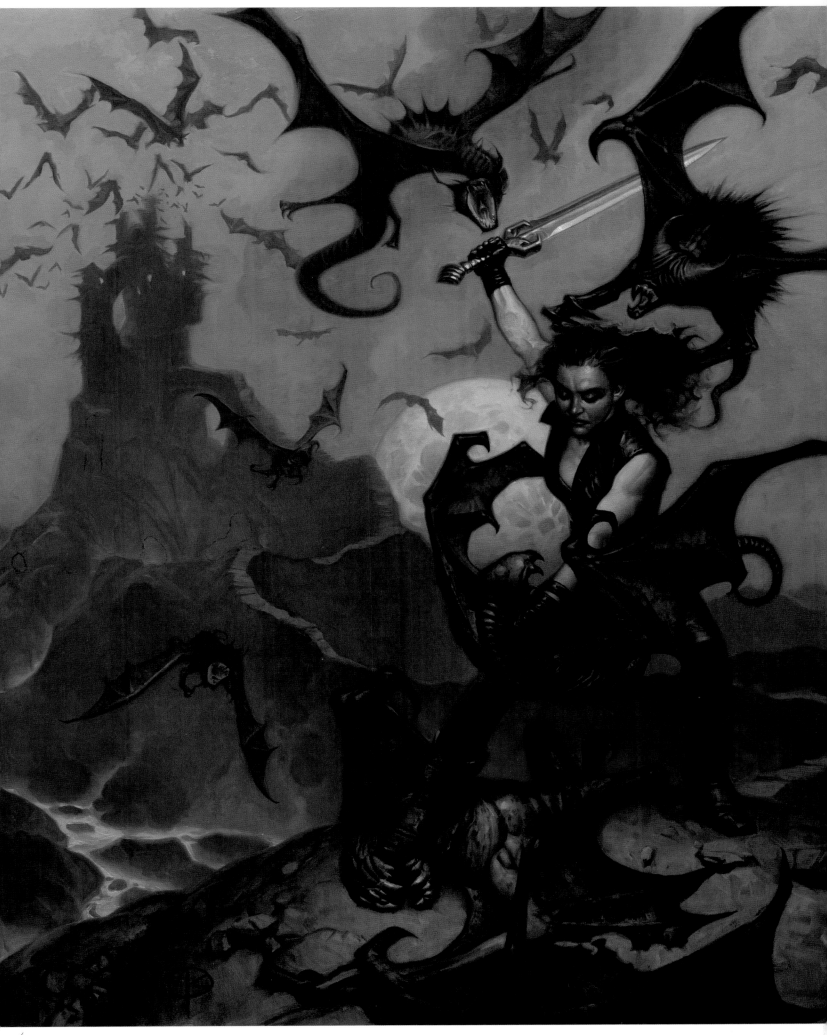

1
artist: **Adam Rex**
art director: Dawn Murin
client: Wizards of the Coast
title: Races of Destiny
medium: Oil
size: 23"x18"

2
artist: **Armel Gaulme**
art director: Armel Gaulme/
 Anne-Catherine Boudet
client: Adam Biro Jeunesse
title: Merlin
medium: Color inks/pencils
size: 28cm x 42cm

3
artist: **Leo & Diane Dillon**
art director: David Saylor
client: Scholastic
title: Tales From Shakespeare
medium: Acrylic on acetate
size: 11¹/2"x15¹/4"

4
artist: **Leo & Diane Dillon**
art director: Connor Cochran
client: Conlan Press
title: The Last Unicorn
medium: Acrylic & oil
size: 12"x16¹/2"

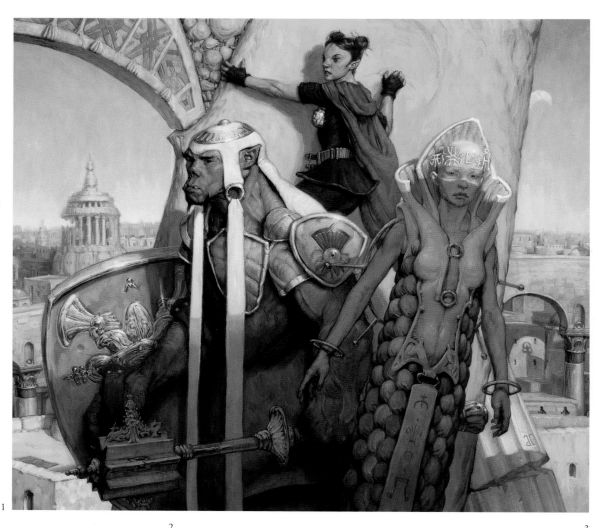

1

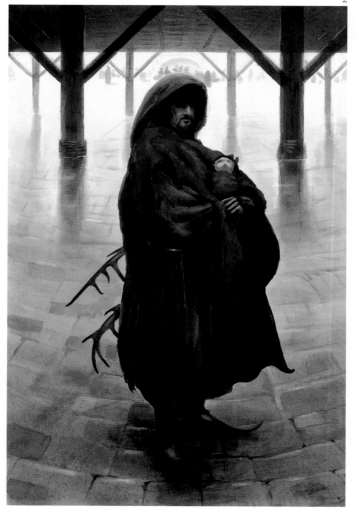

2

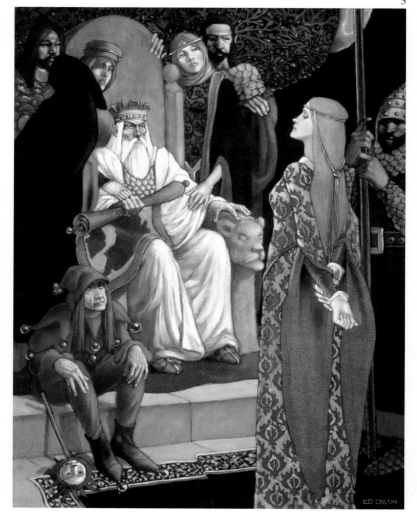

3

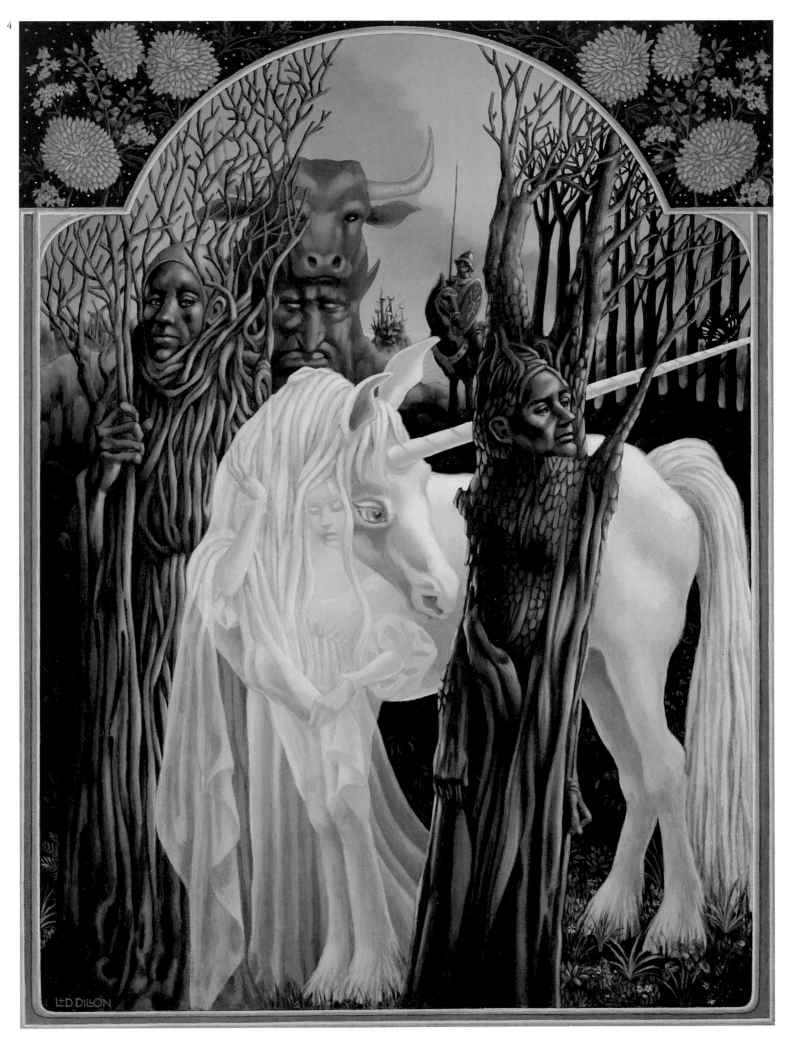

1
artist: **Ciruelo**
art director: Nele Schutz
client: Piper Verlag
title: E Scudo
medium: Mixed/digital

2
artist: **Gris Grimly**
art director: Gris Grimly
client: Baby Tattoo Books
title: Mad Hare
medium: Ink & watercolor
size: 9"x8"

3
artist: **Red Nose Studio**
art director: Iren Gallo
client: Starscape Books
title: The Borribles
medium: Super sculpy/fabric

4
artist: **Justin Sweet**
art director: Theo Berquist
client: Conan Properties
medium: Oil/digital

5
artist: **Todd Lockwood**
art director: Hope Matthiessen
client: COS Books
title: The Highwayman
medium: Digital
size: 18"x13"

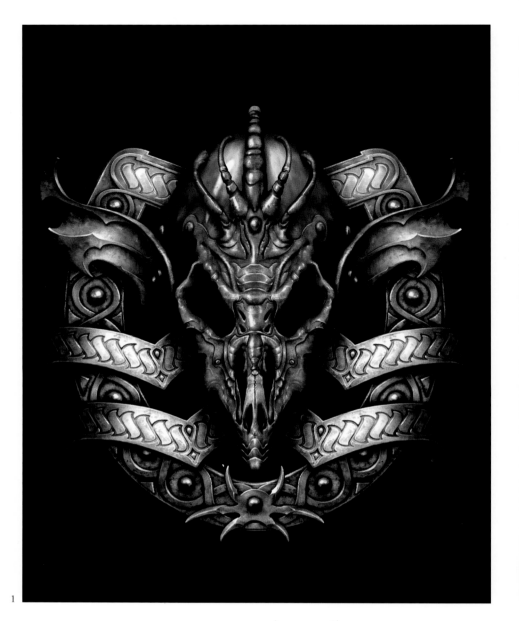

1

2

1
artist: **Robh Ruppel**
client: Bar Libres
title: Rocket Boy
medium: Digital
size: 10"x10"

2
artist: **Ronny Vardy**
art director: Ronny Vardy
client: Baby Tattoo Books
title: Girls That Bite
medium: Watercolor

3
artist: **James Jean**
art director: Irene Gallo
client: Starscape Books
title: The Green Futures
of Tycho
medium: Digital

4
artist: **Dave McKean**
art director: Irene Gallo
designer: Irene Gallo
client: Tor Books
title: Sleeping in Flame
medium: Mixed
size: 6"x8¹/₂"

1

2

3

1
artist: **Stephen Youll**
art director: Don Puckey
client: Warner Books
title: Scattered Suns
medium: Mixed/digital
size: 14"x12"

2
artist: **John Harris**
art director: Irene Gallo
client: Tor Books
title: Armies of Memory
medium: Oil on canvas
size: 21"x30"

3
artist: **John Harris**
art director: Nicholas Sica
client: Bookspan
title: Ports of Call
medium: Oil on canvas
size: 28"x42"

4
artist: **Stephan Martiniere**
art director: Irene Gallo
client: Tor Books
title: Elantris
medium: Digital

1

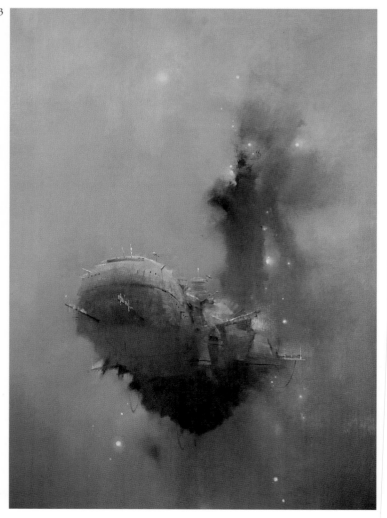

2

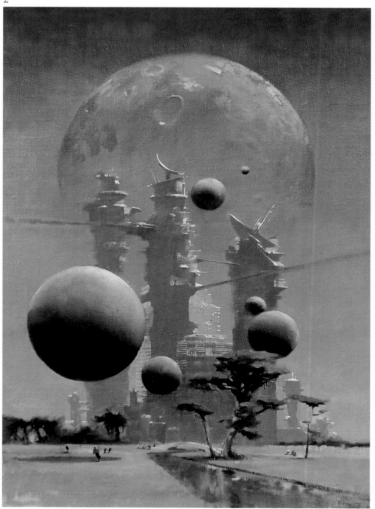

3

4

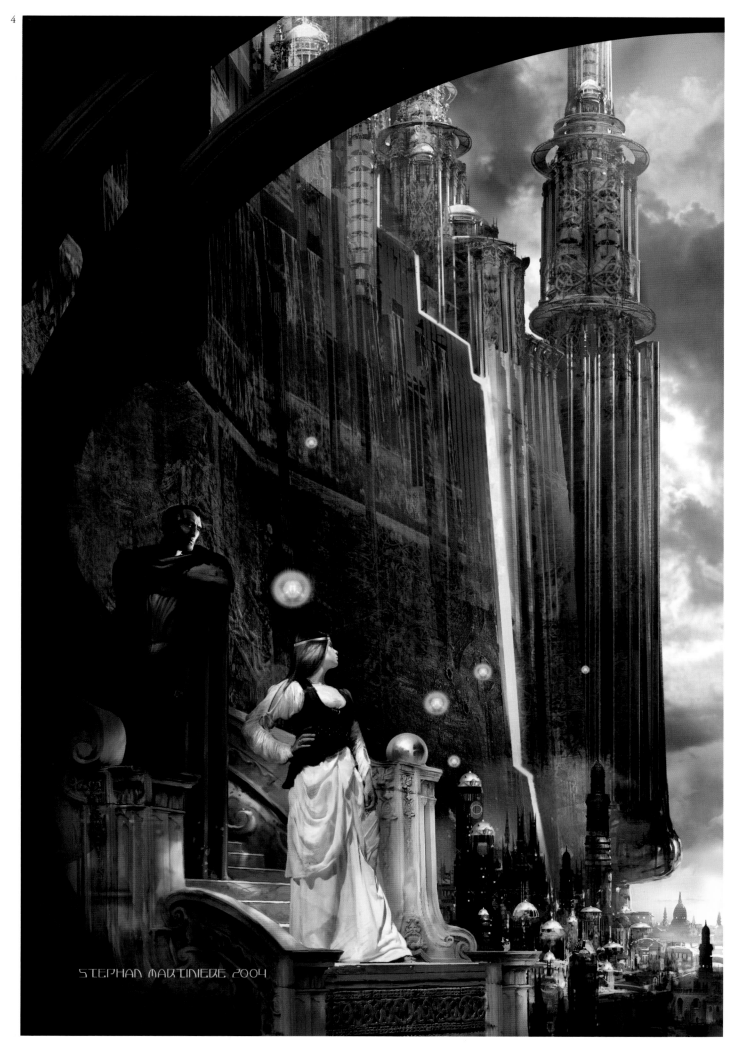

STEPHAN MARTINIERE 2004

1
artist: **Kinuko Y. Craft**
art director: Judy Murello
client: Berkley Books
title: Old Magic
medium: Oil over watercolor
size: 23"x16"

2
artist: **Gregory Manchess**
art director: Irene Gallo
client: Tor Books
title: The Wizard
medium: Oil on linen
size: 30"x25"

3
artist: **Bruce Jensen**
art director: Judith Murello
client: Ace Books
title: For Those Who Fell
medium: Digital

4
artist: **Kinuko Y. Craft**
art director: Irene Gallo
client: Tor Books
title: The Divided Crown
medium: Oil over watercolor
size: 15^1/4"x20"

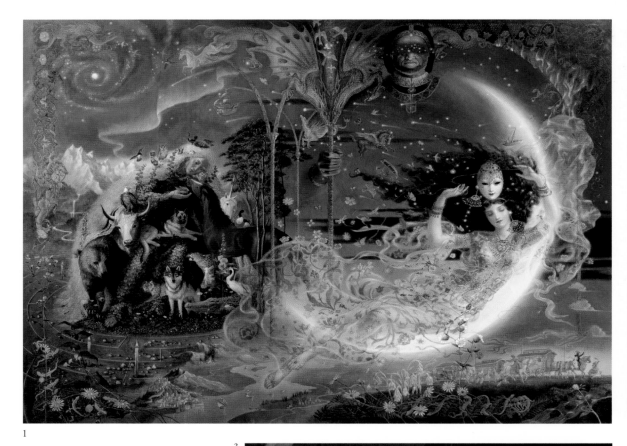

1

3

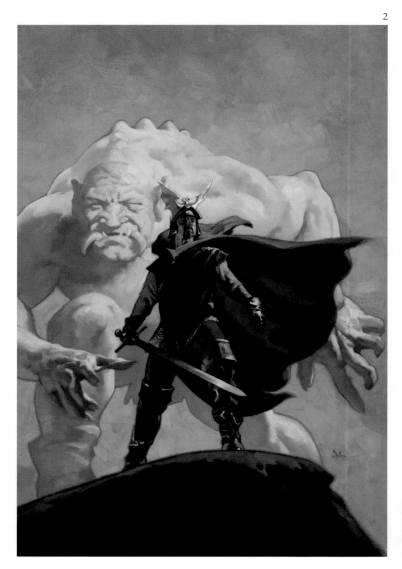

2

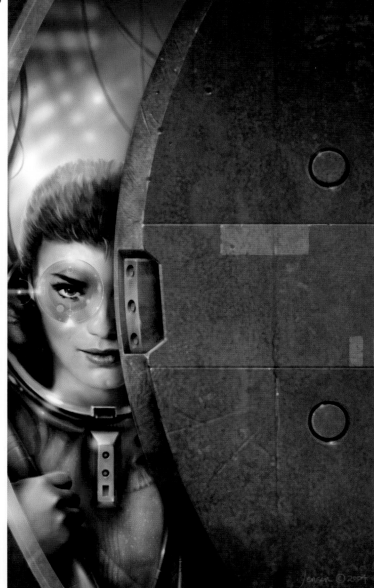

4

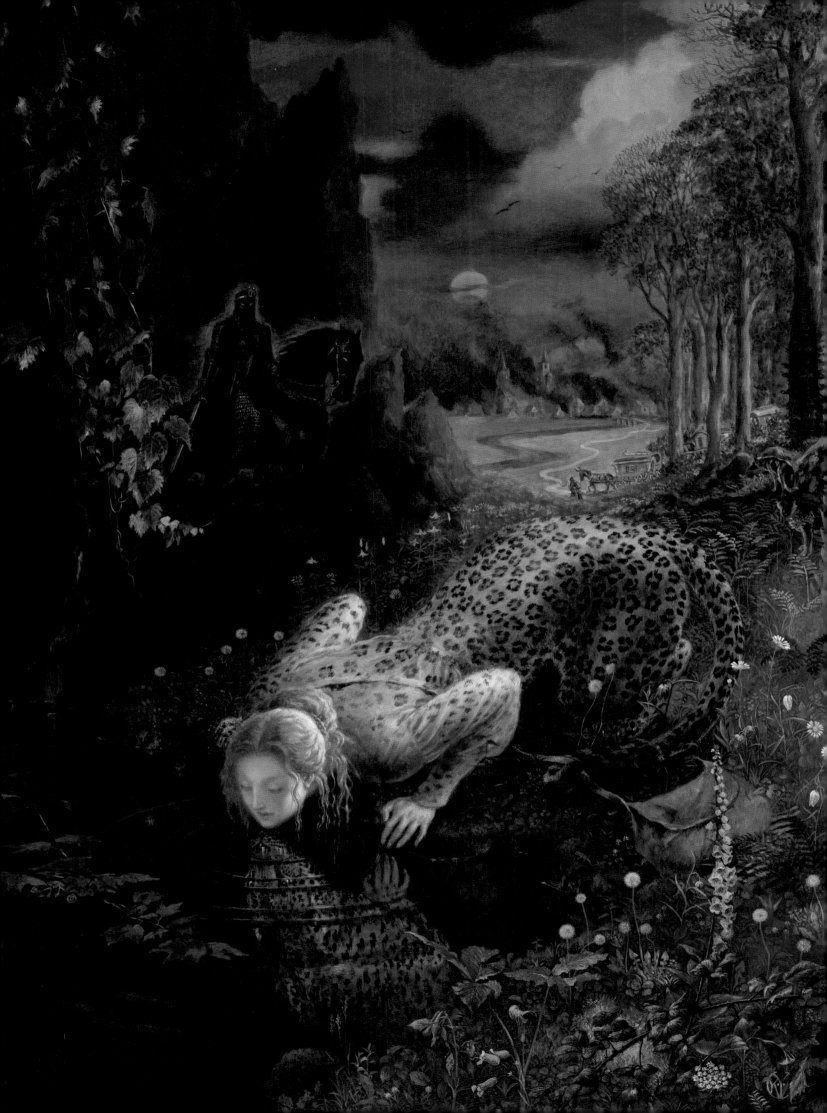

1
artist: **Adam Rex**
art director: Dawn Murin
client: Wizards of the Coast
title: Races of the Wild
medium: Oil
size: 23"x18"

2
artist: **Adam Rex**
art director: Matt Adelsperger
client: Wizards of the Coast
title: The Farthest Reach
medium: Oil
size: 20"x15"

3
artist: **Jon Sullivan**
art director: Matt Adelsperger
client: Wizards of the Coast
title: Spell Fire
medium: Oil
size: 13"x18"

4
artist: **R.K. Post**
art director: Sue Cook
client: Malhavoc Press
title: Beyond Countless
 Doorways
medium: Digital
size: 7"x12"

5
artist: **Luis Royo**
art director: Luis Royo
client: Norma Editorial
title: The Mist's Edge
medium: Acrylic
size: 24"x12"

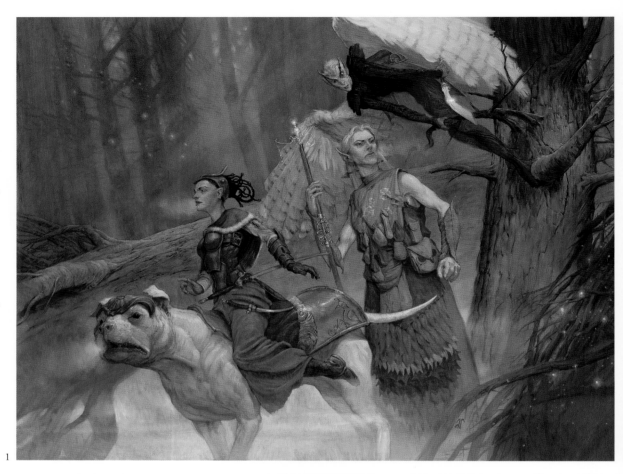

1

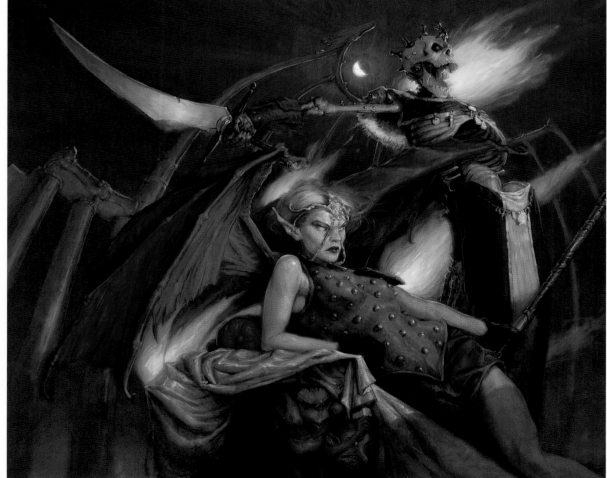

2

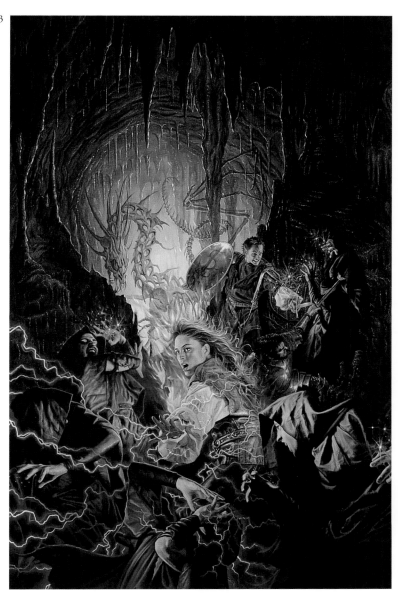

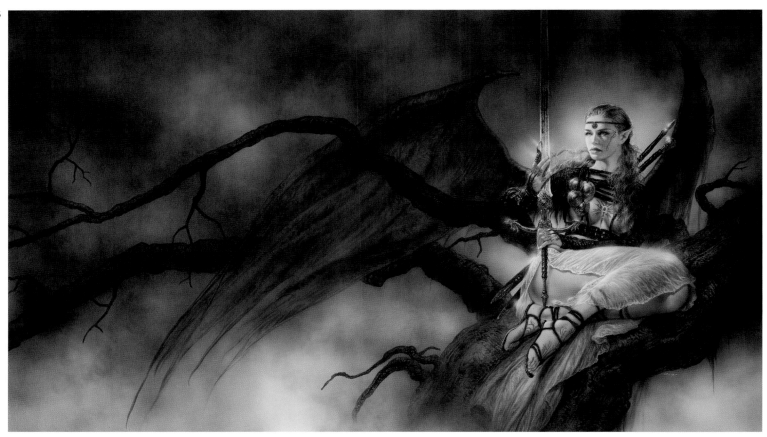

1
artist: **Jim & Ruth Keegan**
client: Wandering Star
title: El Borak
medium: Oil on canvas
size: 30"x40"

2
artist: **Tristan Elwell**
art director: Kenneth Holcomb
client: Random House
title: Lady Ilena: Way of the Warrior
medium: Oil on board
size: 12"x16"

3
artist: **Greg Newbold**
art director: Mark Siegel
client: Simon & Schuster
title: Tree
medium: Acrylic/mixed
size: 9"x12"

4
artist: **Michael Komarck**
art director: Matt Adelsperger
client: Wizards of the Coast
title: The Binding Stone
medium: Digital

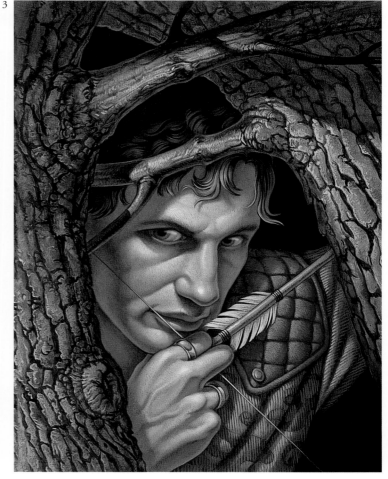

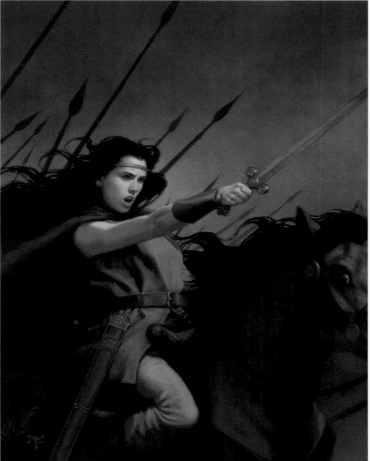

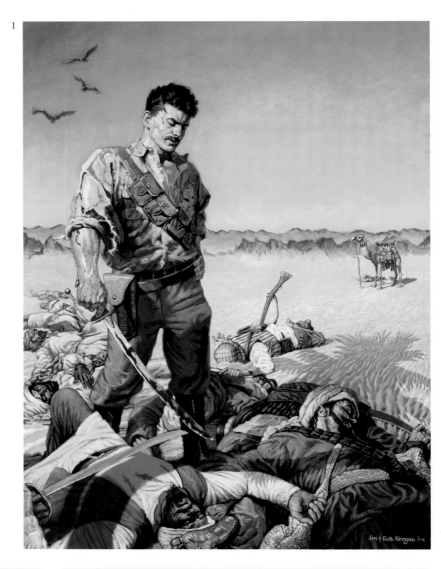

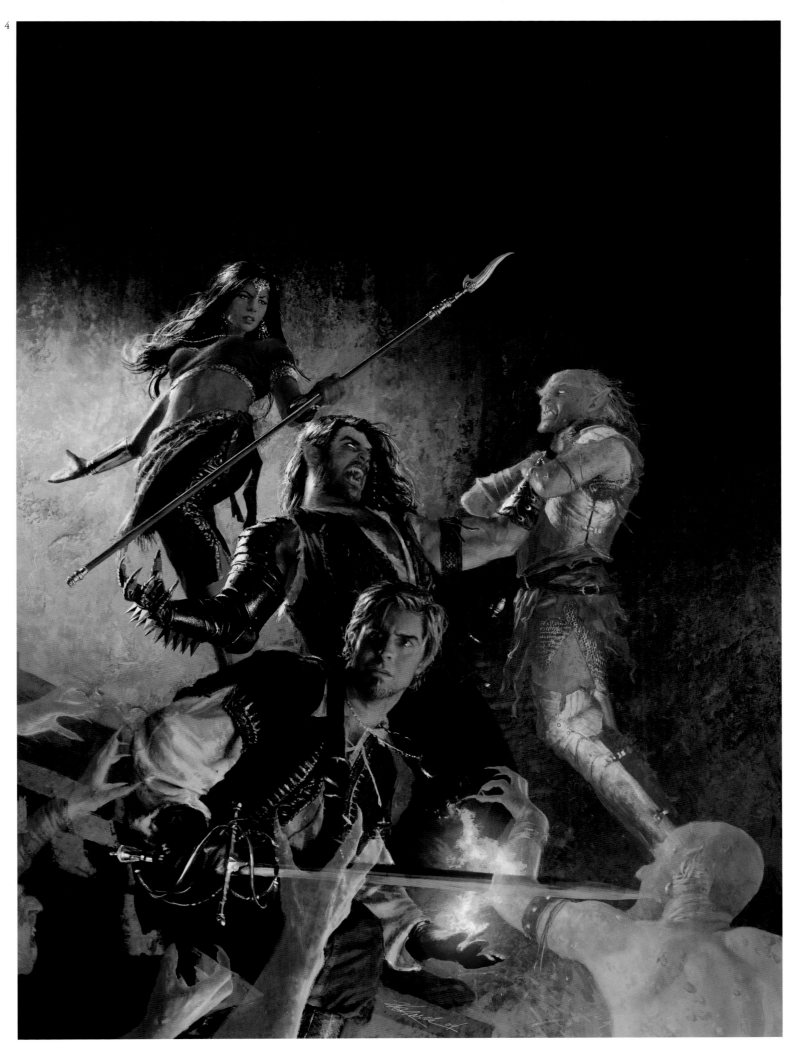

1
artist: **René Milot**
art director: Jason Zamajtuk
client: Random House
title: Island of the
 Blue Dolphins
medium: Oil on canvas
size: 13"x10"

2
artist: **John Jude Palencar**
art director: Irene Gallo
client: Tor Books
title: Someplace to be Flying
medium: Acrylic
size: 28"x20"

3
artist: **John Howe**
art director: Jane Johnson
client: HarperCollins
title: Soldier Son
medium: Watercolor
size: 37"x23"

4
artist: **John Jude Palencar**
art director: Irene Gallo
client: Tor Books
title: Wild Reel
medium: Acrylic
size: 27"x19"

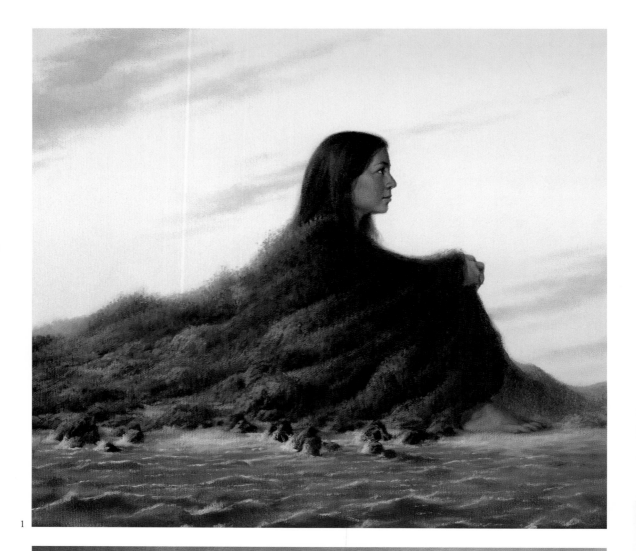

1

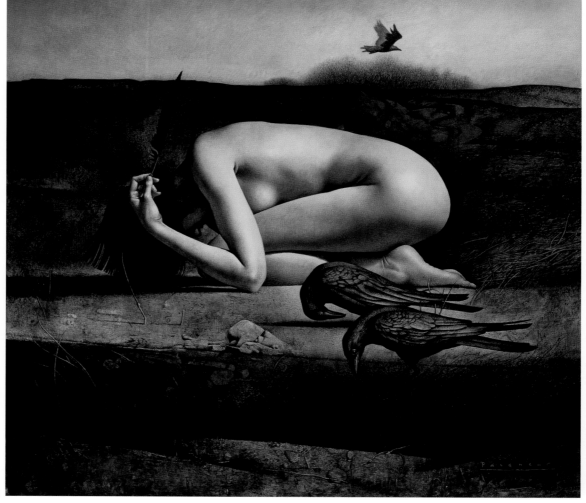

2

3

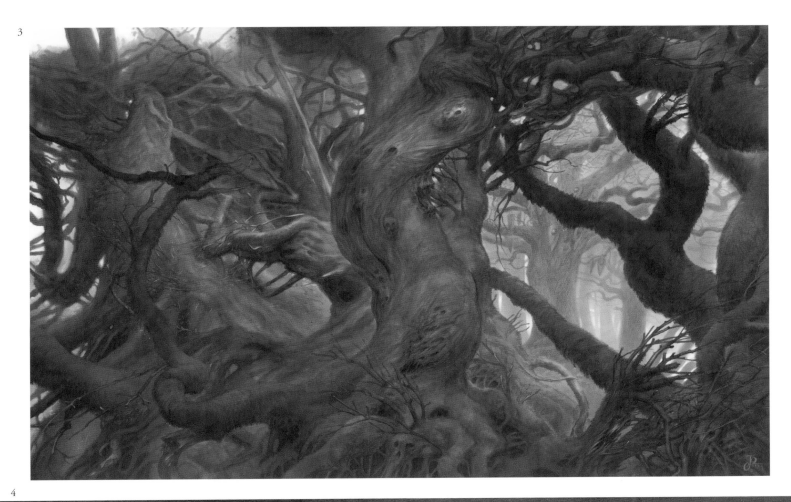

4

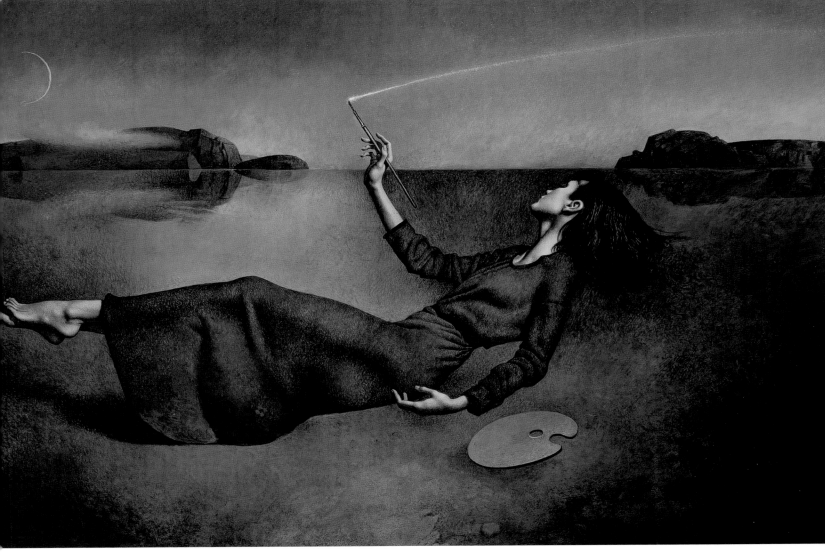

1
artist: **Alejandro Terán**
client: Edge Entertainment
title: Puppetland
medium: Mixed/digital

2
artist: **Jason Felix**
art director: Jason Felix
client: In Your Face Publishing
title: Modo Geisha
medium: Mixed
size: 10"x10"

3
artist: **Thomas Thiemeyer**
art director: Gerold Anrich
client: Beltz & Gelberg
title: The Magic Stones
medium: Oil
size: 20"x24"

4
artist: **Jeff Soto**
art director: Irene Gallo
client: Tor Books
title: Gil's All Fright Diner
medium: Oil

5
artist: **John Picacio**
art director: Jacob Weisman
client: Tachyon
title: The Cat's Pajamas
medium: Mixed/digital
size: 18"x12¹/₂"

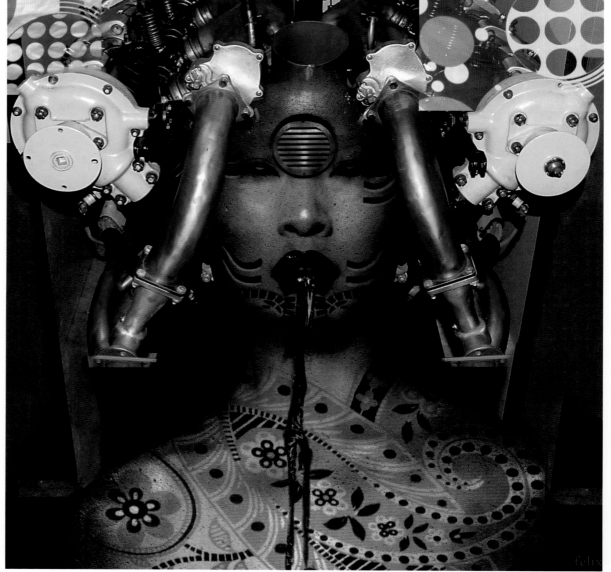

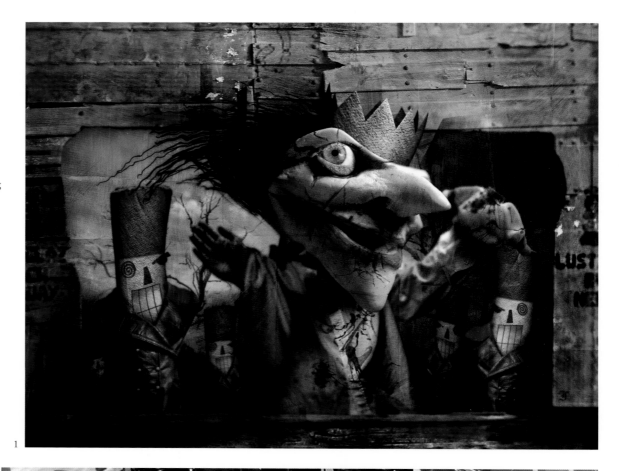

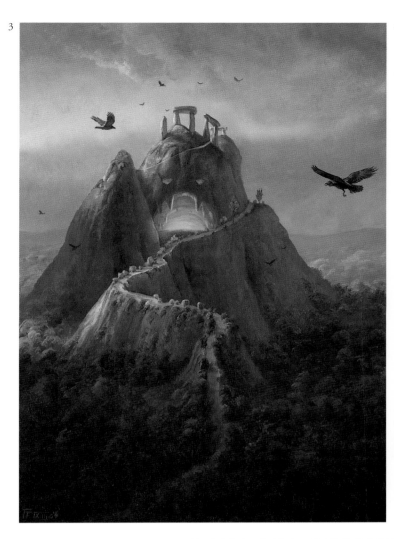

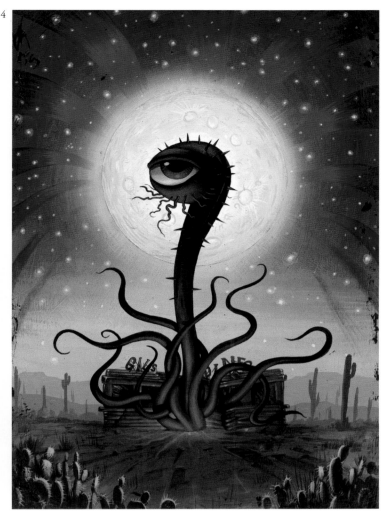

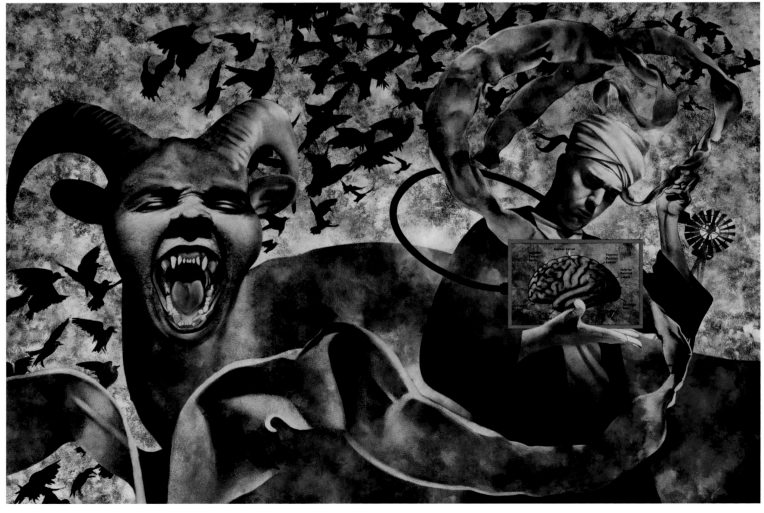

1
artist: **Daarken**
art director: Robert Raper
client: Wizards of the Coast
title: Aerenal Elves
medium: Digital
size: 10"x8"

2
artist: **Brom**
art director: Matt Adelsperger
client: Wizards of the Coast
title: Resurrection
medium: Oil
size: 30"x20"

3
artist: **Paul Bonner**
art director: Theodore Bergquist
client: RiotMinds
medium: Watercolor
size: 39cm x 54cm

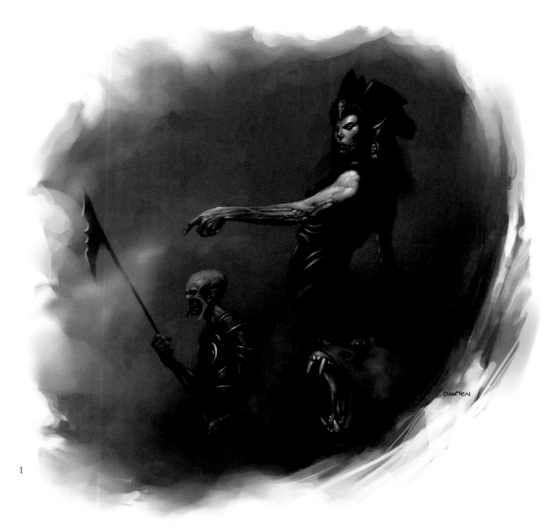

1

2

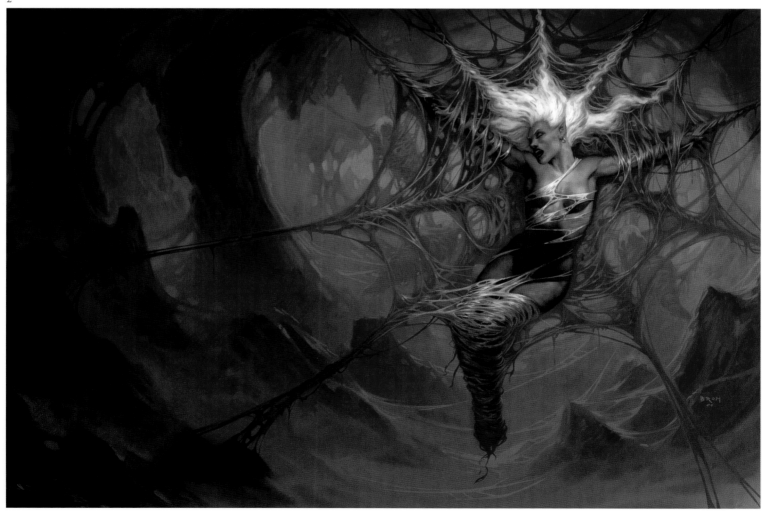

3

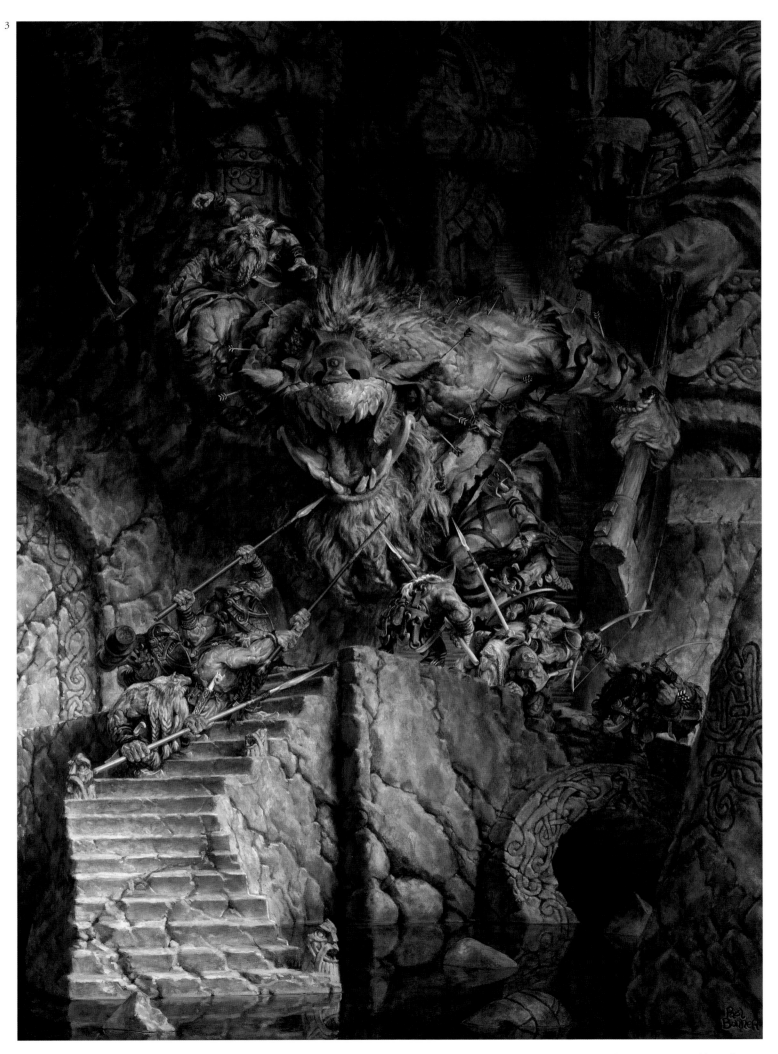

1
artist: **Joe DeVito**
client: DH Press
title: Kong Atop the
 Empire State Building
medium: Oil
size: 8"x8"

2
artist: **Joe DeVito**
client: DH Press
title: Kong: King of Skull Island
medium: Oil
size: 35"x25"

3
artist: **Todd Lockwood**
art director: Irene Gallo
client: Tor Books
title: Crystal Rain
medium: Digital
size: 20"x15"

4
artist: **James Gurney**
title: Chandara
medium: Oil on canvas
size: 52"x24"

1

2

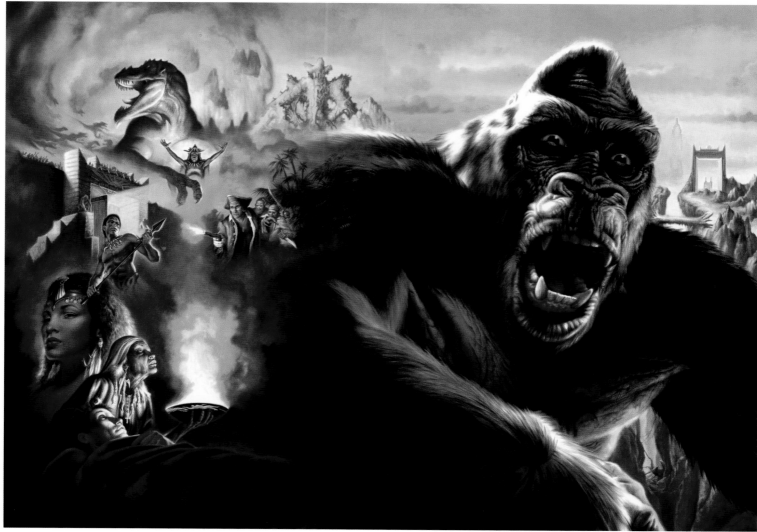

3

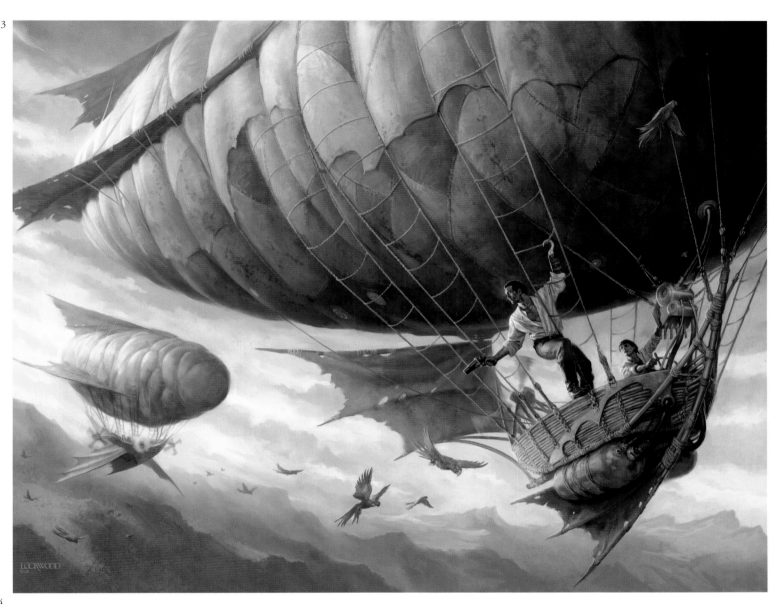

4

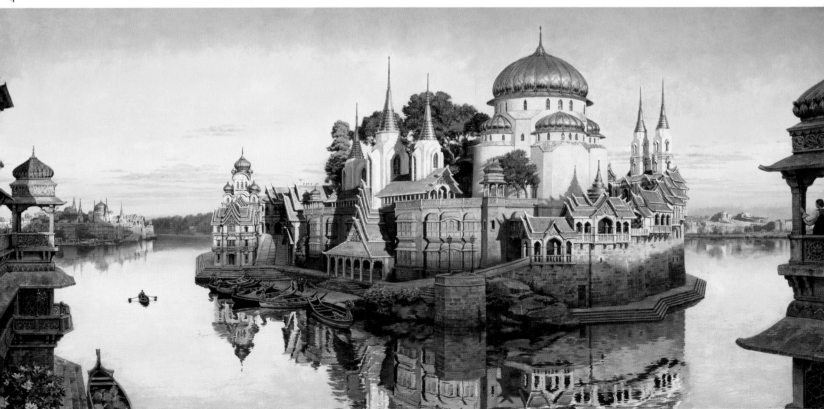

1
artist: **Dennis Nolan**
art director: Ann Diebel
designer: Dennis Nolan
client: Hyperion Books
title: St. Francis of Assisi (The Angel)
medium: Watercolor
size: 10"x10"

2
artist: **Glen Orbik**
art director: Max Phillips
designer: Glen Orbik/Laurel Blechman
client: Hard Case Crime
title: Branded Woman
medium: Oil
size: 16"x22^1/$_2$"

3
artist: **Scott Fischer**
art director: Iren Gallo
client: Tor Books
title: Orphans of Chaos
medium: Mixed
size: 20"x24"

4
artist: **Donato Giancola**
art director: Irene Gallo
client: Tor Books
title: The Ordinary
medium: Oil on paper on panel
size: 18"x28"

1

2

3

4

1
artist: **Richard Bernal**
art director: Richard Bernal
client: Dutton
title: Jag's New Friend
medium: Oil *size:* 10¹/₂"x10¹/₂"

2
artist: **Paul Hess**
client: Frances Lincoln
title: Slovenia [Hidden Tales From Eastern Europe]
medium: Watercolor

3
artist: **Paul Hess**
client: Frances Lincoln
title: Romania [Hidden Tales From Eastern Europe]
medium: Watercolor

4
artist: **Greg Swearingen**
art director: Sammy Yuen
client: Simon & Schuster
title: My Teacher Is An Alien
medium: Mixed *size:* 6¹/₂"x10"

5
artist: **Simon Bartram**
art director: Mike Jolley
client: Templar
title: Bob In the Cockpit [Man On the Moon]
medium: Acrylics

6
artist: **Simon Bartram**
art director: Mike Jolley
client: Templar
title: Bob Goes Home [Man On the Moon]
medium: Acrylics

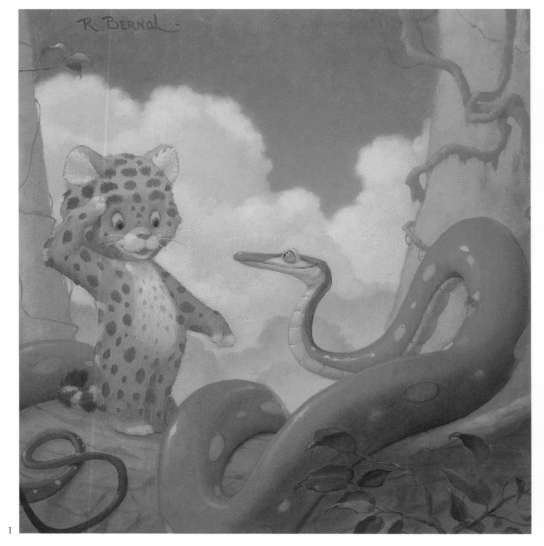

1

3

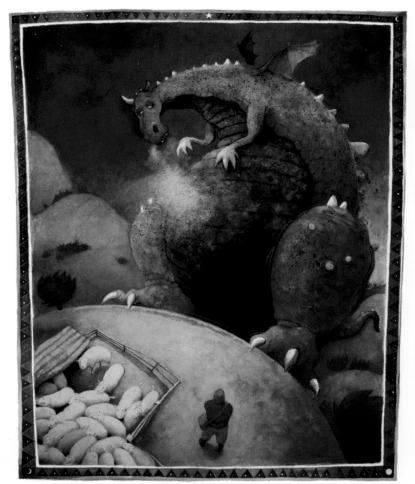

2

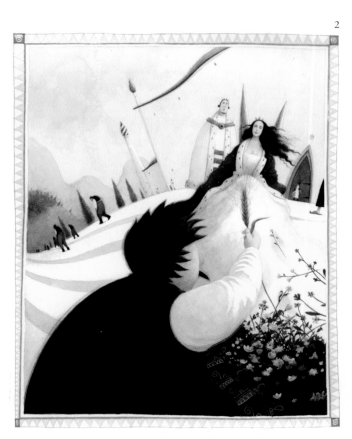

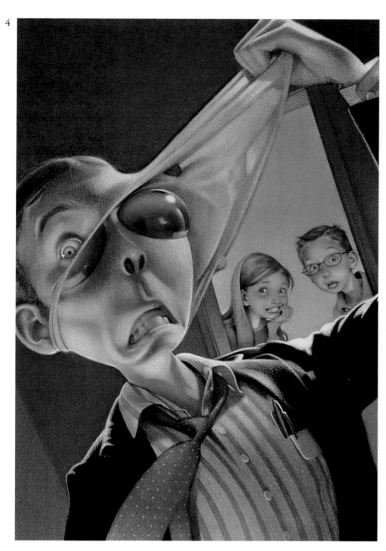

1
artist: **Sym 7**
art director: Dean Smith
client: Orb Interactive
title: The Chosen
medium: Oil/digital *size:* 11"x14"

2
artist: **Chris McGrath**
art director: Dave Stevenson
client: Del Rey Books
title: Iron Hand's Daughter
medium: Digital *size:* 4"x7"

3
artist: **Petar Meseldžija**
client: Museum Mohlmann/Realisten 04
title: The Balance
medium: Oil on canvas *size:* 35$^{1}/_{2}$"x47$^{1}/_{4}$"

4
artist: **Linda Bergkvist**
title: The Boy With the Golden Hair
medium: Digital *size:* 20cm x 30cm

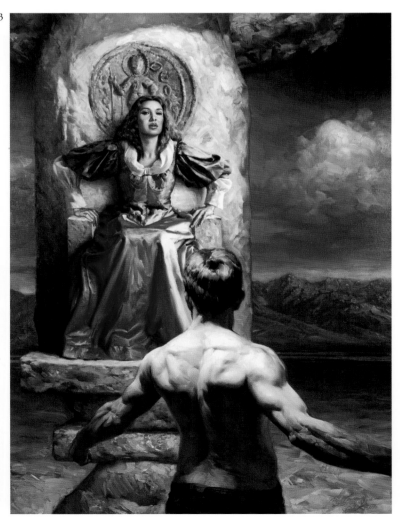

4

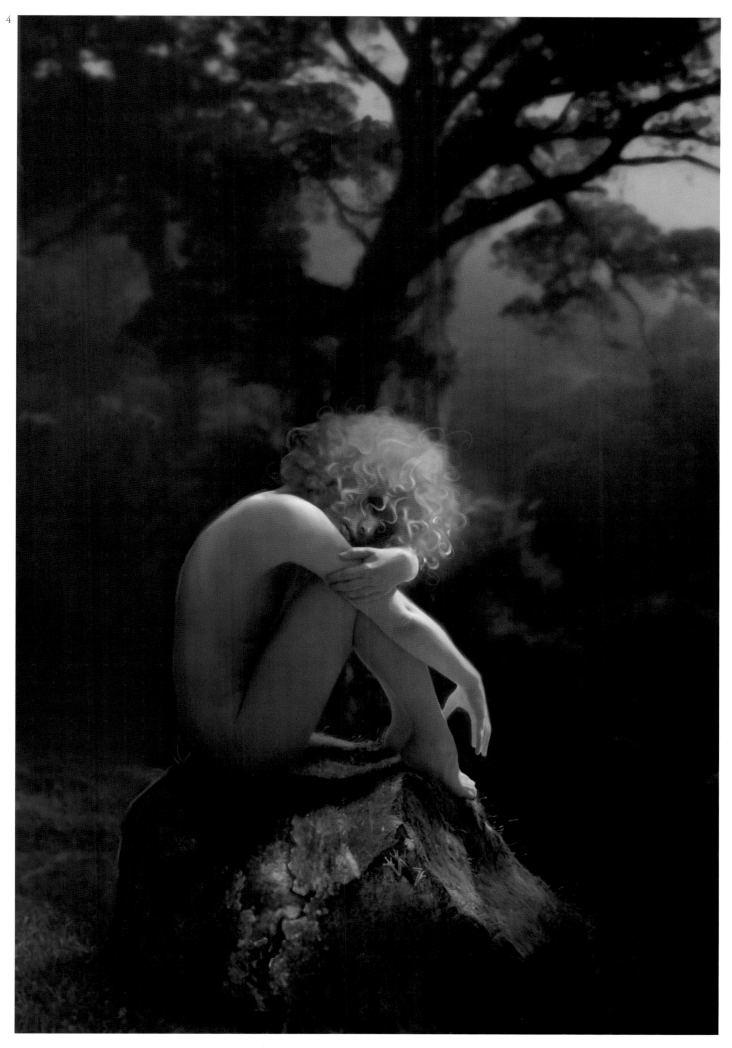

1
artist: **Omar Rayyan**
art director: Alessandra Balzer
client: Hyperion
title: Mistmantle
medium: Watercolor
size: 12"x12"

2
artist: **Marc Fishman**
art director: Matt Adelsperger
client: Wizards of the Coast
title: Queen of the Depths
medium: Oil on canvas
size: 4'x6'

3
artist: **Marc Fishman**
art director: Angi Sullins
client: Duirwaigh Publishing
title: Luna Ascending
medium: Oil
size: 24"x36"

4
artist: **Gary Gianni**
art director: Marcelo Anciano
client: Wandering Star
title: Conan Vol. II
medium: Oil
size: 30"x40"

1

2

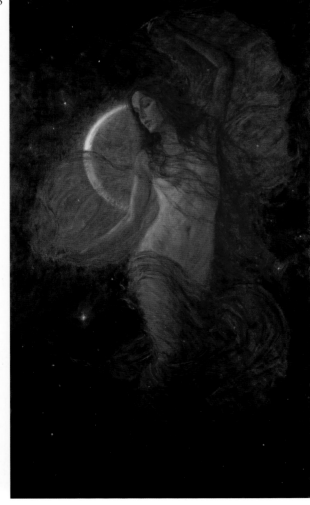

3

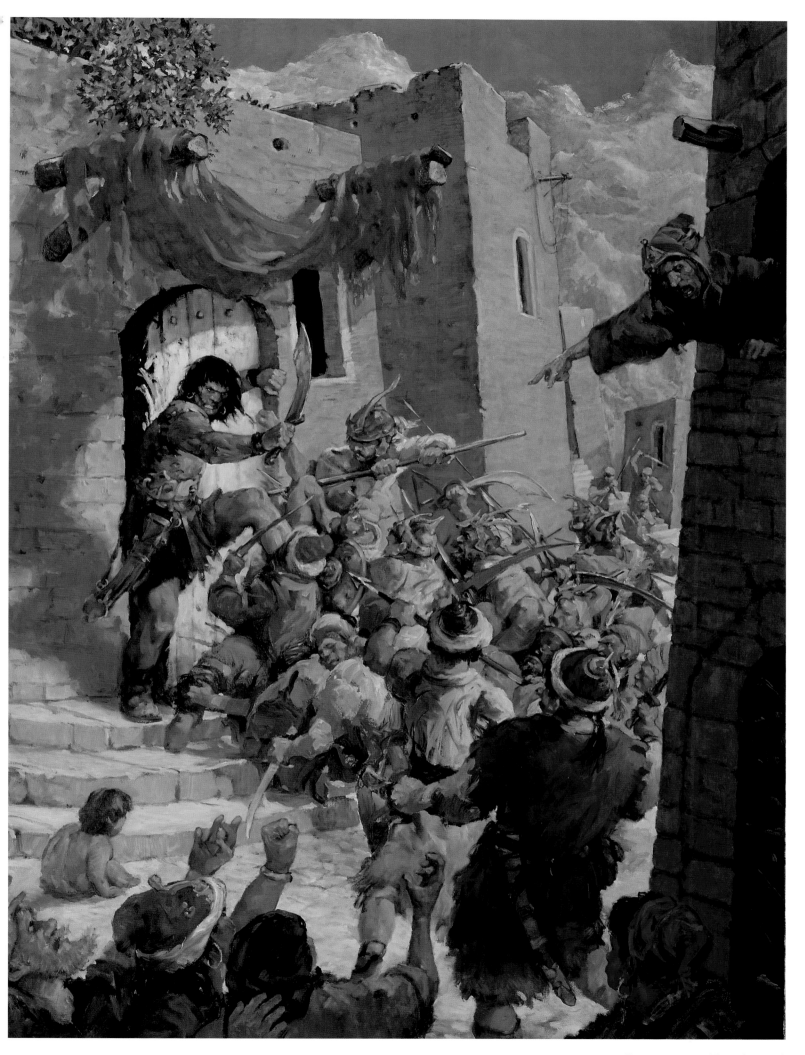

1
artist: **Tony DiTerlizzi**
art director: Dan Potash
client: Simon & Schuster
title: The Wrath of Mulgarath
medium: Gouache
size: 20"x18"

2
artist: **Matt Wilson**
client: Privateet Press
title: Adventure Express
medium: Oil on board
size: 46"x24"

3
artist: **Lewis Lavoie**
art director: Charles McCown
client: Apologetics Press
title: Bounty Hunter
medium: Oil
size: 48"x24"

4
artist: **Douglas Smith**
art director: Brenden Hitt
designer: Brenden Hitt
client: HarperCollins/Regan Books
title: Mirror, Mirror
medium: Scratchboard & watercolor
size: 9"x13"

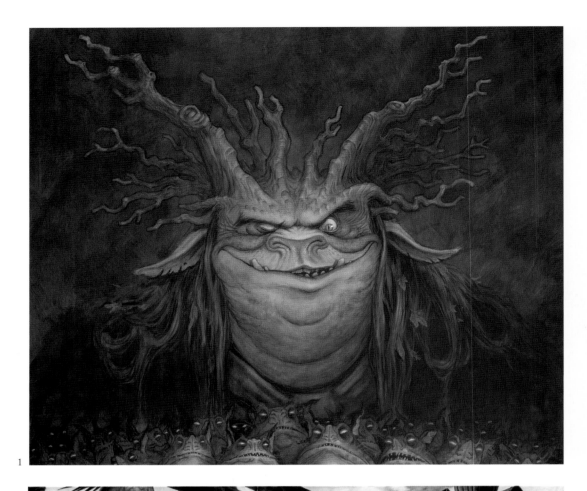

1

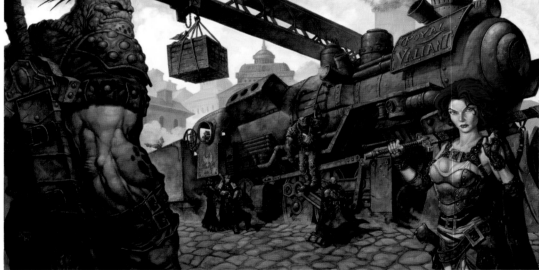

2

3

1
artist: **Raymond Swanland**
art director: Irene Gallo
client: Tor Books
title: Tyranny of the Night
medium: Digital

2
artist: **Donato Giancola**
art director: Irene Gallo
client: Tor Books
title: Elegy For Darkness:
 The Lady of Shalott
medium: Oil on paper
size: 58"x46"

3
artist: **Gordon Crabb**
art director: Irene Gallo
client: Tor Books
title: The Iron Tree
medium: Oil
size: 14"x23"

3

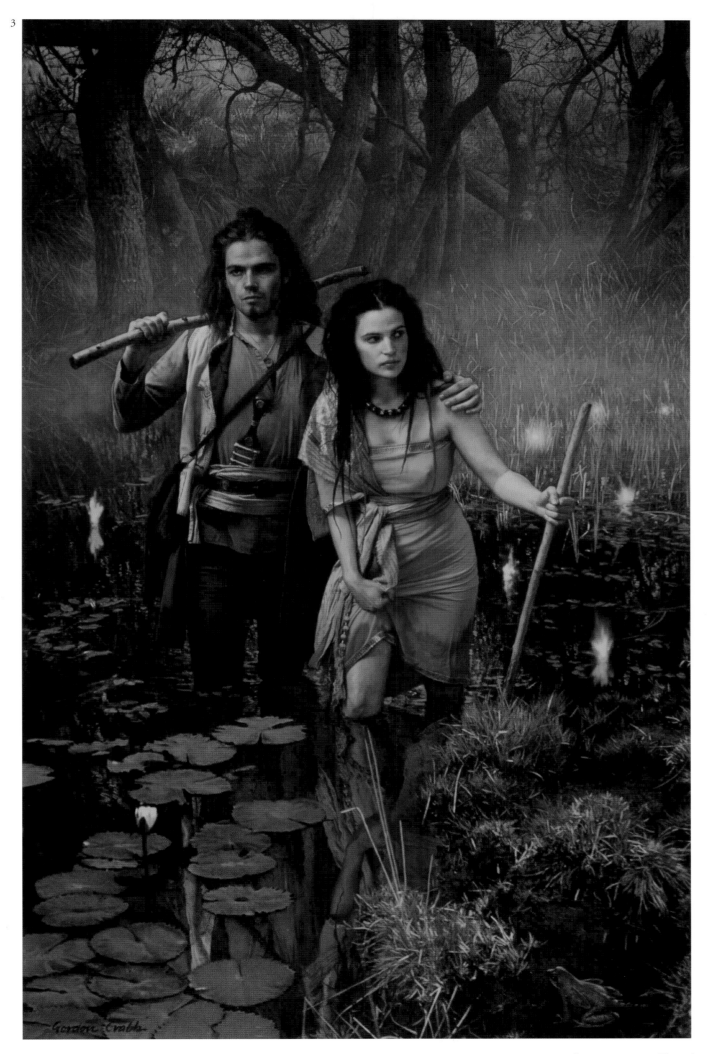

artist: Greg Ruth

art director: Shawna Gore *designer:* Darin Fabrick *client:* Dark Horse Comics *title:* Freaks of the Heartland *medium:* Mixed *size:* 13"x10¹/2"

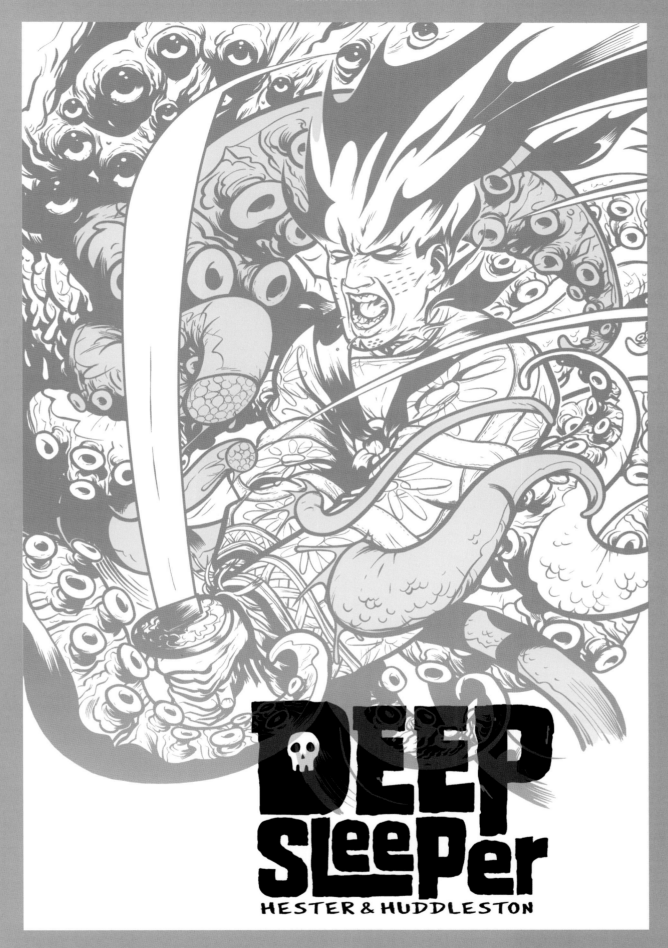

artist: Mike Huddleston

designer: Mike Huddleston *client:* Image Comics *title:* Deep Sleeper #5 *medium:* Mixed/digital

1
artist: **Greg Ruth**
art director: Shawna Gore/Scott Allie
designer: Darin Fabrick
client: Dark Horse Comics
title: Freaks of the Heartland #4
medium: Mixed
size: $6^1/2$"x$10^1/2$"

2
artist: **Greg Staples**
art director: Andy Diggle
client: 2000AD
title: The Duo Out West
medium: Acrylic

3
artist: **Greg Staples**
art director: Alan Barnes
client: Rebellion
title: Judge Death Takes a Trip
medium: Ink/digital

4
artist: **Greg Staples**
art director: Matt Smith
client: Rebellion
title: Judge Dredd Vs Judge Death
medium: Acrylic

1

2

3

Copyright © 2000AD. All Rights Reserved.

Copyright © Rebellion. All Rights Reserved.

Copyright © Rebellion. All Rights Reserved.

1
artist: **Robh Ruppel**
client: Bar Libres
title: Backdoor to Blackmail
medium: Digital
size: 9"x15"

2
artist: **Ken Meyer, Jr.**
client: Image Comics
title: An Eye For An Eye
medium: Watercolor
size: 30"x20"

3
artist: **Michael Wm. Kaluta**
art director: Scott Allie
client: Dark Horse Comics
title: Hellboy™ Weird Tales #8
medium: Ink & watercolor
size: 11"x16"

4
artist: **Glen Orbik**
art director: Teal Chimblo/
 Charles Hancock
designer: Glen Orbik/
 Laurel Blechman
client: Penny-Farthing Press
title: The Victorian #22
medium: Oil
size: 12¹/₂"x18¹/₂"

5
artist: **Nilson**
title: Astro [page 5]
medium: Mixed
size: 25cm x 36cm

6
artist: **Steve Rude**
client: Dark Horse Comics
title: Moth #1 [cover]
medium: Nupastel
size: 18"x24"

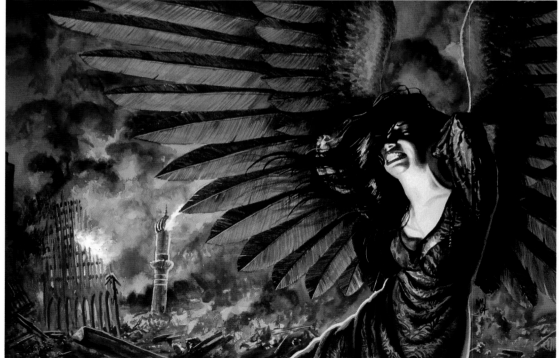

3

Hellboy ™ & © 2005 Mike Mignola. All Rights Reserved.

4

5

6

1
artist: **Jon Van Fleet**
art director: Kevin Kiniry
client: DC Comics
title: Mr. Freeze
medium: Mixed
size: 7"x7"

2
artist: **Aaron McBride**
client: Dark Horse Comics
title: Visionaries
medium: Digital
size: 11"x17"

3
artist: **Raymond Swanland**
art director: Matt Alfard
client: TokyoPop
title: The Reckoning
medium: Digital

4
artist: **Kent Williams**
art director: Shelly Bond
client: DC Comics/Vertigo Comics
title: Blood [interior page]
medium: Mixed
size: 11"x15"

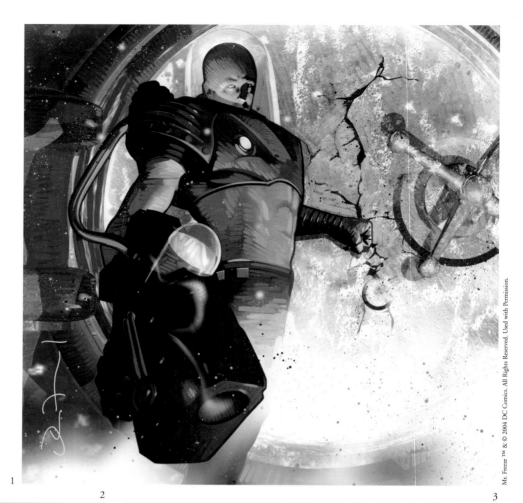

1

2

3

Mr. Freeze ™ & © 2004 DC Comics. All Rights Reserved. Used with Permission.

COURTESY OF LUCASFILM LTD. © Lucasfilm Ltd. & ™. All Rights Reserved. Used under authorization. Unauthorized duplication is a violation of applicable law.

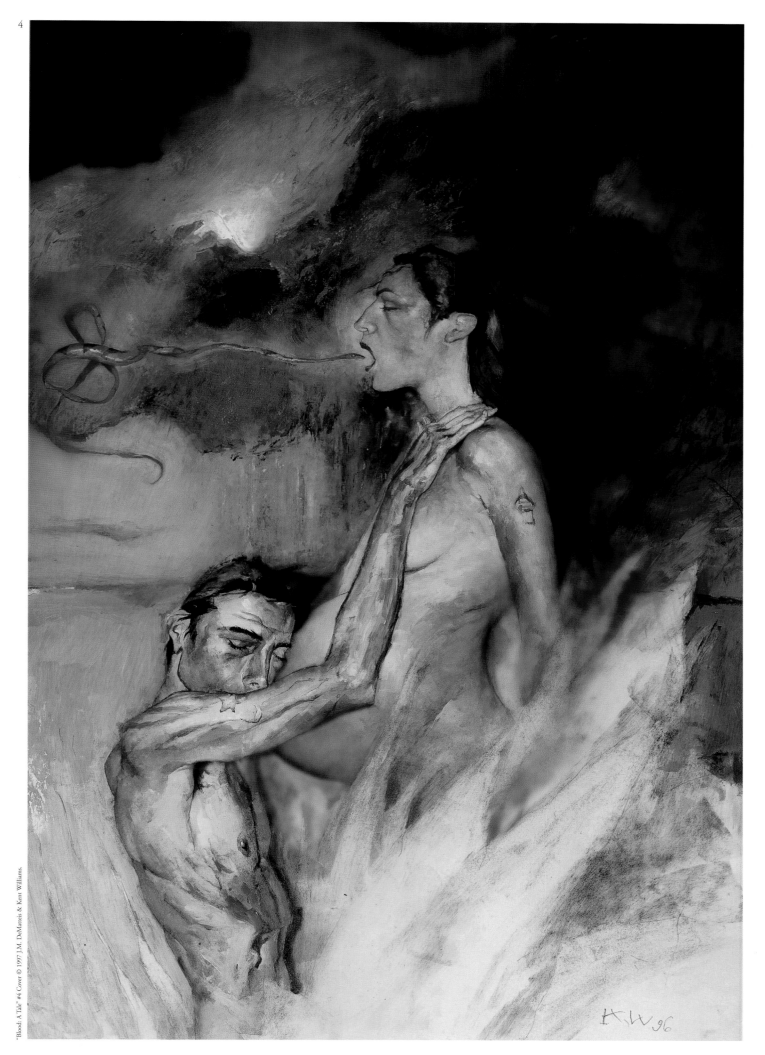

"Blood: A Tale" #4 Cover © 1997 J.M. DeMatteis & Kent Williams.

4

1
artist: **Brandon Peterson**
art director: Ralph Macchio
designer: Brandon Peterson
client: Marvel Comics
title: Ultimate X-Men #49
medium: Pencil/digital
size: 7"x10¹/₂"

2
artist: **Juvaun Kirby/**
Steve Firchow
art director: Jim McLauchlan
designer: Chaz Riggs
client: Top Cow Productions
title: Moritana
medium: Digital
size: 11"x17"

3
artist: **Joe Jusko**
art director: Joe Jusko
client: Harris Publications, Inc.
title: Vampirella
medium: Acrylic
size: 22"x28"

4
artist: **Gary L. Freeman**
art director: Kevin Eastman
client: Heavy Metal Magazine
title: In the Sewers
medium: Digital
size: 12"x16"

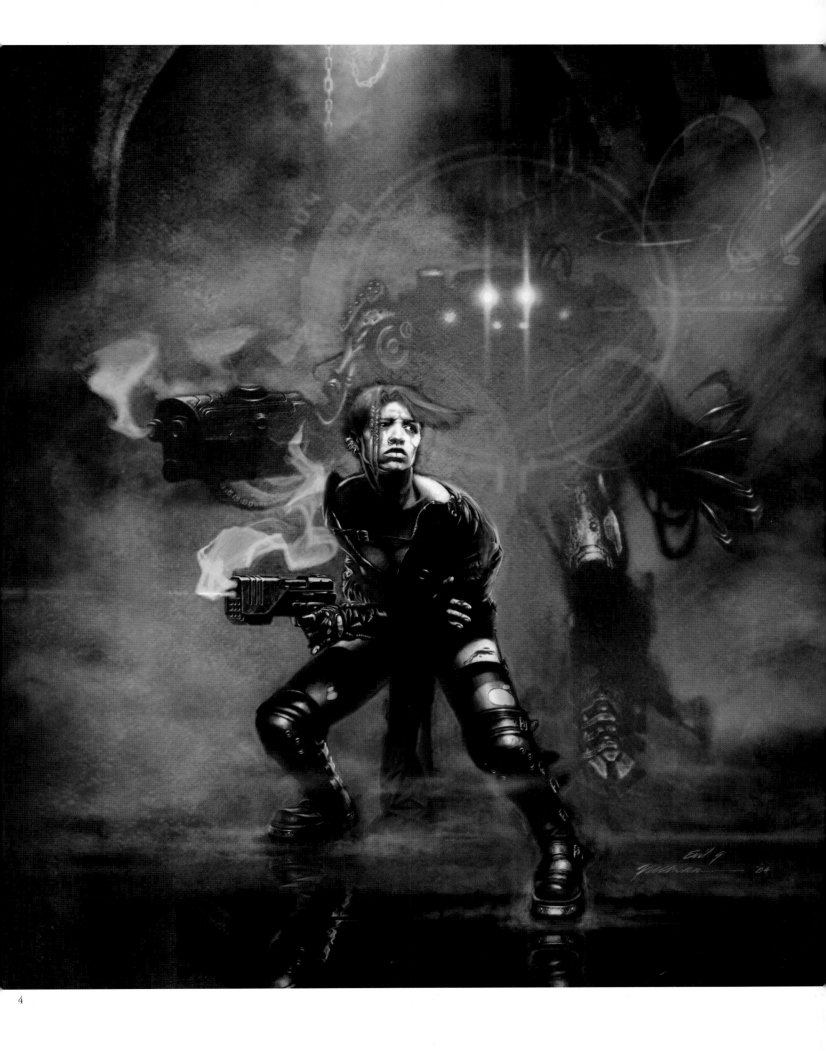

4

1
artist: **Michael Wm. Kaluta**
art director: Maria Heuhner
client: DC Comics/Vertigo
title: Lucifer #56
medium: Ink & watercolor
size: 11"x16"

2
artist: **Charles Vess**
art director: Irene Gallo
designer: Charles Vess
client: Tor Books
title: The Book of Ballads
medium: Ink on board

3
artist: **Frank Cho**
designer: Frank Cho
colorist: Laura Depuy Martin
client: Marvel Comics
title: Marvel Knights:
 Spider-Man #5
medium: Ink/digital
size: 14"x21"

4
artist: **Farzad Varahramyan**
art director: Dave Wilkins
client: Dark Horse Comics
title: El Zombo
medium: Digital
size: 10"x15"

5
artist: **Frank Cho**
designer: Frank Cho
colorist: Dave Stewart
client: Dark Horse Comics
title: Hellboy™
 Weird Tales #6
medium: Ink/digital
size: 14"x21"

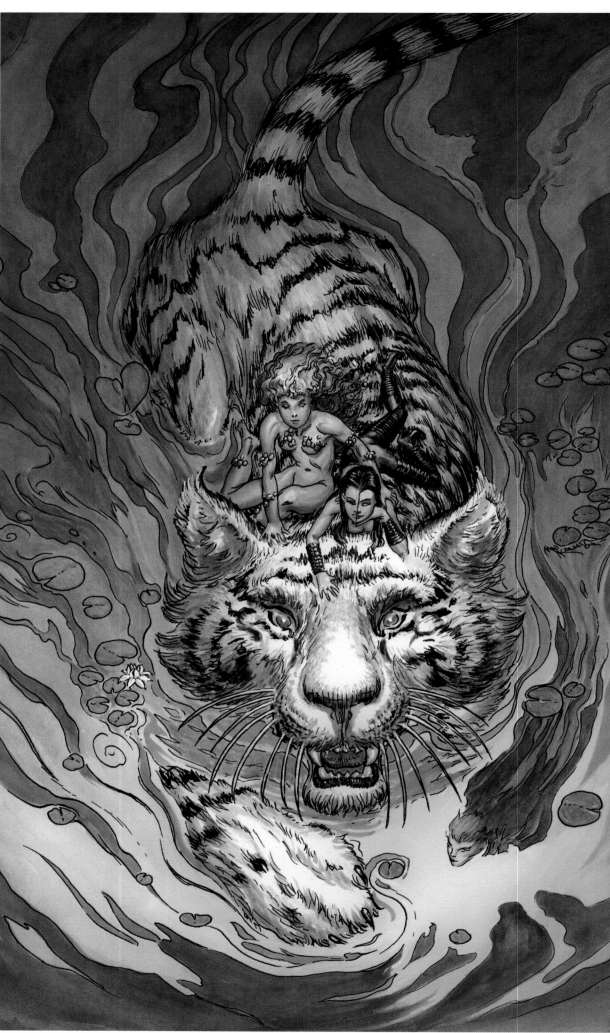

1

"Lucifer" #56 © 2005 DC Comics. All Rights Reserved. Used with Permission.

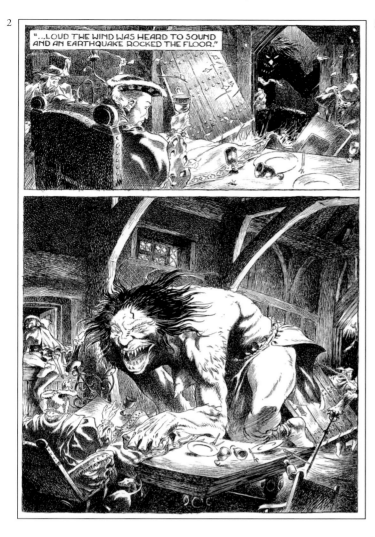

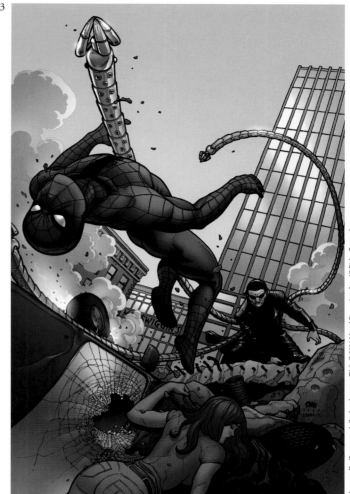

Spider-man, Dr. Octopus, and all other characters ™ & © 2004 Marvel Enterprises, Inc. All Rights Reserved.

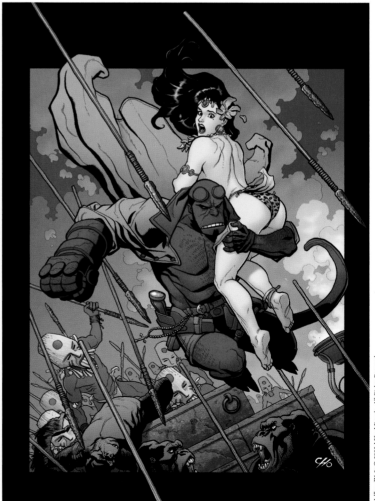

Hellboy ™ & © 2005 Mike Mignola. All Rights Reserved.

1
artist: **Mike Huddleston**
designer: Mike Huddleston
client: Image Comics
title: Deep Sleeper #3
medium: Mixed/digital

2
artist: **Gary Gianni**
client: King Features Syndicate
title: Prince Valiant
medium: Ink on board
size: 13"x20"

3
artist: **Eric Powell**
client: Dark Horse Comics
title: The Goon: Vampire Dame
medium: Oil on canvas
size: 24"x36"

4
artist: **Eric Powell**
client: Dark Horse Comics
title: The Goon: Heaps of Ruination
medium: Oil on canvas
size: 24"x36"

1

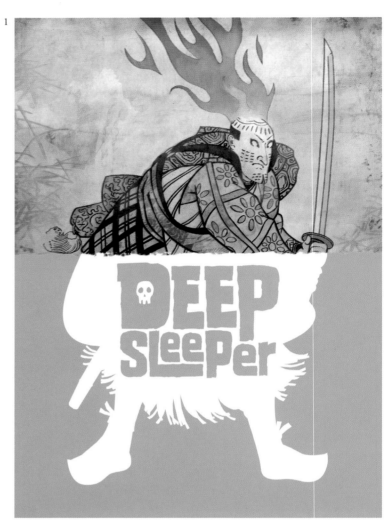

2

3

4

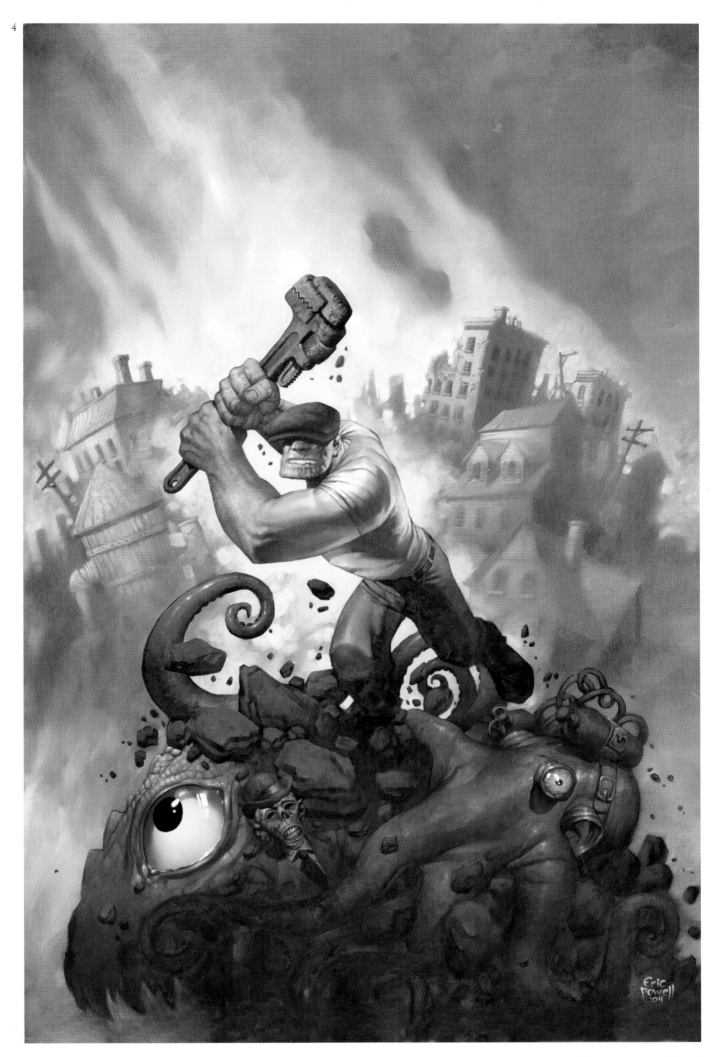

1
artist: **Stephan Martiniere**
art director: Courtney Huddleston
client: Penny-Farthing Press
title: Para 5
medium: Digital

2
artist: **Joe Jusko**
art director: Joe Jusko
client: Top Cow Productions
title: Tomb Raider
medium: Acrylic
size: 14"x22"

1

DIMENSIONAL
Gold Award

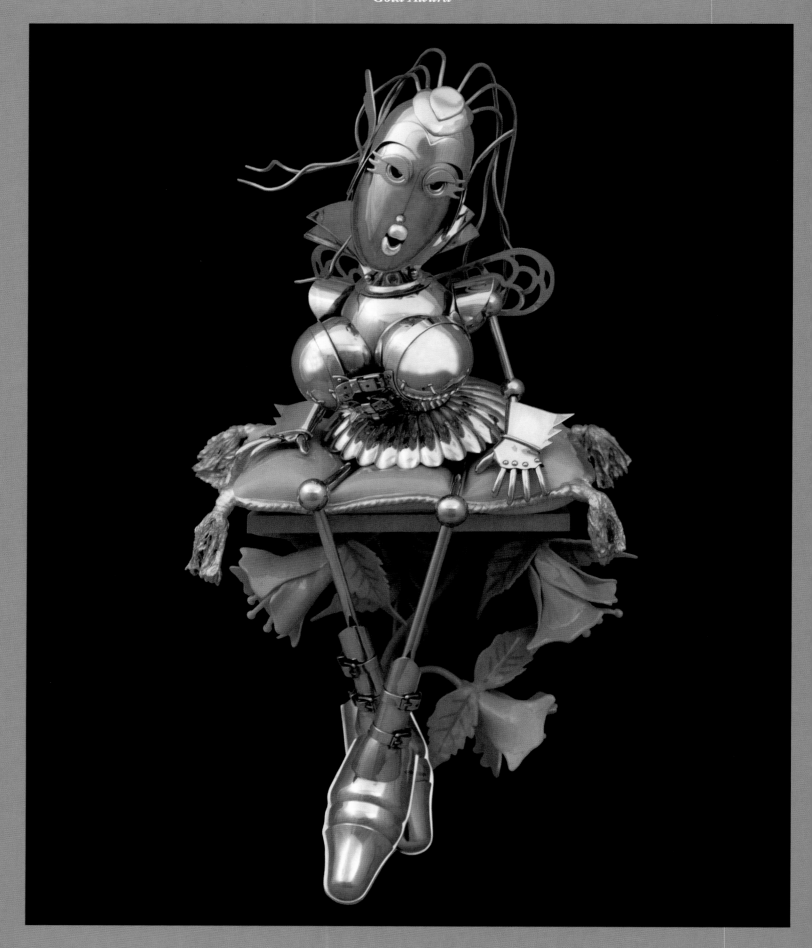

artist: **Lawrence Northey**

designer: Lawrence Northey *client:* www.robotart.net *title:* Quan Yin *medium:* Metal (fiberglass pillow) *size:* 33"h

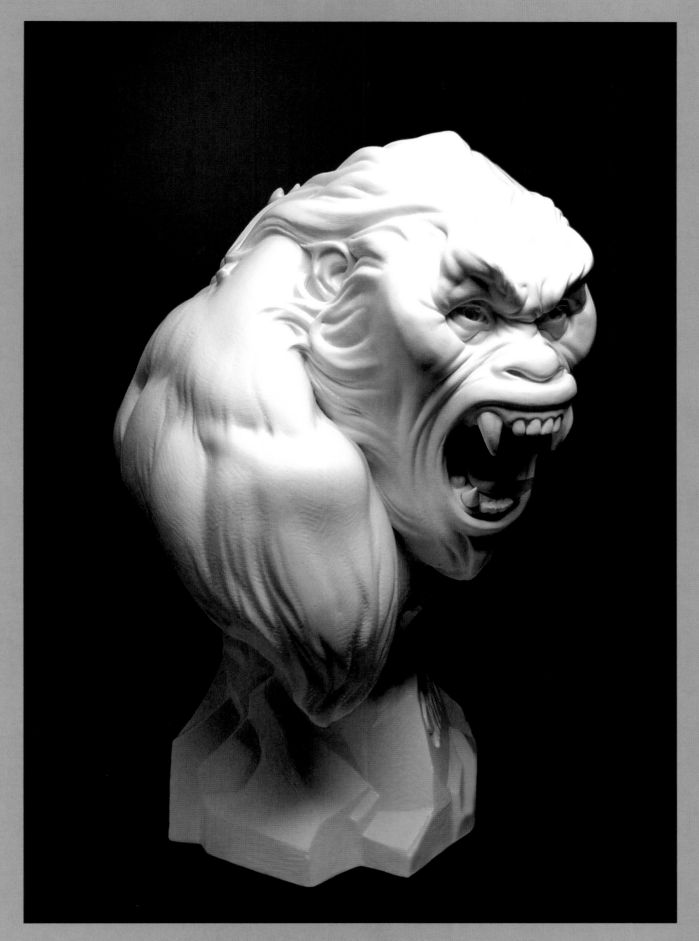

artist: Ryan K. Peterson

art director: Michael R. Todd/Ryan K. Peterson *client:* Secret Lab Studios *title:* Cryptid Yeti *medium:* Resin *size:* 16"h x 8"w

1
artist: **Thomas S. Kuebler**
title: Hobgoblin
medium: Polymer clay/mixed
size: 25"h x 15"w

2
artist: **David Renn/Cheryl Newton**
art director: John Cox
client: Creatures On Tour
title: Snowman
medium: Silicone & fur
size: 6'10"h

3
artist: **David Renn**
title: Homo Digitalis
medium: Urethane
size: 14"h x 17"w

4
artist: **Thomas S. Kuebler**
title: Chaney's Phantom
medium: Silicone/mixed
size: Life-size

1

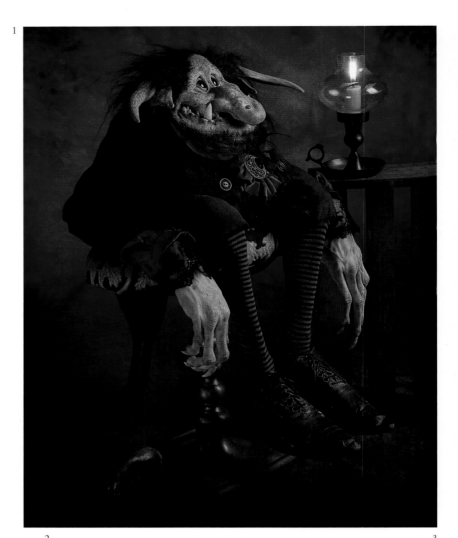

2

3

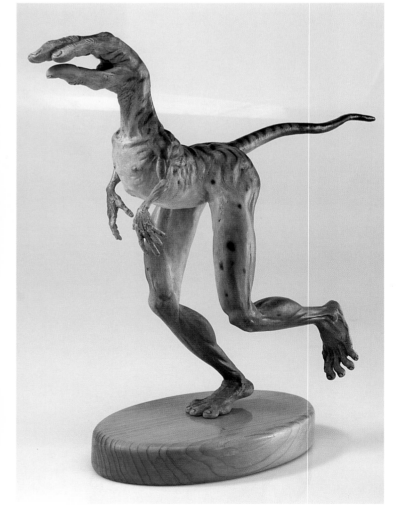

4

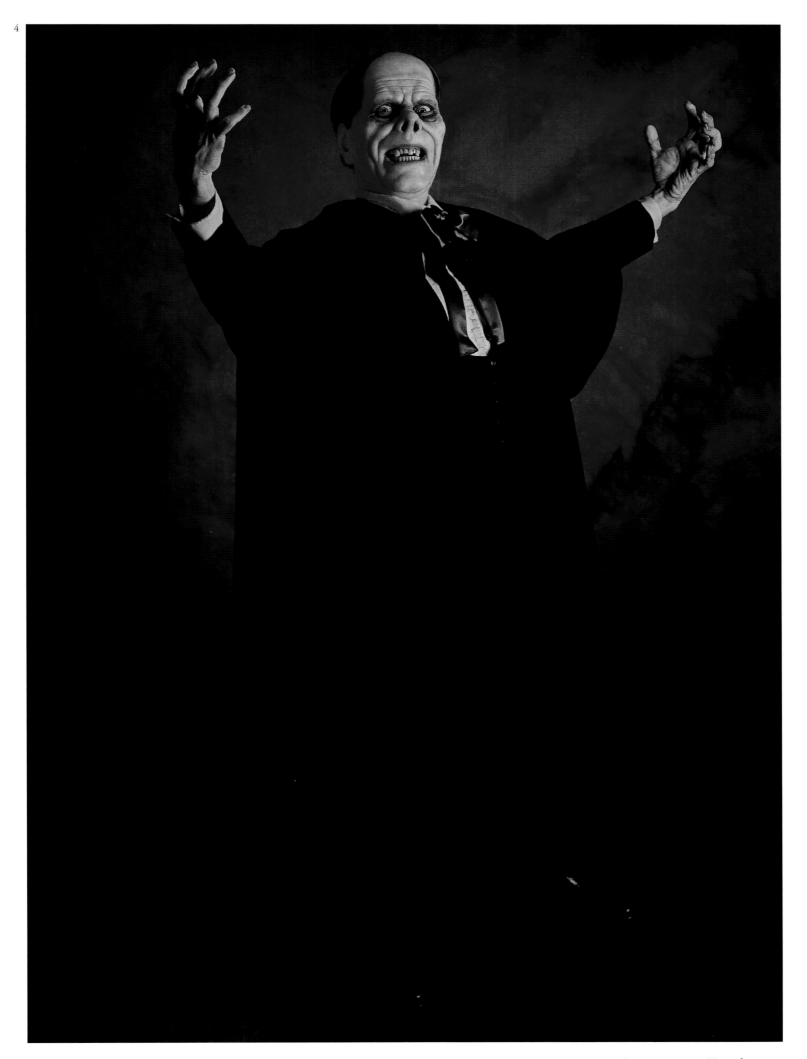

1
artist: **Jonathan Matthews**
art director: Jim Fletcher
designer: Tim Sale
client: DC Direct
title: Batman Black & White
medium: Resin
size: 7"h

2
artist: **Barsom**
art director: Ed Bolkus
designer: Barsom
client: DC Direct
title: Zatanna
medium: Wax
size: 6"h

3
artist: **Tim Holter Bruckner**
art director: Georg Brewer
designer: Jim Lee
client: DC Direct
title: Superman
medium: Painted resin
size: 9^1/$_2$"h x 5"w

4
artist: **Tim Holter Bruckner**
art director: Georg Brewer
designer: Alex Ross
client: DC Direct
title: Bizarro
medium: Painted resin
size: 6^1/$_2$"h

5
artist: **Tim Holter Bruckner**
art director: Georg Brewer
designer: Frank Miller
client: DC Direct
title: Joker
medium: Painted resin
size: 7"h

6
artist: **Tim Holter Bruckner**
art director: Georg Brewer
designer: Frank Miller
client: DC Direct
title: Dark Knight
medium: Painted resin
size: 7"h

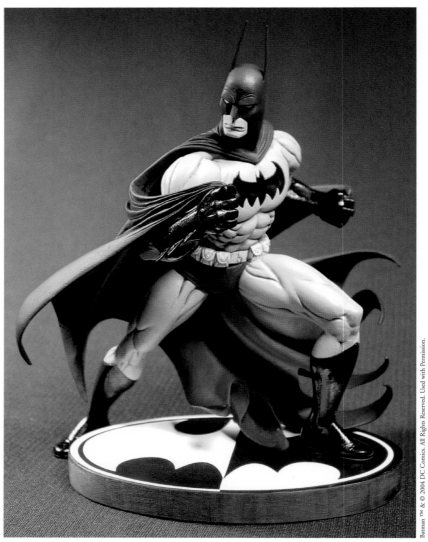

1

2

Batman ™ & © 2004 DC Comics. All Rights Reserved. Used with Permission.

Zatanna ™ & © 2004 DC Comics. All Rights Reserved. Used with Permission.

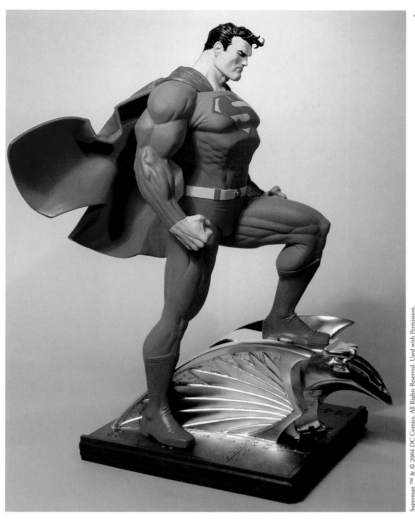

Superman ™ & © 2004 DC Comics. All Rights Reserved. Used with Permission.

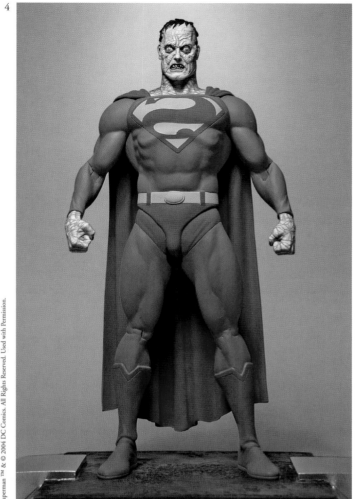

Bizarro ™ & © 2004 DC Comics. All Rights Reserved. Used with Permission.

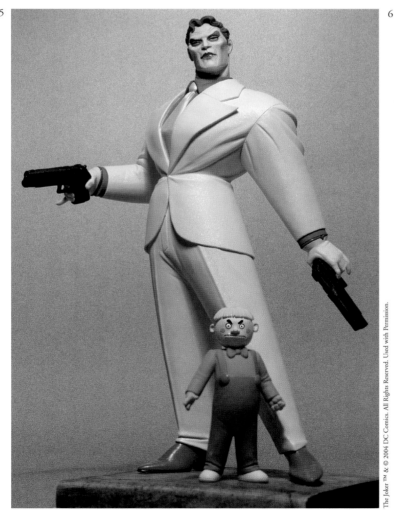

The Joker ™ & © 2004 DC Comics. All Rights Reserved. Used with Permission.

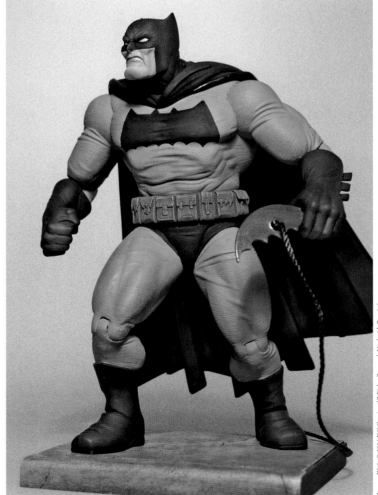

Batman ™ & © 2004 DC Comics. All Rights Reserved. Used with Permission.

1
artist: **Spencer Davis**
client: www.bootybabeart.com
title: Desert Rose
medium: Resin

2
artist: **Dave Cortés**
art director: Randy Falk
designer: Dave Cortés
colorist: Brandy Anderson
client: NECA
title: Gale [Sin City]
medium: Resin
size: 12"h

3
artist: **Angela Giovanna Loroux**
designer: Angela Giovanna Loroux
title: Morrigan
medium: Polymer clay/mixed
size: 22"h

4
artist: **Sam Greenwell**
designer: Sam Greenwell
client: Greenwell Studios
title: Calliope
medium: Resin
size: 10"h

1

2

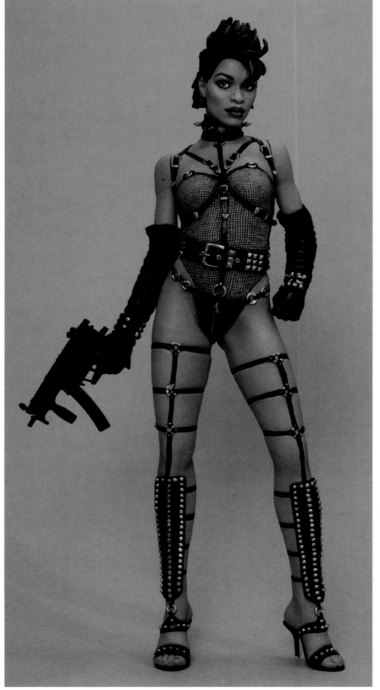

3

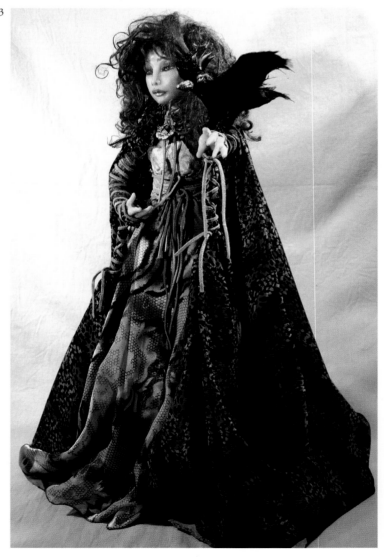

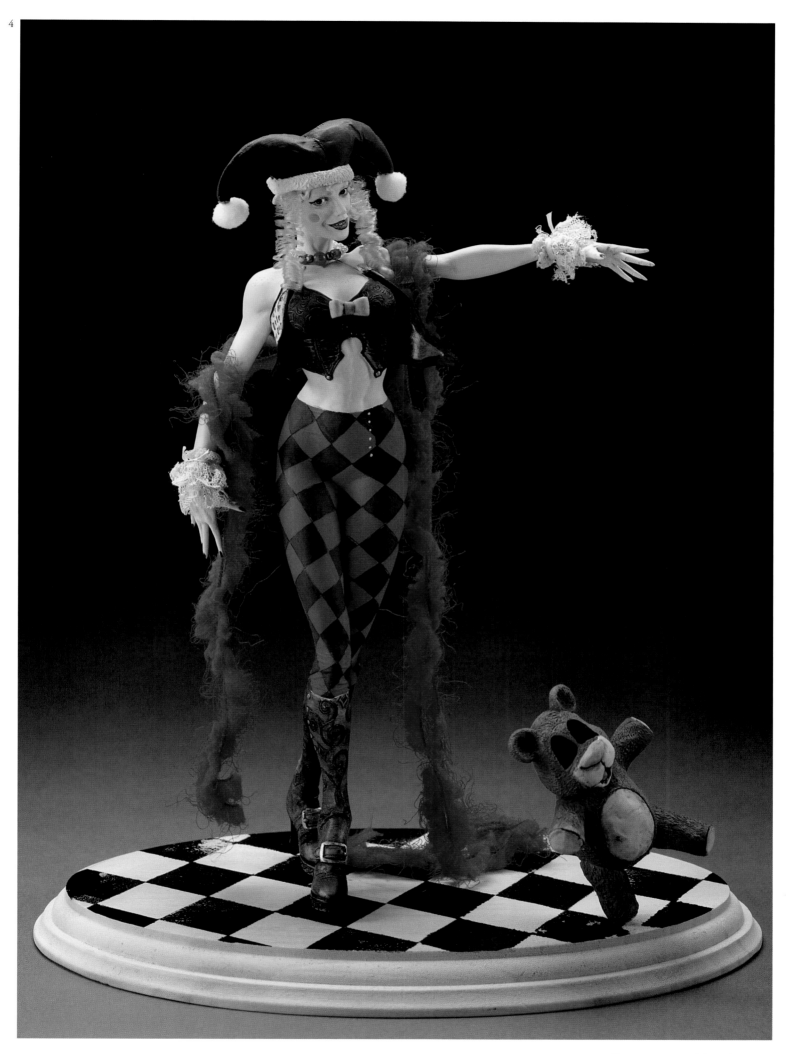

1
artist: **Tony DeBartolis**
photographer: Jeff Gross
title: Humpty Delvetto's Garden of
 Unearthly Delights
medium: Mixed
size: 22"h x 24"w

2
artist: **Marc Goodrich**
title: Brian and His Girl
medium: Roma clay

3
artist: **Randy Hand**
title: Metamorph-Fish
medium: Super sculpey, resin
size: 7"h x 5"w

4
artist: **Gary A. Lippincott**
art director: Robert Vansickle
client: Distinctive Collections, Inc.
title: Ring Dwarfs
medium: Bronze
size: 14"h x 16"w

5
artist: **David Renn**
art director: John Cox
client: Creatures on Tour
title: Gillman
medium: Plasticene
size: 6'7"h

6
artist: **Son Duong**
client: Hyperlite Mfg.
title: Parks
medium: Pencil/digital/mixed
size: 62"h x 19"w

7
artist: **Sandra Little**
photographer: Dean Barnes
title: Gargoyle
medium: Mixed
size: 4'h x 2'w

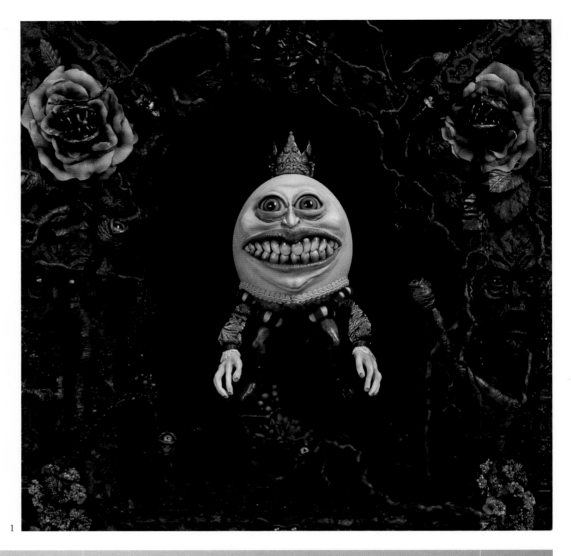

1

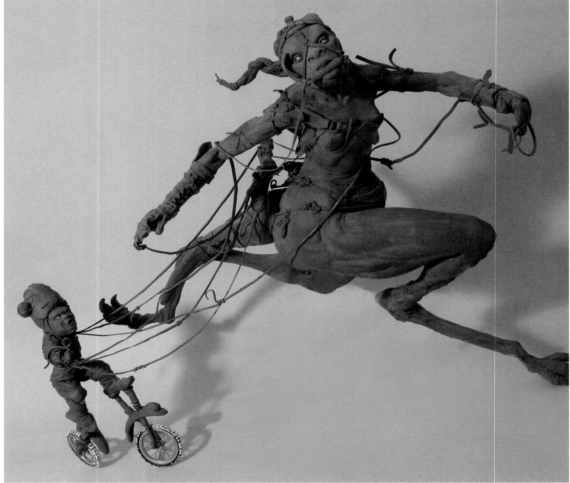

2

3

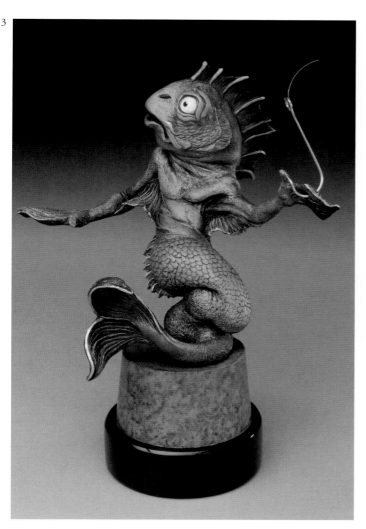

4

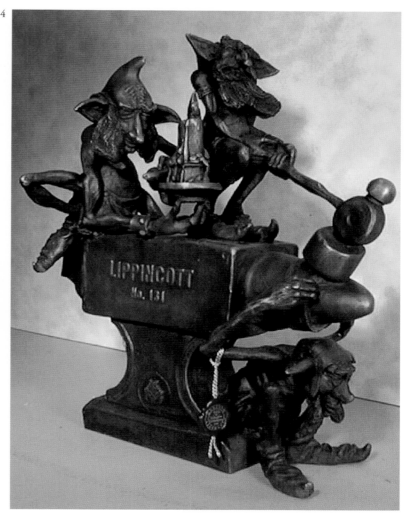

5

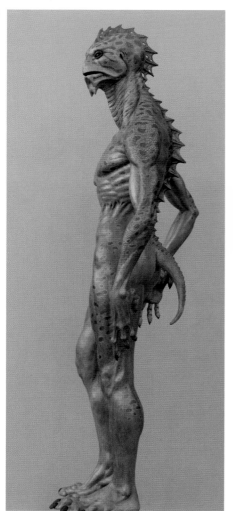

6

7

1
artist: **Dave Cortés**
art director: Randy Falk
designer: Dave Cortés
colorist: Brandy Anderson
client: NECA
title: Captain Jack Sparrow
medium: Resin
size: 18"h

2
artist: **Dave Presssler**
title: Automated Pirate
medium: Resin
size: 9^1/$_2$"h x 6^1/$_2$"w

3
artist: **Virginia Lee**
title: A Call In the Night
medium: Super sculpey/acrylic
size: 5^1/$_2$"h

4
artist: **Paul Harding**
art director: Mez
designer: Paul Harding
client: Mexco Toyz
title: Extreme Hellboy™
medium: Vinyl
size: 10"h

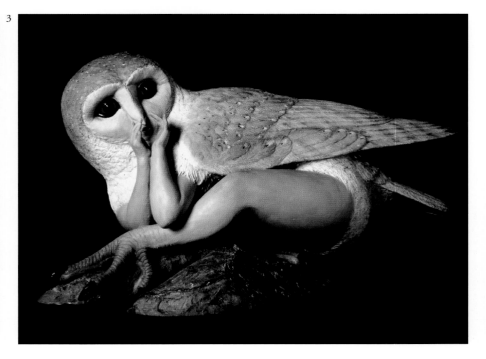

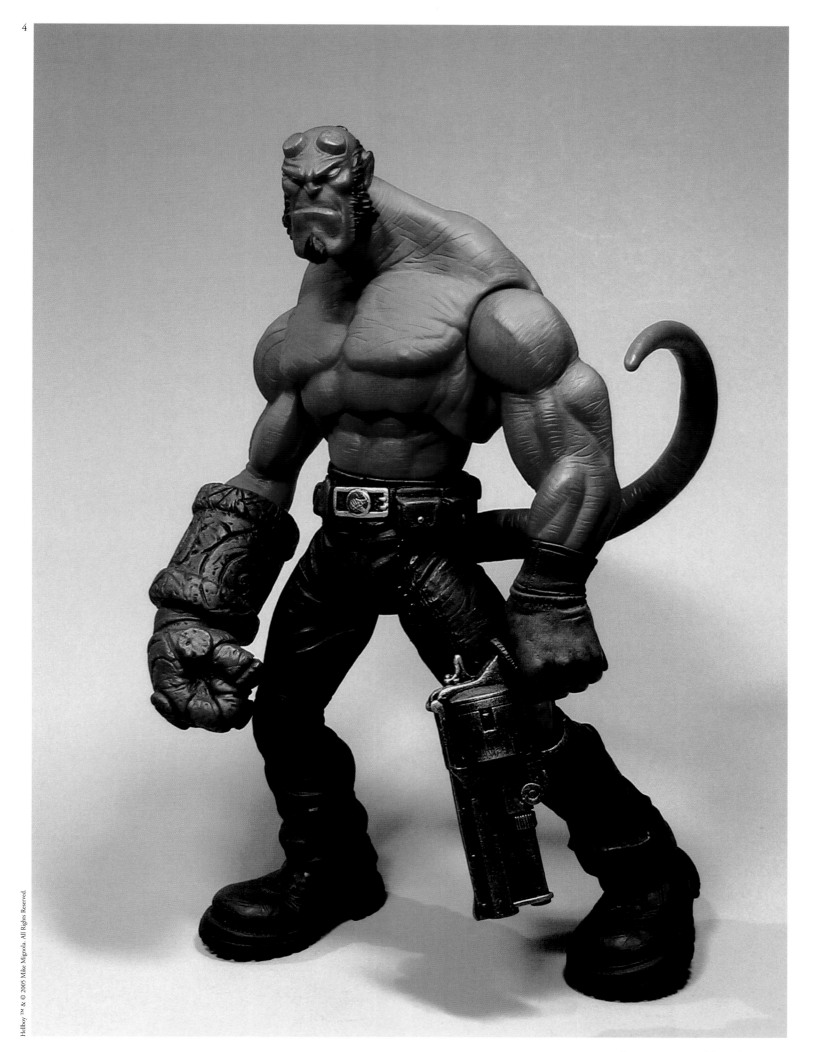

Hellboy ™ & © 2005 Mike Mignola. All Rights Reserved.

1
artist: **Lawrence Northey**
client: Janet Palmaccio
title: USA Star 1: American Hero
medium: Metal/glass/fiberglass
size: 31"h

2
artist: **Michael R. Todd/
Gentle Giant Studios**
art director: Michael R. Todd
client: Secret Lab Studios
title: Kipling McKay
medium: Bronze
size: 18"h

3
artist: **Jonathan Matthews**
art director: Ken Lilly
client: Palisades Tous
title: Destro
medium: Wax/plastic
size: 6"h

4
artist: **Tim Holter Bruckner**
client: The Art Farm, Inc.
title: He Who Laughs Last
medium: Painted resin
size: 19"h x 5"w

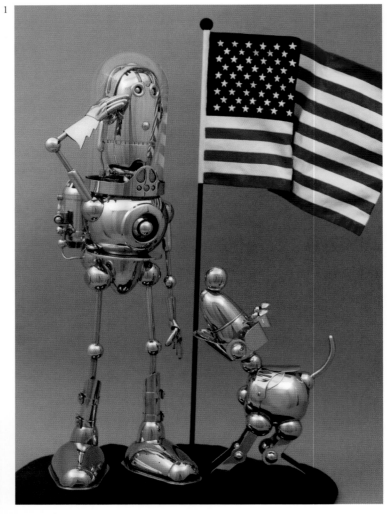

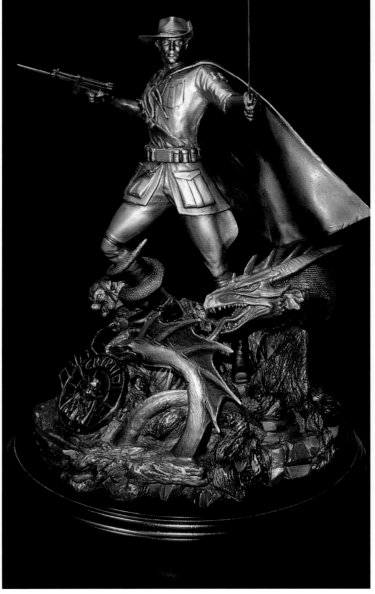

artist: **Thomas L. Fluharty**

title: Sir Hillary Poised For a Takeover *medium:* Acrylic on Bristol *size:* 19"x24"

artist: **Shaun Tan**

art director: Michael Killalea/Shaun Tan *client:* The Bulletin *title:* Summer Rading Guide *medium:* Oil *size:* 40cm x 60cm

1
artist: **Thomas L. Fluharty**
title: Bushie the Kid
medium: Acrylic
size: 11"x14"

2
artist: **Tariq Raheem**
art director: Kevin Eastman
designer: Tariq Raheem
client: Heavy Metal
title: Battle Angel
medium: Digital
size: 15"x18"

3
artist: **Peter Scanlan**
art director: Minh Unong
client: The Village Voice
title: Will Vote For Food
medium: Digital
size: 11"x14"

4
artist: **Alex Ross**
art director: Ted Keller
client: The Village Voice
title: Sucking Democracy Dry
medium: Gouache

1

2

3

1
artist: **Janet Woolley**
art director: Tom Staebler
designer: Scott Anderson
client: Playboy Magazine
title: Detroit Death City

2
artist: **Marco Ventura**
art director: Tom Staebler
designer: Rob Wilson
client: Playboy Magazine
title: The Agony & Ecstasy of
 Alexander Shulgin

3
artist: **Tifenn Python**
art director: Tom Staebler
designer: Tom Staebler
client: Playboy Magazine
title: Are Dreams Faster Than
 the Speed of Light

4
artist: **Pat Andrea**
art director: Tom Staebler
designer: Tom Staebler
client: Playboy Magazine
title: Powder

5
artist: **Dave McKean**
art director: Tom Staebler
designer: Tom Staebler
client: Playboy Magazine
title: St. Mark's Day

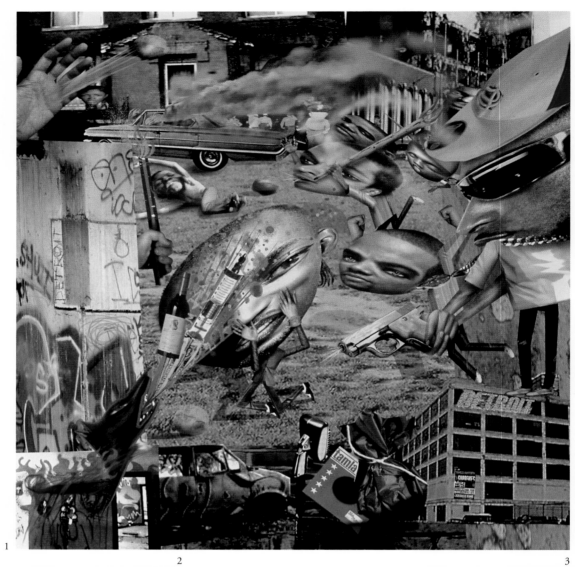

1

2

3

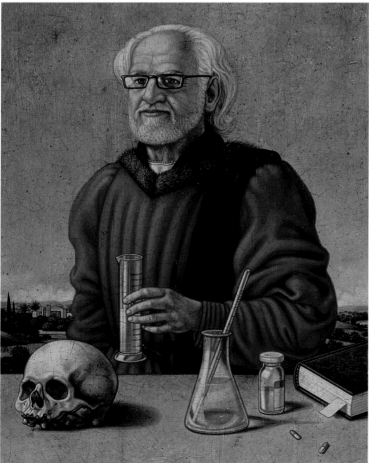

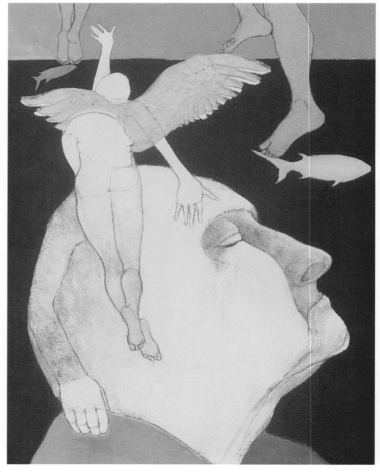

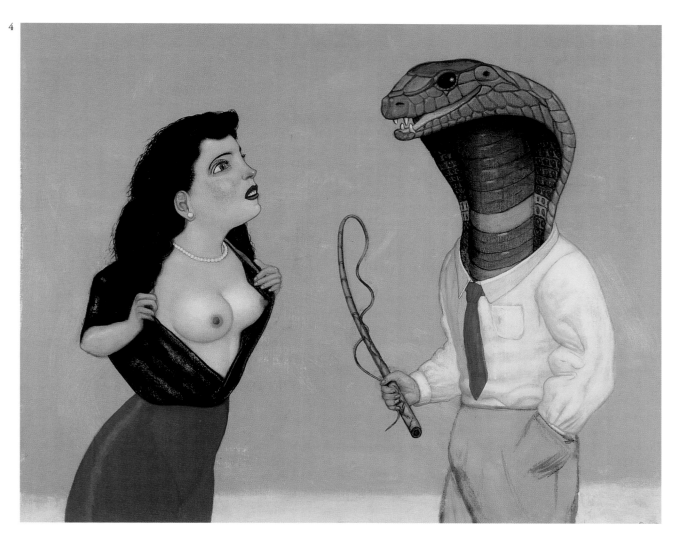

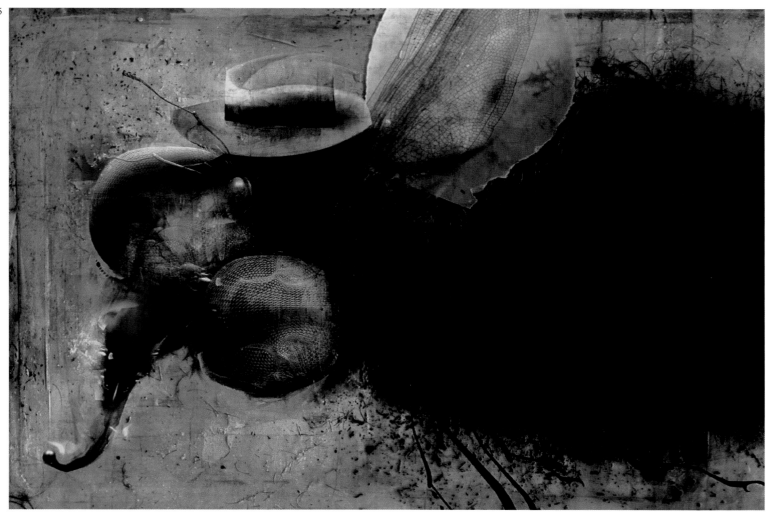

1
artist: **Cheryl Griesbach/**
Stanley Martucci
art director: Minh Unong
designer: Ted Keller
client: The Village Voice
title: The Evil That Al Doeth
medium: Oil on board
size: 11"x14"

2
artist: **Howard Lyon**
art director: Lisa Chido
client: Paizo Publishing
title: Dark Stalker
medium: Digital
size: 8^1/2"x11^1/4"

3
artist: **Jim Nelson**
art director: Robin Demougeot
client: Weekly Reader
title: Grendel
medium: Digital
size: 6"x9"

4
artist: **Chris Spollen**
art director: Courtney
 Eltringhally
client: Penthouse
title: Shocking Sex
medium: Mixed/digital
size: 16"x20"

5
artist: **Yoshihito Tomobe**
client: Vibes Magazine
title: Angel Cross
medium: Acrylic
size: 9"x12"

1

2

3

4

5

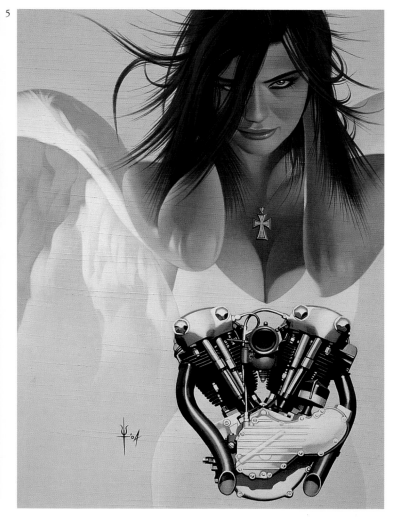

1
artist: **Manchu**
client: Folio SF
title: Norstilia
medium: Acrylic
size: 50cm x 65cm

2
artist: **Erik Siador**
art director: John Carr
client: www.yowhathappenedtopeace.org
title: Monkeys On Our Back
medium: Ink/silkscreen
size: 45"x15"

3
artist: **John Picacio**
art director: Mark Mahorsky
client: Texas Parks & Wildlife Magazine
title: The Second Hunt
medium: Mixed/digital
size: 9"x12"

4
artist: **Sally Wern Comport**
art director: Elizabeth Lankes
client: Security Management
title: Delivering the Goods
medium: Mixed
size: 8$\frac{1}{2}$"x11$\frac{1}{2}$"

5
artist: **Greg Horn**
art director: Dan Reily
client: Toyfare Magazine
title: Halo 2: I Hate Flood Critters
medium: Digital

6
artist: **Todd Lockwood**
art director: Mike Meyer
client: Atari
title: Zhai
medium: Digital
size: 15"x20"

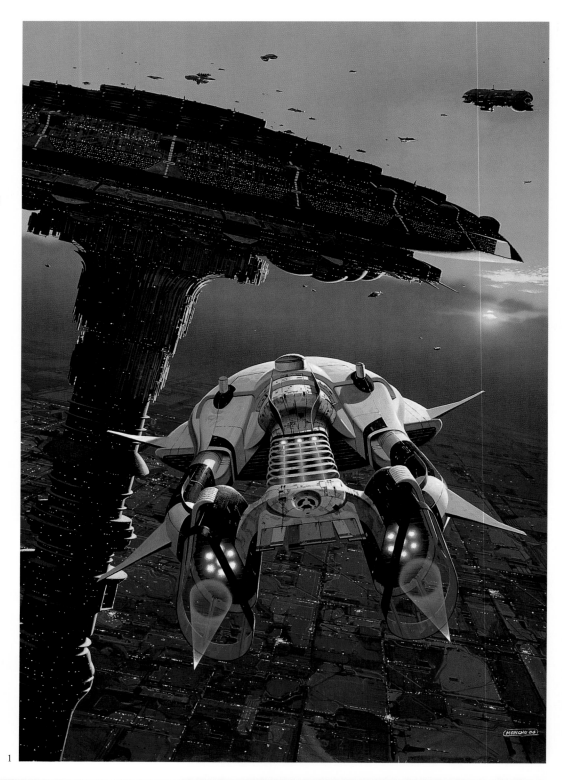

1

2

3

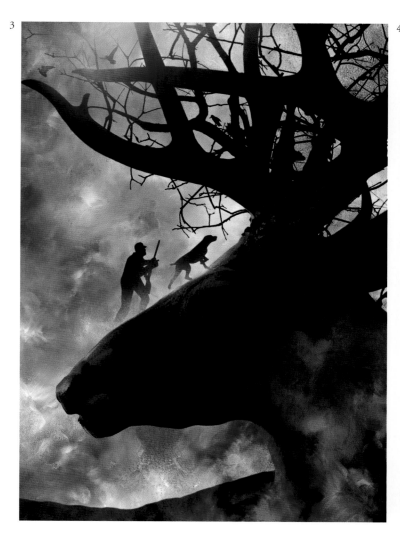

4

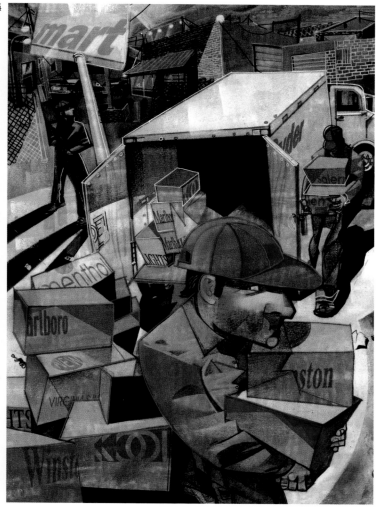

5

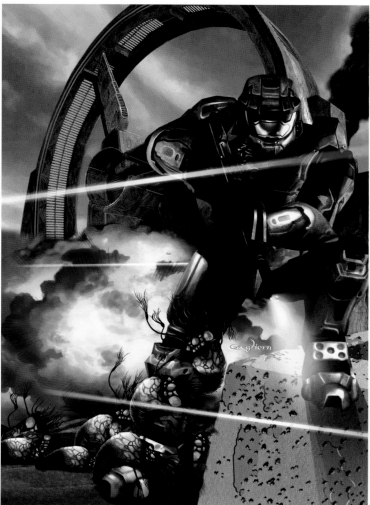

6

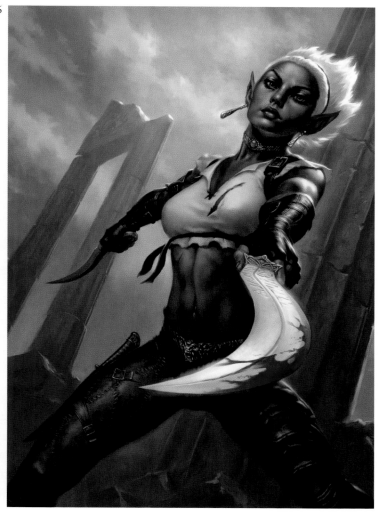

1
artist: **Jeff Faerber**
art director: Deb Kory
client: Tikkun Magazine
medium: Mixed
size: 10"x13"

2
artist: **David Christiana**
art director: Chiara Caballero
designer: Chiara Caballero
client: Ornithopter
title: Ludd's Monster
medium: Oil
size: 23"x14"

3
artist: **Joseph Daniel Fiedler**
art director: Billie Bishop
client: Arizona Highways Magazine
title: Deer Drive
medium: Mixed
size: 11"x17"

4
artist: **Philip Straub**
client: Fantasy Magazine
title: Where Fears Roam
medium: Digital
size: 28"x16"

1

2

1
artist: **Patrick Arrasmith**
art director: Carl Gnam
client: Realms of Fantasy
title: Glass Casket
medium: Scratchboard/digital
size: 8"x11"

2
artist: **Richard Bernal**
art director: Tony Jacobson
designer: Richard Bernal
client: Spider Magazine
title: Popcorn Wizard
medium: Oil
size: 6"x14"

3
artist: **Nathan Hale**
art director: Ron McCutchan
client: Cricket Magazine
title: Dog Shrine Caper
medium: Acrylic
size: 16"x20"

4
artist: **Omar Rayyan**
art director: Sue Beck
client: Spider Magazine
title: Nobody Here
 But Us Chickens
medium: Watercolor
size: 10"x13"

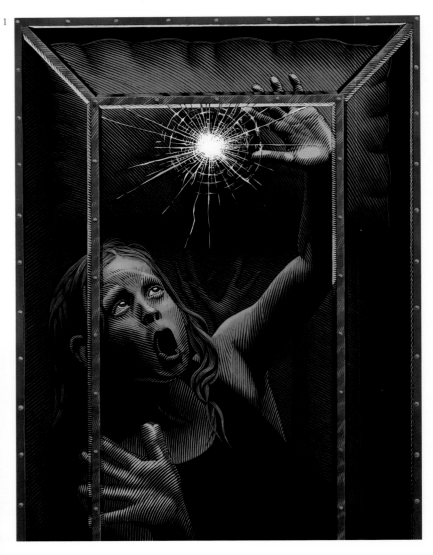

4

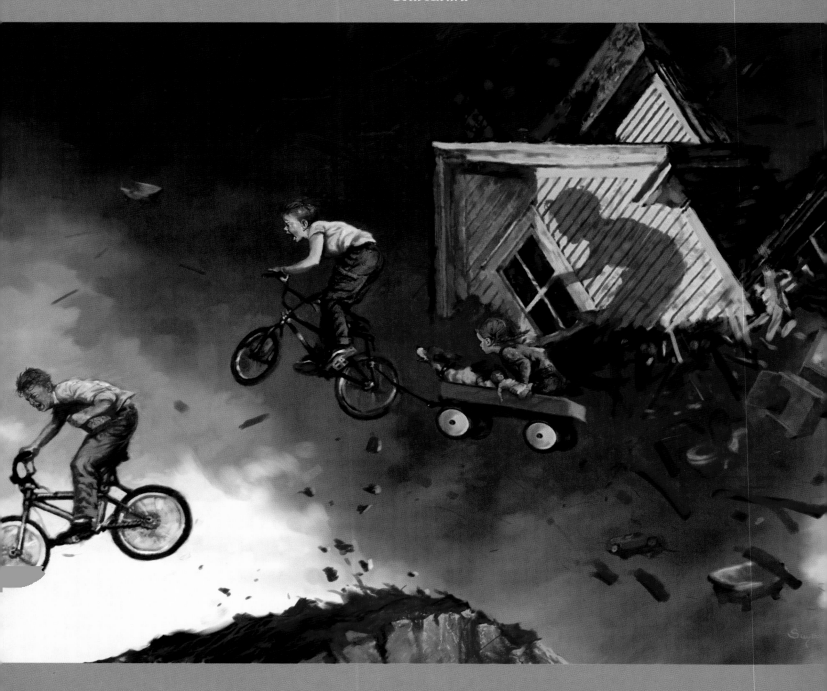

artist: **Arthur Suydam**

client: Dark Horse Entertainment *title:* When Giants Walk the Earth *medium:* Oil/mixed *size:* 40"x20"

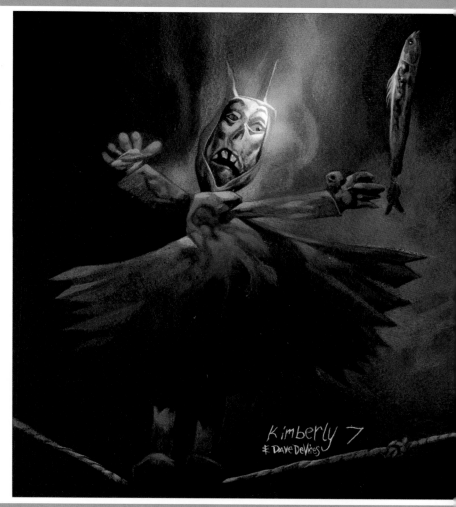

artist: Dave DeVries

title: Old Scratch and The Fish *medium:* Acrylic/mixed *size:* 6"x6"

1
artist: **Montgomery S. Kane**
title: Frog Dragon Familiar 2
medium: Oil

2
artist: **Scott Fischer**
art director: Teresa Green
client: Green Fisch Studios
title: Choices
medium: Mixed
size: 13"x19"

3
artist: **Paul Bonner**
art director: Jean Bey
client: Rackham
title: Wolfen of Yllia
medium: Watercolor
size: 43cm x 56cm

4
artist: **Paul Bonner**
art director: Theodore Bergquist
client: Riotminds
title: Lindorm
medium: Watercolor
size: 40cm x 45cm

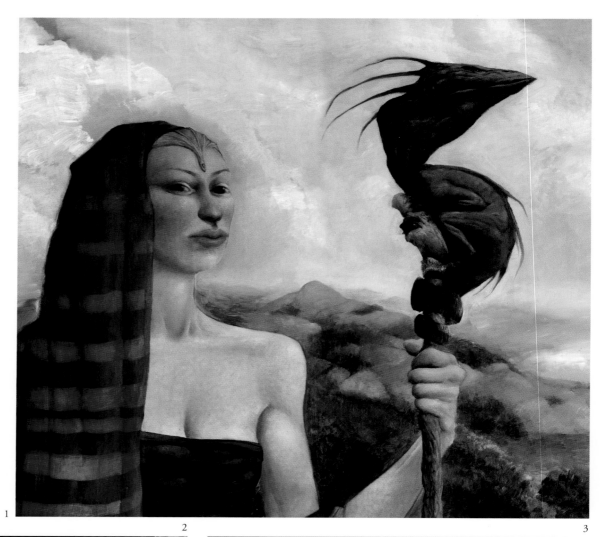

1

2

3

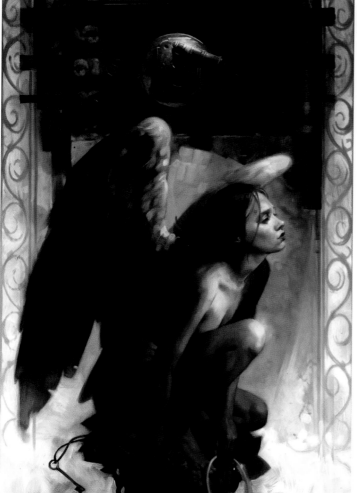

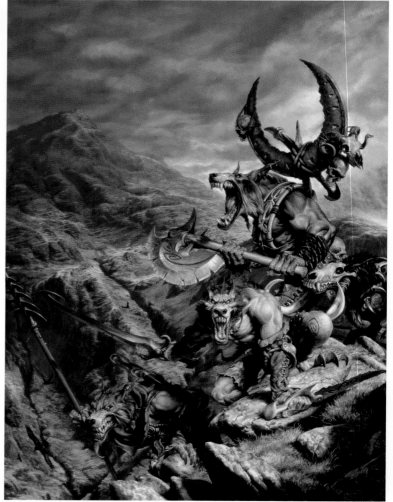

4

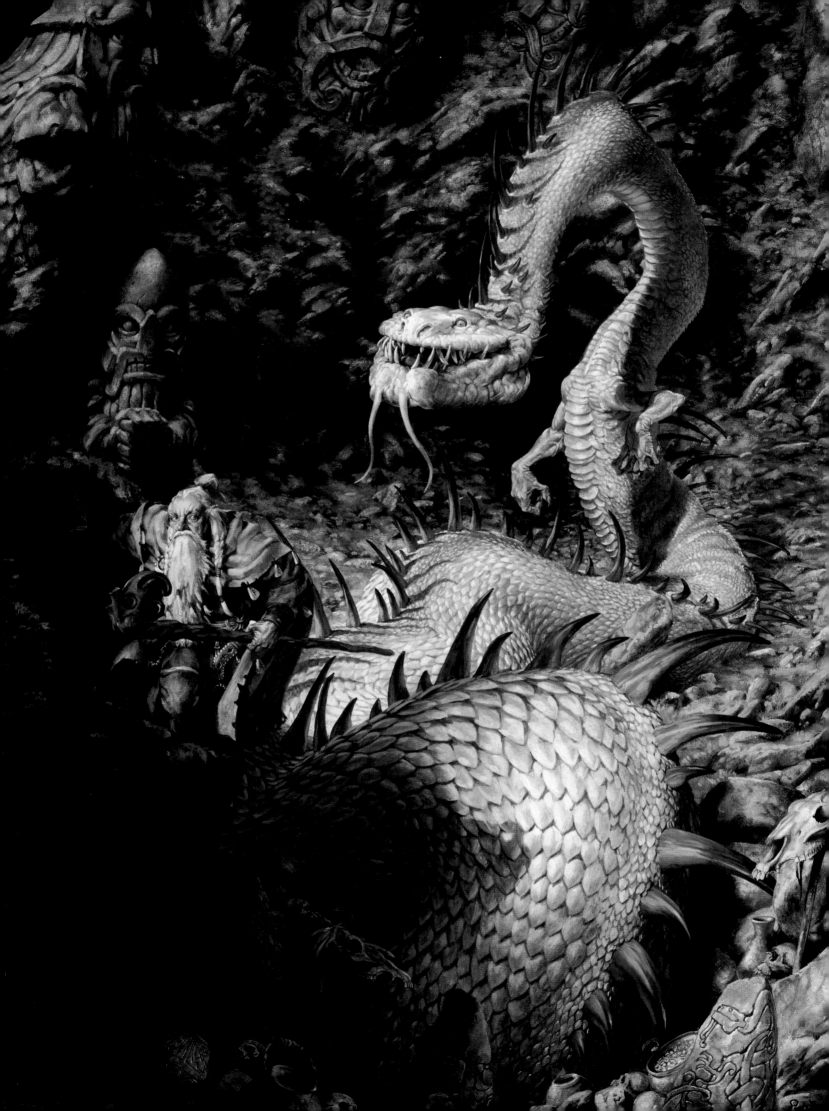

1
artist: **Stephan Martiniere**
art director: Patrick Tatopoulos
client: I, Robot/Fox
title: Spoonerville Lower
medium: Digital

2
artist: **Beric Henderson**
title: Binary
medium: Acrylic/digital
size: 78"x30"

3
artist: **Linda Joyce Franks**
title: Angelique
medium: Oil on paper
size: 29"x13"

4
artist: **Jeremy Geddes**
client: Ashley Wood
title: Symphony In Green
medium: Oil
size: 160cm x 68cm

5
artist: **Matt Cavotta**
art director: Jeremy Cranford
client: Wizards of the Coast
title: Etched Oracle
medium: Acrylic/digital
size: 16"x11"

6
artist: **David Von Bassewitz**
client: Guru
title: Ghoom
medium: Mixed
size: 29"x18"

1

2

3

4

5

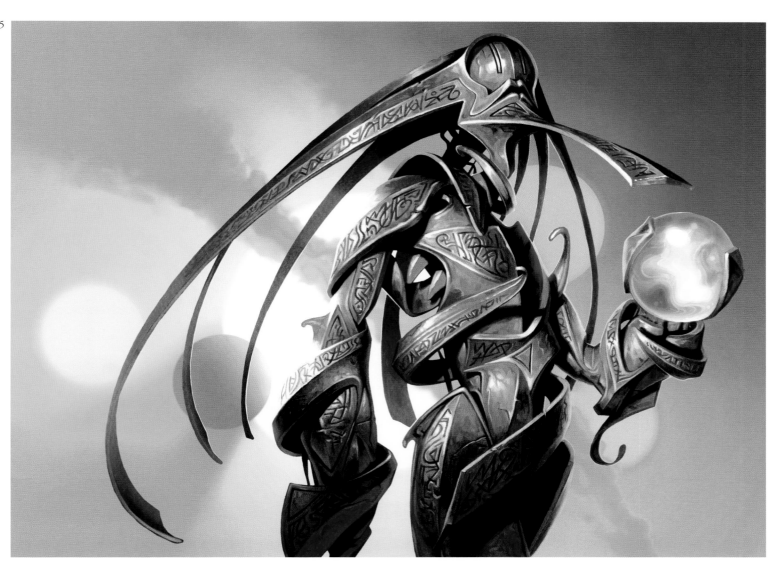

6

1
artist: **Christopher Moeller**
art director: Jeremy Cranfrod
client: Wizards of the Coast
title: Patron of the Orochi
medium: Acrylic
size: 20"x15"

2
artist: **Jonathan Wayshak**

3
artist: **Robert Carter**
title: Inner Dialogue
medium: Oil
size: 12"x15"

4
artist: **Carlos Huante**
client: Monsters, Inc.
title: Techlados
medium: Graphite
size: 8"x10"

1

2

3

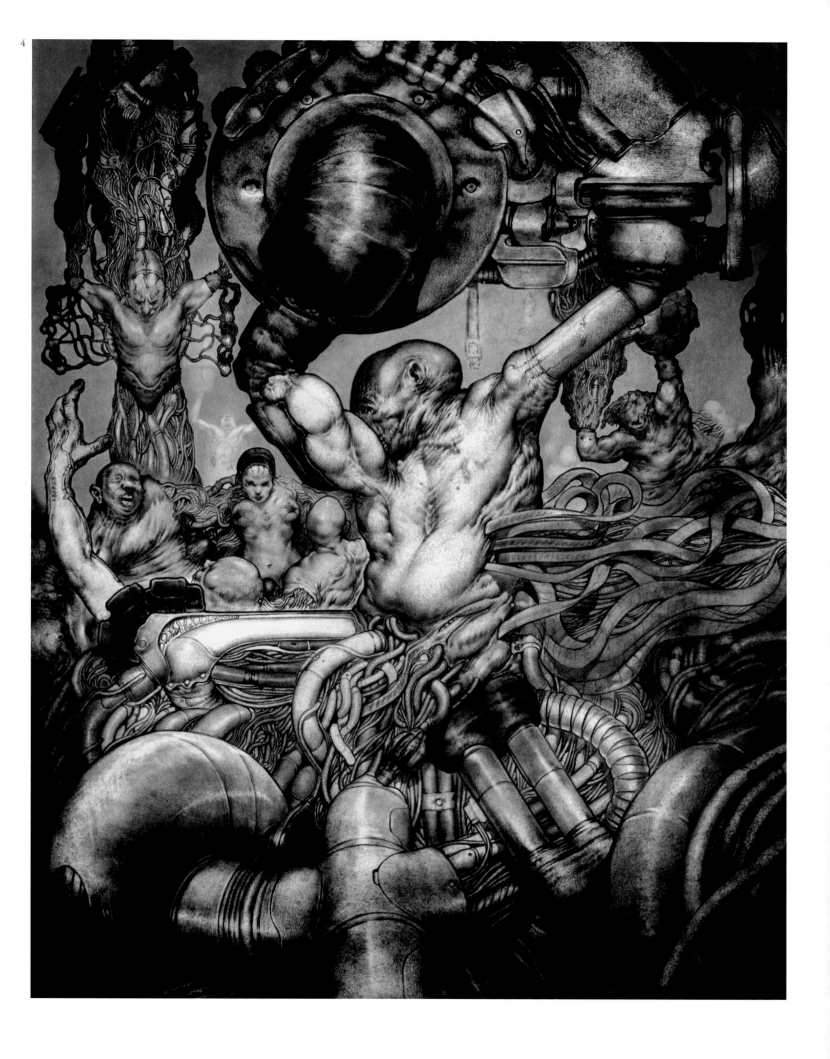

1
artist: **Andrew Bawidamann**
client: www.bawidamann.com
title: WWII Army Ranger Girl
medium: Digital
size: 18"x24"

2
artist: **Joseph Daniel Fiedler**
title: Horckheimers' Fistua
medium: Mixed
size: 4'x4'

3
artist: **Jesse Vital**
designer: Photo Studio FX
title: Eat Pussy, Not Cows
medium: Oil on linen
size: 52"x24"

4
artist: **Chris Trevas**
title: It Came From Panet X-Mas
medium: Digital
size: 6"x9"

5
artist: **Christian Slade**
title: Comic Shop Thugs
medium: Mixed
size: 11"x14"

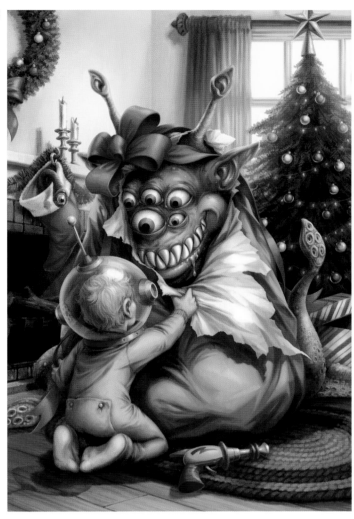

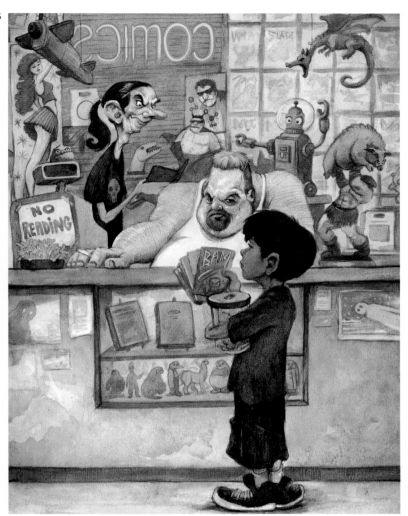

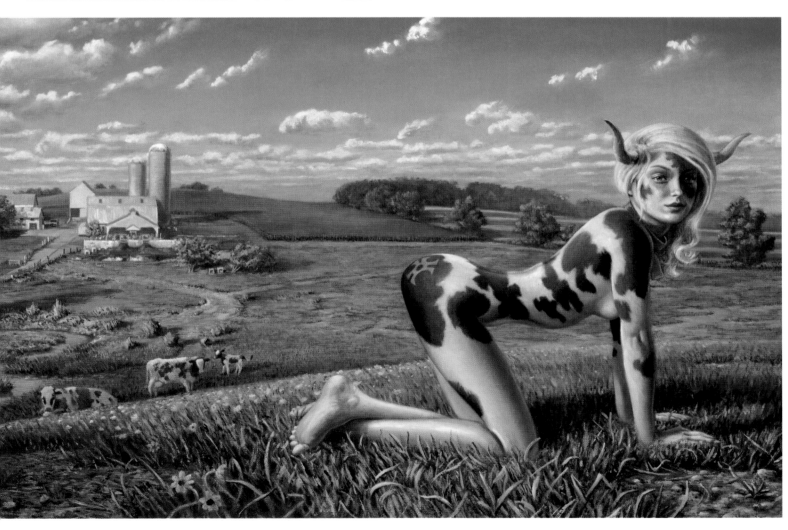

1

artist: **Kent Williams**
art director: Allen Spiegal
client: Allen Spiegal Fine Arts
title: Winged Victory
medium: Mixed
size: 16"x20"

2

artist: **Terese Nielsen**
art director: Ken Meyer, Jr.
client: Rainn
title: Torrefaction
medium: Mixed
size: 11"x8^1/$_2$"

3

artist: **Kent Williams**
art director: Allen Spiegal
client: Allen Spiegal Fine Arts
title: Two Women In a Boat
medium: Mixed
size: 16"x24"

4

artist: **Amoreno**
art director: Angi Sullins
client: Duirwaigh Publishing
title: Myth
medium: Oil
size: 16"x20"

5

artist: **Christophe Vacher**
client: Rainn
title: Untouched Gardens
medium: Oil on canvas
size: 24"x18"

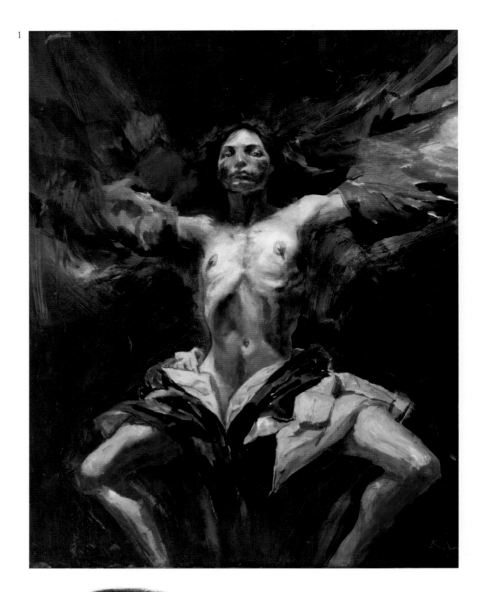

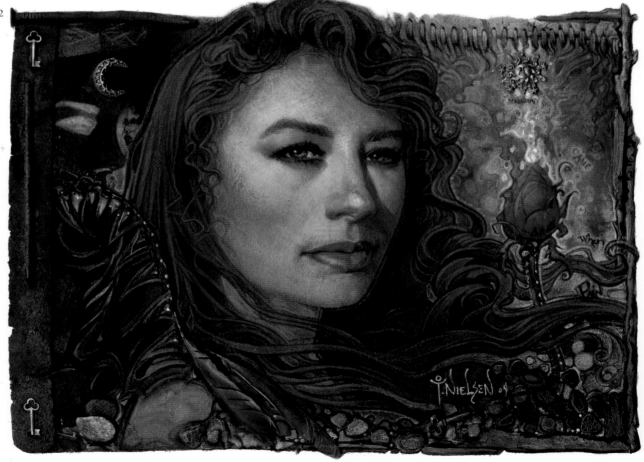

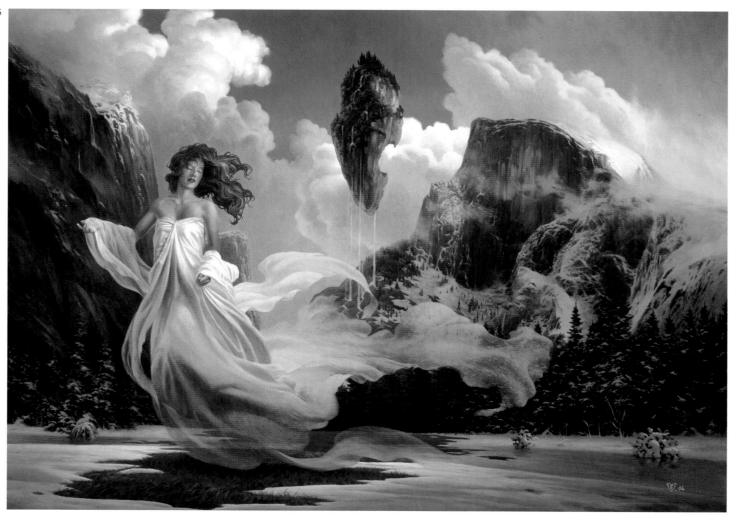

1
artist: **Daren Bader**
art director: Jeremy Cranford
client: Wizards of the Coast
title: Eight And A Half Tails
medium: Oil
size: 9"x13"

2
artist: **Chris Hopkins**
client: Illustrated Images
title: Shield Maiden
medium: Oil
size: 20"x30"

3
artist: **Daren Bader**
art director: Franz Vohwinkel
client: Kosmos Games
title: Helitos
medium: Digital

4
artist: **Gregory Manchess**
art director: Jim Keegan
client: Wandering Star
title: Conan of Cimmeria
medium: Oil on linen
size: 18"x24"

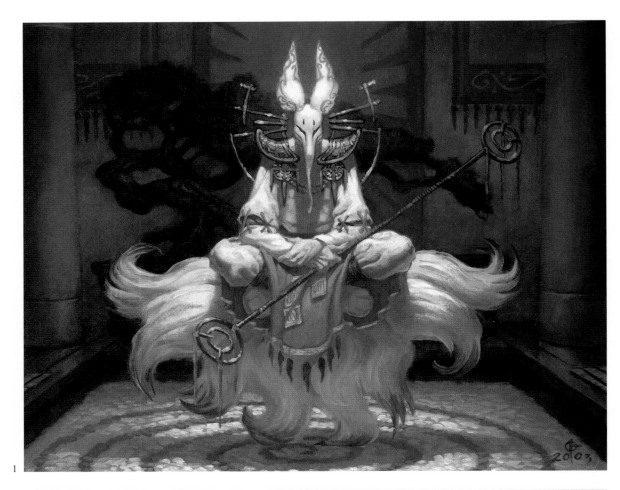

1

2

3

4

1
artist: **Cam de Leon**
client: Happy Pencil
title: Dreams.02
medium: Digital
size: 28"x28"

2
artist: **Wes Benscoter**
client: Zoku Shobo
title: Move It or Lose It
medium: Acrylic on paper
size: 28"x22"

3
artist: **Edward Binkley**
client: Stark-Raving Studios
title: Harpy
medium: Digital
size: 14"x9"

4
artist: **Edward Binkley**
client: Stark-Raving Studios
title: Jailer
medium: Digital
size: 14"x9"

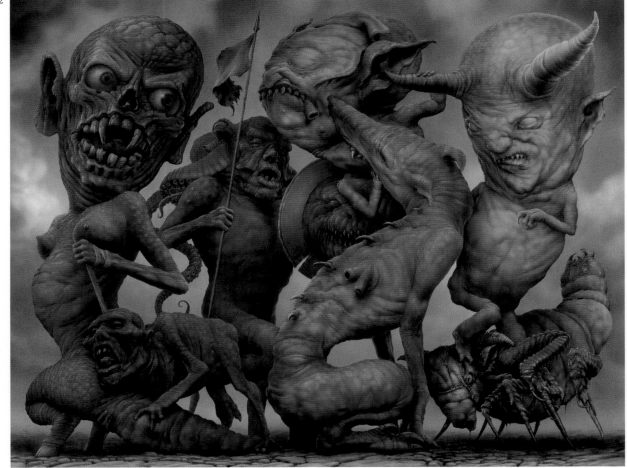

1

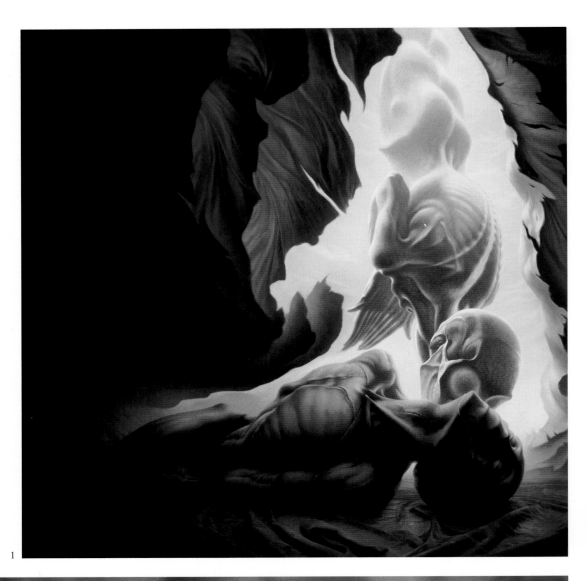

2

1
artist: **Todd Lockwood**
art director: Pauline Benney
client: White Wolf
title: Red Dress
medium: Digital
size: 12"x20"

2
artist: **Nate Van Dyke**
client: Upper Playground
title: Slayer
medium: Ink
size: 11"x17"

3
artist: **Vincent Di Fate**
title: Above and Below
medium: Acrylic
size: 16"x24"

4
artist: **John Dickenson**
art director: Tim Neveu
client: Bottlerocket Ent.
title: Rise of the Kasai "I"
medium: Digital
size: 8"x10"

5
artist: **Francis Tsai**
art director: Farzad
 Varahramyan
client: Sammy Studios
title: Ground Zero
medium: Digital
size: 8"x11 1/2"

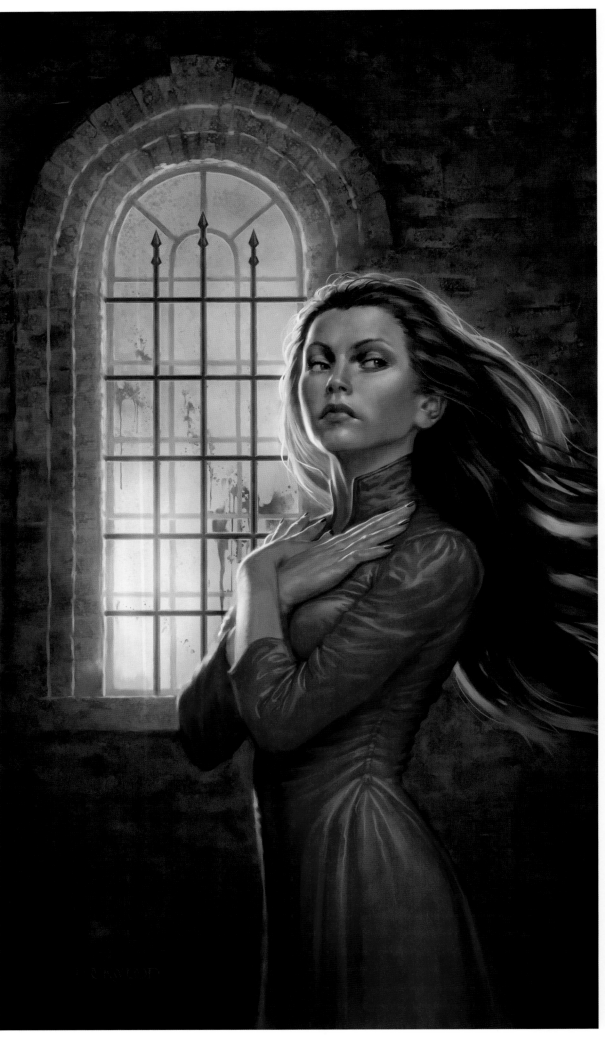

1

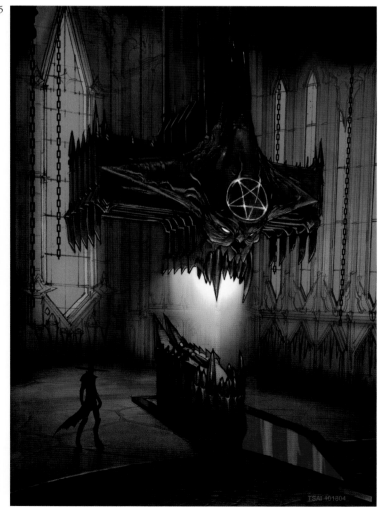

1
artist: **Greg Couch**
art director: Steve Martino
designer: Greg Couch
client: 20th Century Fox/Blue Sky Studios
title: Robots: The Movie
medium: Pencil/digital
size: 14"x17"

2
artist: **Peter de Sève**
art director: Chris Wedge
client: 20th Century Fox/Blue Sky Studios
title: Rodney [Robots: The Movie]
medium: Pencil

3
artist: **Peter de Sève**
art director: Chris Wedge
client: 20th Century Fox/Blue Sky Studios
title: Rodney [Robots: The Movie]
medium: Pencil

4
artist: **Greg Couch**
art director: Steve Martino
designer: Greg Couch
client: 20th Century Fox/Blue Sky Studios
title: Building Security [Robots: The Movie]
medium: Digital
size: 17"x11"

5
artist: **Greg Couch**
art director: Steve Martino
designer: Greg Couch
client: 20th Century Fox/Blue Sky Studios
title: The Coronation [Robots: The Movie]
medium: Digital
size: 17"x11"

"ROBOTS"™ & © 2005 Twentieth Century Fox. All Rights Reserved.

1

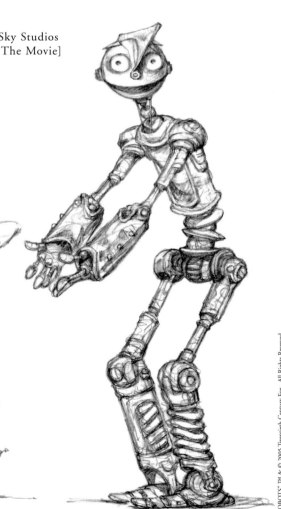

2

"ROBOTS"™ & © 2005 Twentieth Century Fox. All Rights Reserved.

3

"ROBOTS"™ & © 2005 Twentieth Century Fox. All Rights Reserved.

"ROBOTS" ™ & © 2005 Twentieth Century Fox. All Rights Reserved.

4

"ROBOTS" ™ & © 2005 Twentieth Century Fox. All Rights Reserved.

5

1
artist: **Matt Wilson**
client: Privateer Press
title: Centurion
medium: Oil on board
size: 13"x18"

2
artist: **Raymond Swanland**
client: Oddworld Inhabitants
title: Ma Spa Temple
medium: Digital
size: 8"x11"

3
artist: **Raymond Swanland**
client: Oddworld Inhabitants
title: The Canyon
medium: Digital
size: 9"x12"

4
artist: **Dan Seagrave**
client: Furioso
title: Pre-Disposal Unit
medium: Acrylic on board
size: 15"x20"

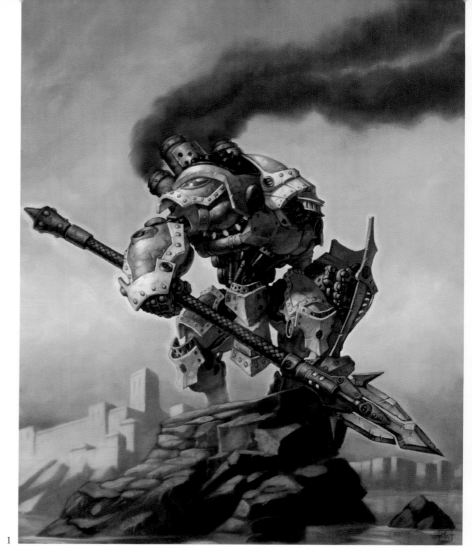

2

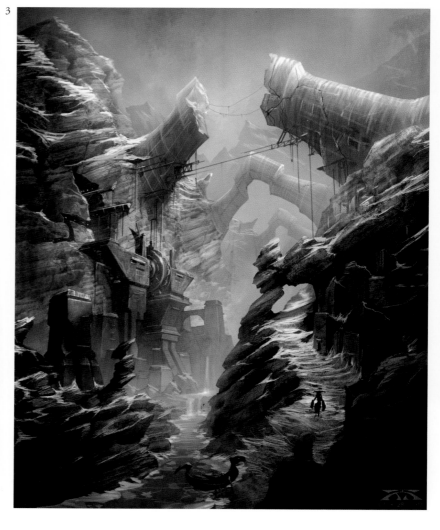

1

3

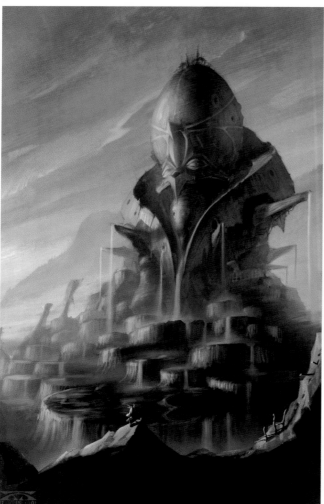

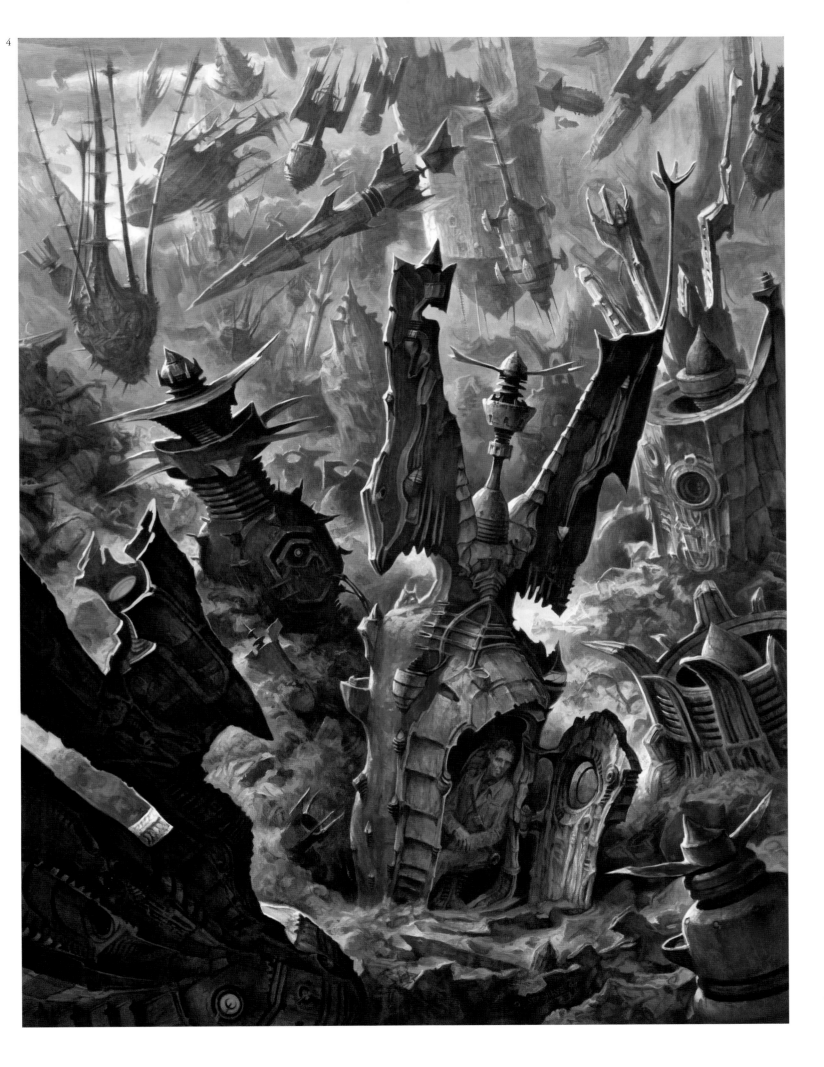

1
artist: **Marc Gabbana**
title: Destination Earth
medium: Digital

2
artist: **Scott Fischer**
art director: Angela DiTerlizzi
client: Green Fisch Studios
title: The Spark
medium: Digital

3
artist: **Josh Viers**
title: Obsessed
medium: Mixed/digital
size: 8"x10"

4
artist: **Marc Gabbana**
title: Titanium Bone
medium: Digital

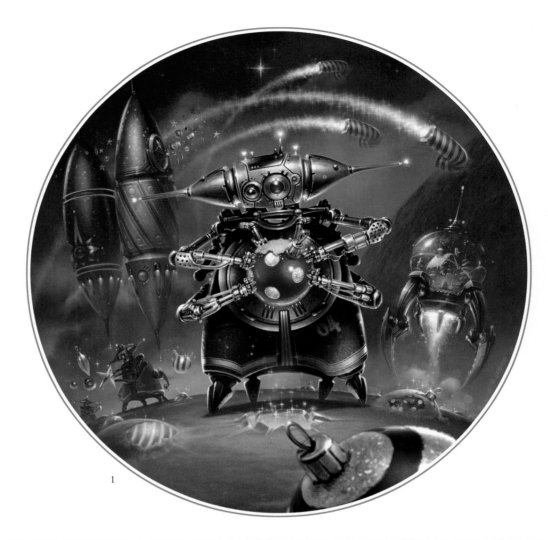

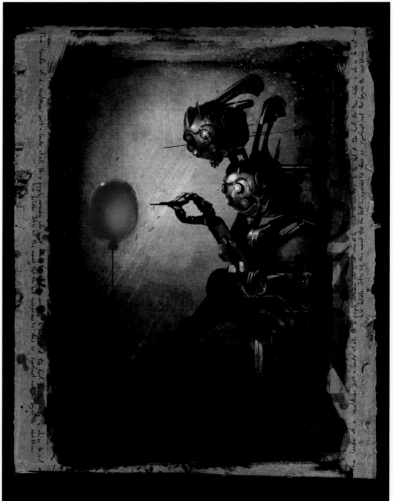

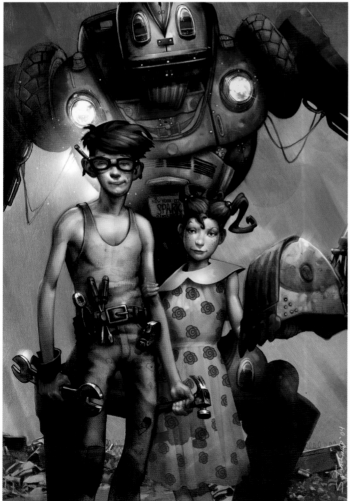

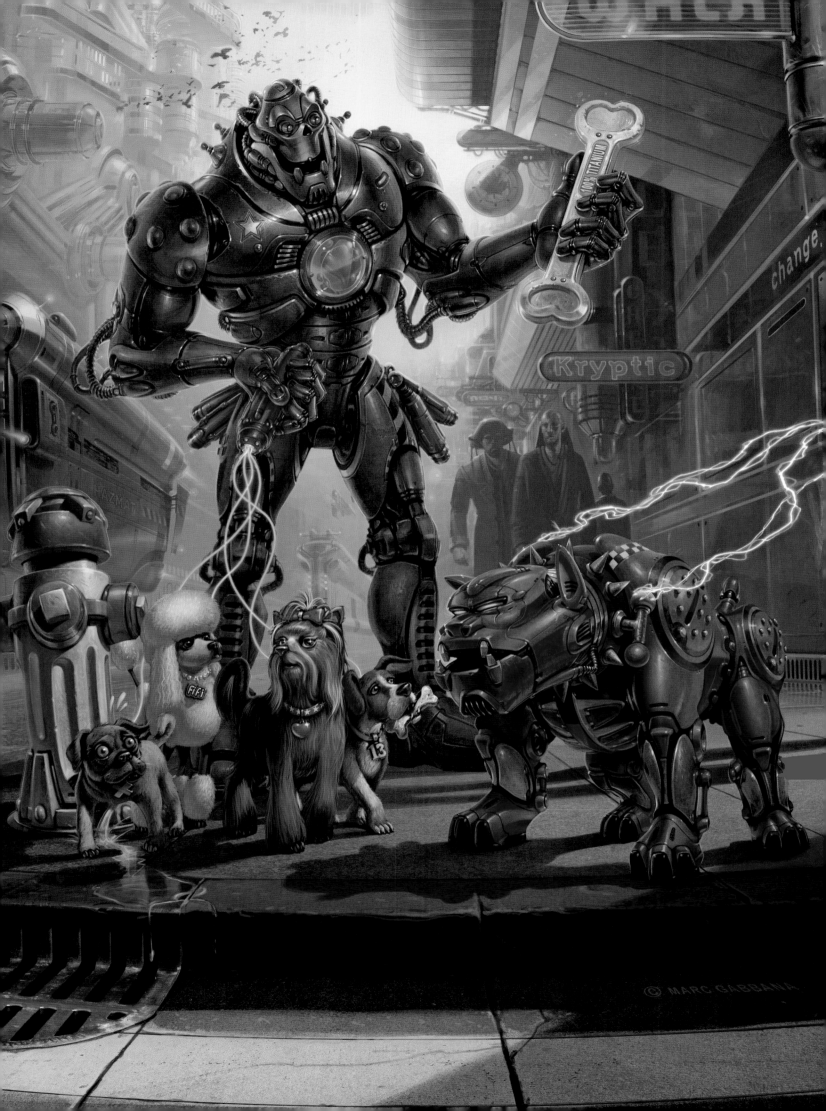

1
artist: **Jeremy Jarvis**
art director: Jeremy Cranford
client: Wizards of the Coast
title: Reverse the Sands
medium: Watercolor
size: 9"x6¹/₂"

2
artist: **Gnemo**
art director: John Onoda/Tom Kidd
client: John Onoda
title: Amber
medium: Oil
size: 40"x24"

3
artist: **Justin Sweet**
art director: Luis Fernandez
client: Walt Disney Studios
medium: Oil
size: 80"x34"

4
artist: **John Matson**
art director: Franz Vohwinkel
client: Kosmos Verlag
title: Flash
medium: Oil/digital
size: 7"x12"

5
artist: **Jeff Haynie**
client: Blowser's Books & Gallery
title: Bullseye, My Alien Pet
medium: Digital
size: 11"x14"

6
artist: **Jesper Ejsing**
art director: Darrell Hardy
client: Fantasy Flight Games
title: Descent
medium: Acrylic
size: 75cm x 45cm

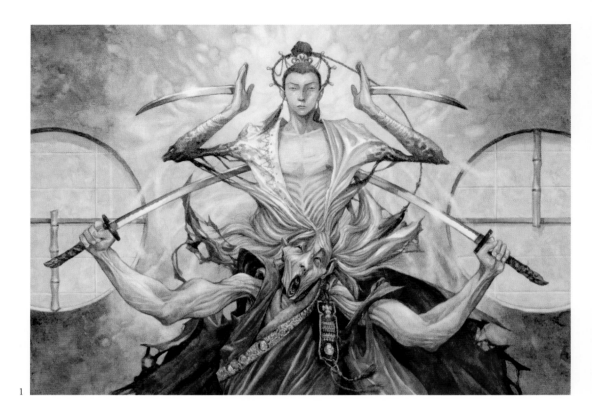

1

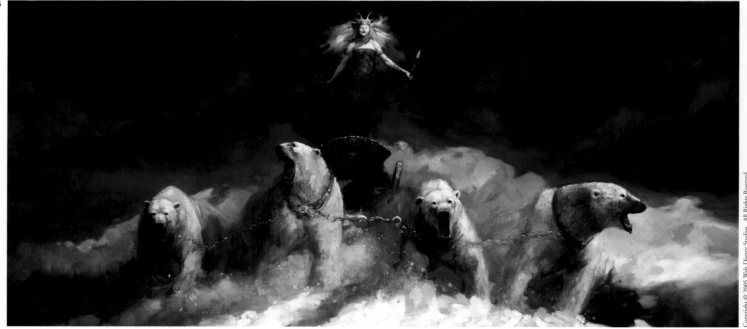

2

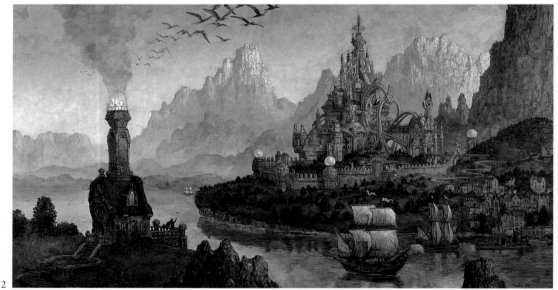

3

Copyright © 2005 Walt Disney Studios. All Rights Reserved.

4

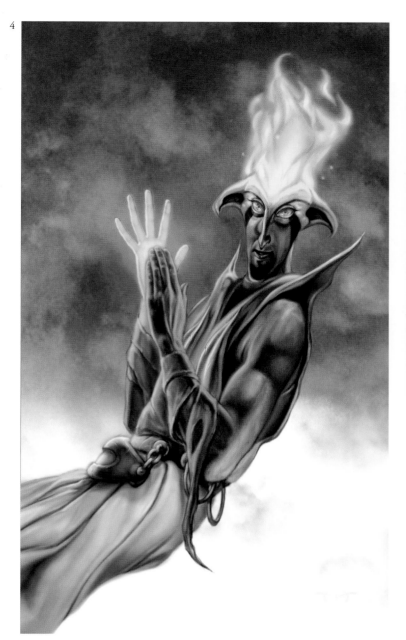

5

6

1
artist: **Philip Howe**
client: Illustrated Images
title: Far Below
medium: Oil
size: 48"x48"

2
artist: **Ian Daniels**
art director: Angi Sullins
client: Duirwaigh Publishing
title: The Star
medium: Acrylic
size: 18"x24"

3
artist: **Roxana Villa**
title: Born
medium: Acrylic on panel
size: 8¹/₂"x11"

4
artist: **Justin Sweet**
art director: Luis Fernandez
client: Walt Disney Studios
medium: Oil/digital

1

2

3

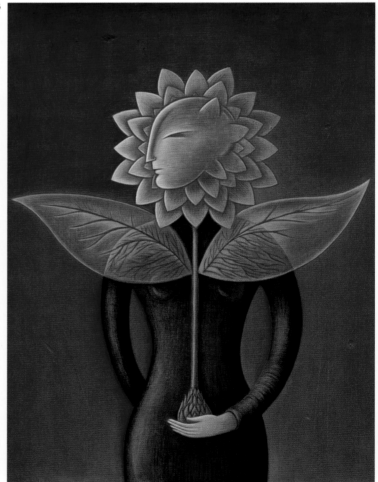

Copyright © 2005 Walt Disney Studios. All Rights Reserved.

1
artist: **Anthony S. Waters**
art director: Corey Dangel/
John Shroades
client: MicroSoft
title: Tyn's Gate .01
medium: Digital
size: 9"x15"

2
artist: **João P.A. Ruas**
art director: Nando Costa
client: brasilinspired.com
title: Saci
medium: Watercolor/digital
size: 30cm x 25cm

3
artist: **William Stout**
art director: Mark Long
designer: William Stout
client: Zombie, Inc.
title: Hellbillys!
medium: Ink & watercolor
on board
size: 13"x16"

4
artist: **Dan L. Henderson**
title: Husk
medium: Charcoal
size: 20"x26"

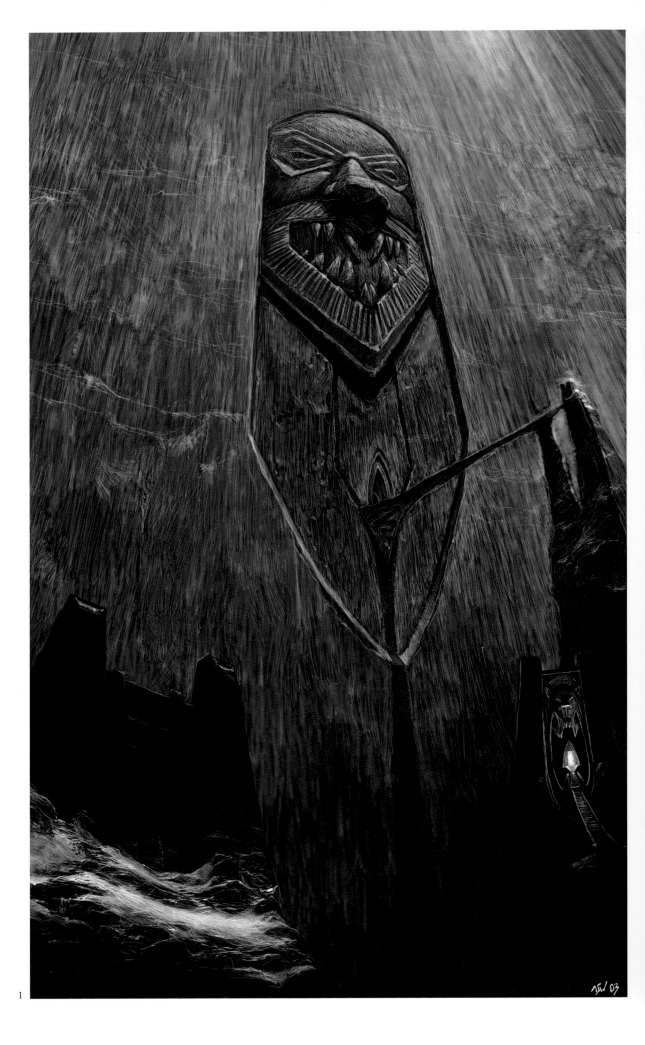

1

2

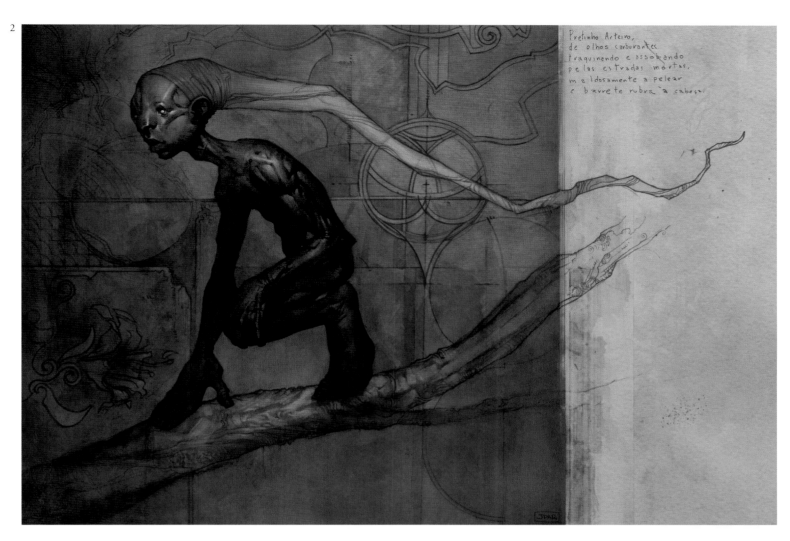

Pretinho Arteiro,
de olhos carburantes
traquinendo e assobrando
pelas estradas mortas,
maldosamente a pelear
e barrete rubra à cabeça.

3

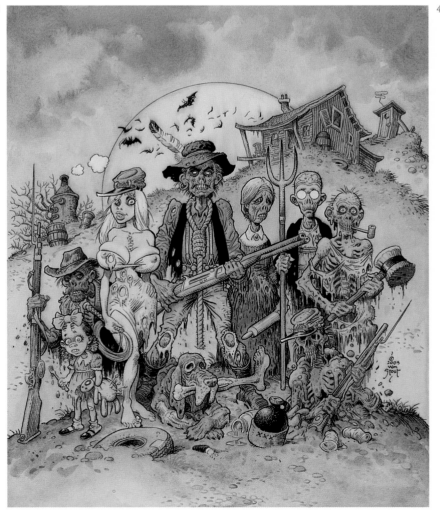

4

1
artist: **Richard Laurent**
art director: Cheryl Jefferson
client: Laurent Design
title: The Simple Life
medium: Oil on canvas
size: 24"x24"

2
artist: **Amoreno**
art director: Angi Sullins
client: Duirwaigh Publishing
title: Lyonesse
medium: Oil
size: 16"x20"

3
artist: **Andrew Bawidamann**
art director: Doug Focht
client: Express Men
title: One Rude Ride
medium: Digital
size: 3¹/2"x5"

4
artist: **Scott Gustafson**
art director: Scott Usher
designer: Scott Gustafson
client: The Greenwich Workshop
title: The Pirate and the Mermaid
medium: Oil
size: 30"x38"

1

2

3

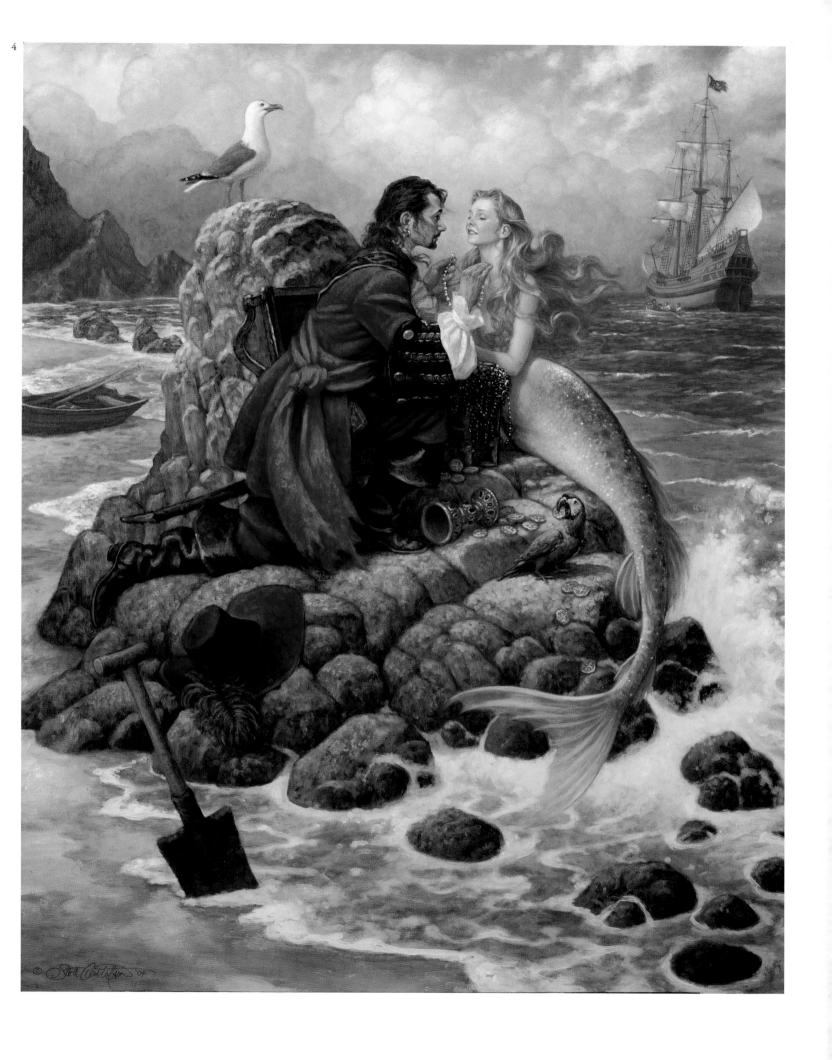

1
artist: **Leah Palmer Preiss**
art director: Leah Palmer Preiss/
 Ron McCutchan
title: Silent Meadow
medium: Acrylic/digital
size: 16¹/₂"x20¹/₂"

2
artist: **Will Bullas**
client: Portnoy Galleries
title: One-Wheel Willie...
medium: Watercolor
size: 12"x22"

3
artist: **Ray-Mel Cornelius**
art director: Allyson Bradley
client: Half-Price Books
title: The Invisible Man
medium: Acrylic on canvas
size: 11¹/₂"x8"

4
artist: **Cheryl Griesbach/
 Stanley Martucci**
art director: Stanley Martucci
client: Bernstein & Andriulli
title: Birds With Attitude
medium: Oil on board
size: 10"x12"

5
artist: **Omar Rayyan**
art director: Carolina Stewart
client: Bud Plant Comic Art
title: Christmas Carrot
medium: Watercolor
size: 7¹/₂"x10"

6
artist: **Robh Ruppel**
client: Bar Libres
title: Still Innocent
medium: Digital
size: 17"x11"

1

2

3

4

5

6

1
artist: **Scott Fischer**
art director: Jeremy Cranford
client: Wizards of the Coast
title: Kamigawa-Kunoici
medium: Mixed
size: 22"x22"

2
artist: **Shawn Ye Zhongyi**
client: Envisage Reality Pte. Ltd.
title: Immortals
medium: Digital
size: 23"x7$^{1}/_{2}$"

3
artist: **Mark A. Nelson**
client: Grazing Dinosaur Press
title: AG: Life Lotus Women
medium: Pencil/digital
size: 10"x13"

4
artist: **Michael Knapp**
art director: Steve Martino
client: 20th Century Fox/Blue Sky Studios
title: Piper [Robots: The Movie]
medium: Graphite/digital
size: 11"x14"

1

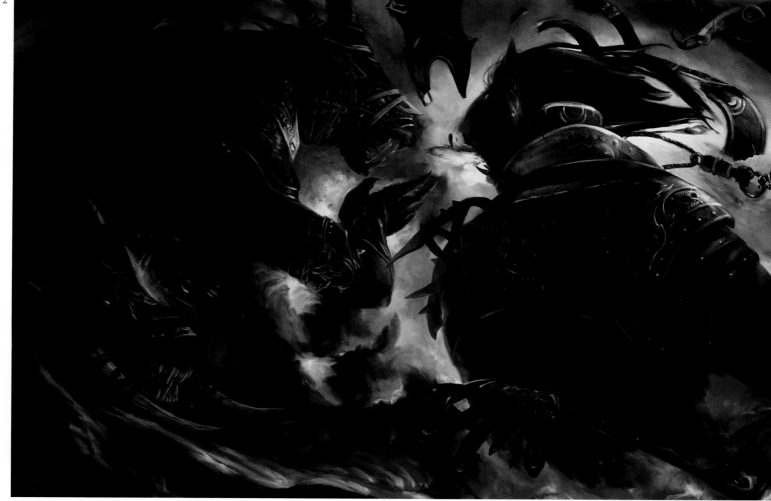

2

3

4

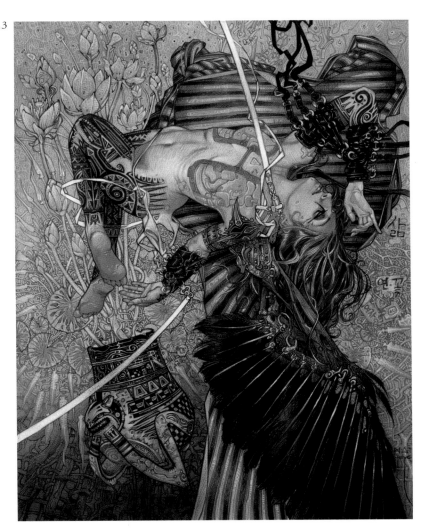

"ROBOTS"™ & © 2005 Twentieth Century Fox. All Rights Reserved.

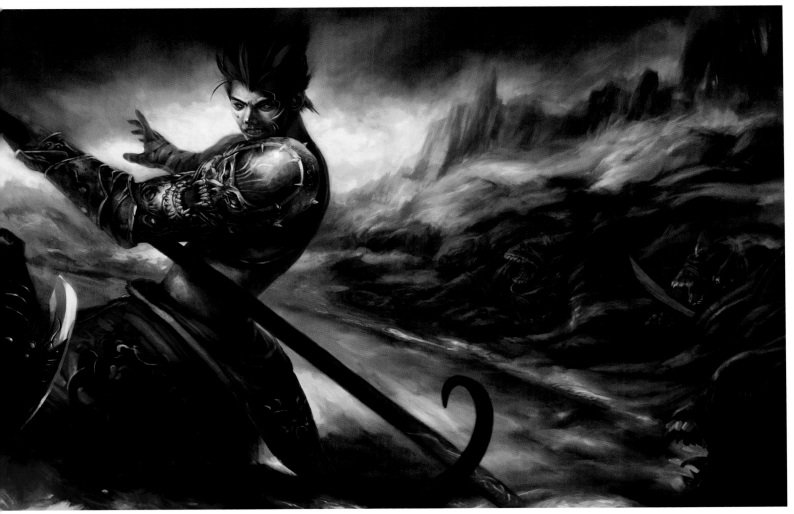

1
artist: **Brian Despain**
title: Paper Fish
medium: Digital
size: 6"x8"

2
artist: **Will Bullas**
client: Will Bullas Studios
title: The Hare of the Dog
medium: Watercolor
size: 22"x12"

3
artist: **Scott Fischer**
art director: Teresa Green
client: Green Fisch Studios
title: Le Pilot
medium: Mixed
size: 13"x19"

1

2

3

1
artist: **Greg Couch**
art director: Steve Martino
designer: Greg Couch
client: 20th Century Fox/
 Blue Sky Studios
title: Robots: The Movie
medium: Pencil/digital
size: 11"x10"

2
artist: **Eric Wilkerson**
client: Bookspan
title: Captain of the Guard
medium: Digital

3
artist: **Daniel López Muñoz**
art director: Steve Martino
designer: Daniel López Muñoz
client: 20th Century Fox/
 Blue Sky Studios
title: Mme Gasket's Chop Shop
 [Robots: The Movie]
medium: Pencil/digital
size: 14"x11"

4
artist: **Greg Couch**
art director: Steve Martino
designer: Greg Couch
client: 20th Century Fox/
 Blue Sky Studios
title: Robots: The Movie
medium: Acrylic/digital
size: 16"x10"

1

"ROBOTS" ™ & © 2005 Twentieth Century Fox. All Rights Reserved.

2

3

"ROBOTS" ™ & © 2005 Twentieth Century Fox. All Rights Reserved.

4

"ROBOTS" ™ & © 2005 Twentieth Century Fox. All Rights Reserved.

1
artist: **Dave DeVries**
title: Big Blok
medium: Acrylic/mixed
size: 7"x7"

2
artist: **Dave DeVries**
title: Big Fat Footie
medium: Acrylic/mixed
size: 5"x5"

3
artist: **Sym 7**
art director: Niles David
designer: Sym 7
client: Chisholm Prints
title: Mixed
medium: Robo Gabe
size: 11"x14"

1

2

3

artist: **Travis A. Louie**

title: Victorian Goblin In Formal Dress Circa 1893 *medium:* Acrylic on board *size:* 8"x10"

artist: Matt Gaser
title: Gluba Vanderhon the Giant *medium:* Digital *size:* 12"x5"

1
artist: **Don Maitz**
title: Arthur Steps Up
medium: Oil on masonite
size: 20"x20"

2
artist: **Omar Rayyan**
title: Man With Gold Earring
medium: Oil on panel
size: 19"x24"

3
artist: **Juda Tverski**
title: Battle For Anteca
medium: Acrylics/digital
size: 24"x30"

4
artist: **Raoul Vitale**
title: The Sword and the Rose
medium: Oil on masonite
size: 16$^{1}/2$"x23"

1

2

3

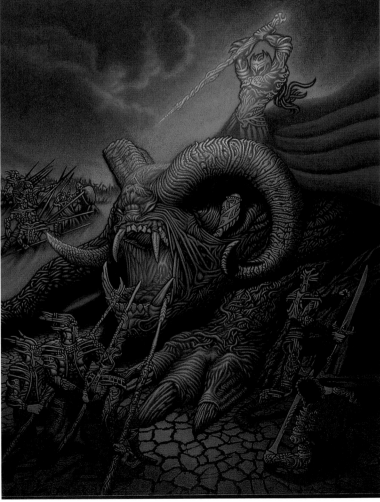

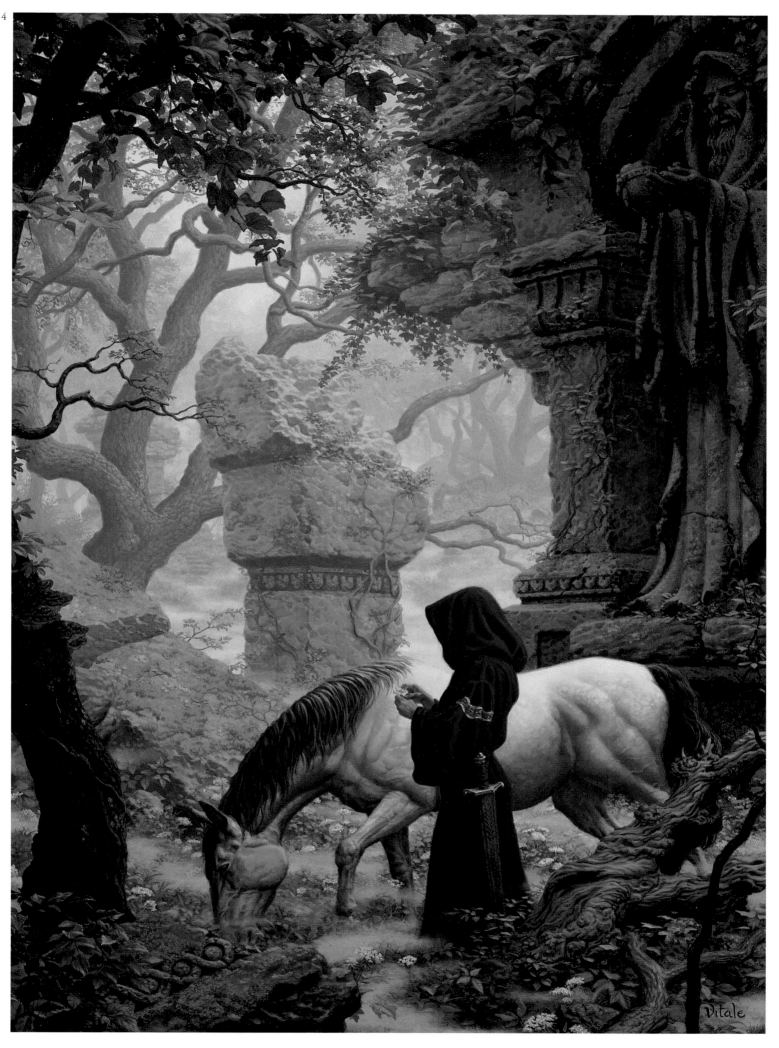

1
artist: **Craig Elliott**
title: Dragonfly Girl
medium: Oil
size: 24"x10"

2
artist: **Janet Woolley**
title: Frog Prince: Bed Time
medium: Digital

3
artist: **Matt Gaser**
title: Washington Gets Lost
medium: Digital
size: 11"x5"

4
artist: **Richard Hescox**
title: Lamia Transformed
medium: Oil on canvas
size: 30"x24"

5
artist: **Michael Whelan**
title: The Divining Heart
medium: Acrylic on panel
size: 36"x24"

1

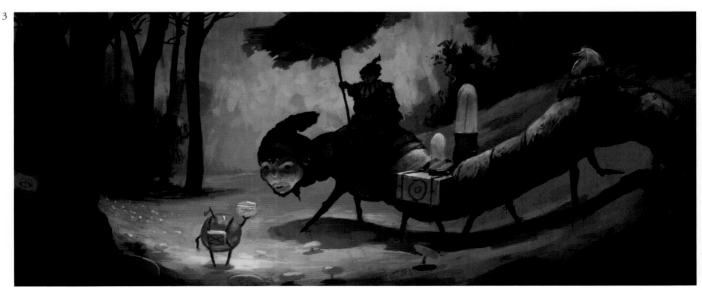

2

3

4

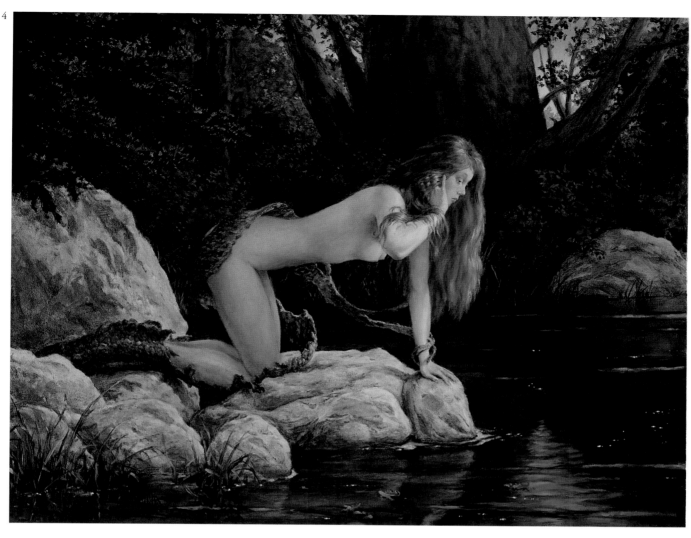

5

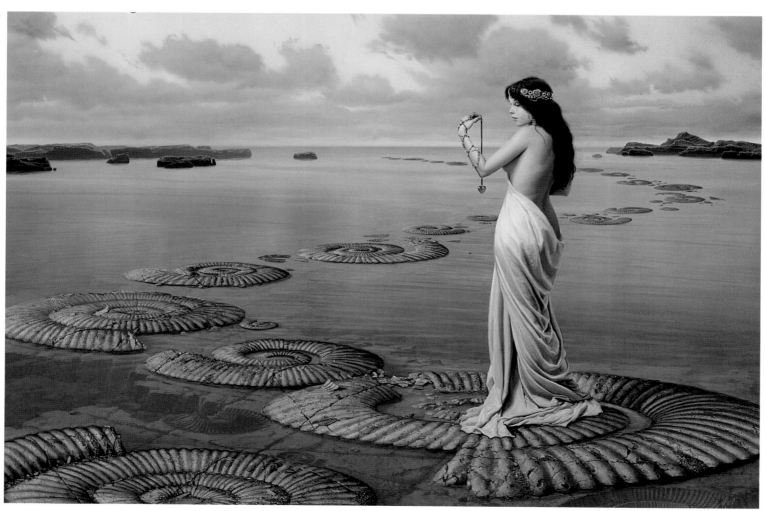

1
artist: **Raúl Cruz**
title: Diana's Descendant
medium: Digital
size: 20"x28"

2
artist: **Elio Guevara**
client: www.elioguevara.com
title: Smoked
medium: Oil/mixed
size: 20"x30"

3
artist: **E.M. Gist**
title: Electic Dogma
medium: Oil
size: 24"x36"

4
artist: **Ray Toh**
medium: Digital
size: 8^{1}/$_{4}$"x10^{1}/$_{2}$"

1

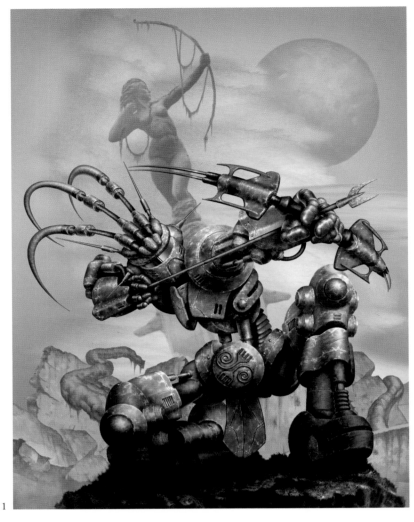

2

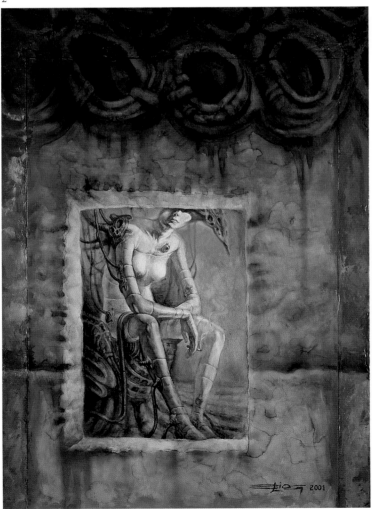

3

4

1
artist: **Stephen Player**
title: Loose Spirits
medium: Watercolor
size: 12"x16"

2
artist: **Pamelina H.**
title: Turning To Stone
medium: Acrylic on canvas
size: 4'x5'

3
artist: **Travis A. Louie**
title: Grandma Cyclops Circa 1896
medium: Acrylic & graphite on board
size: 8"x10"

4
artist: **Jeremy Geddes**
title: Better Than One
medium: Oil
size: 700cm x 1100cm

1

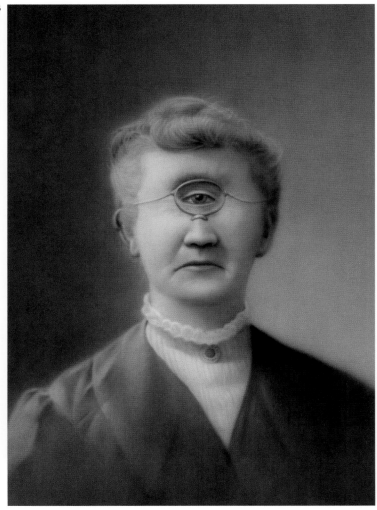

2

3

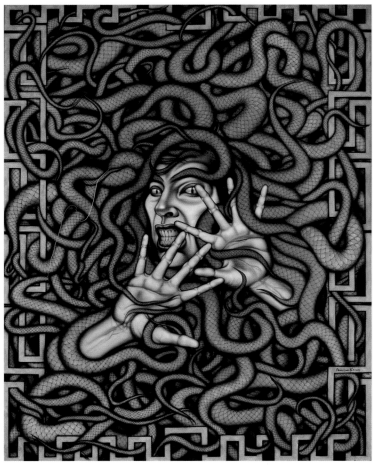

4

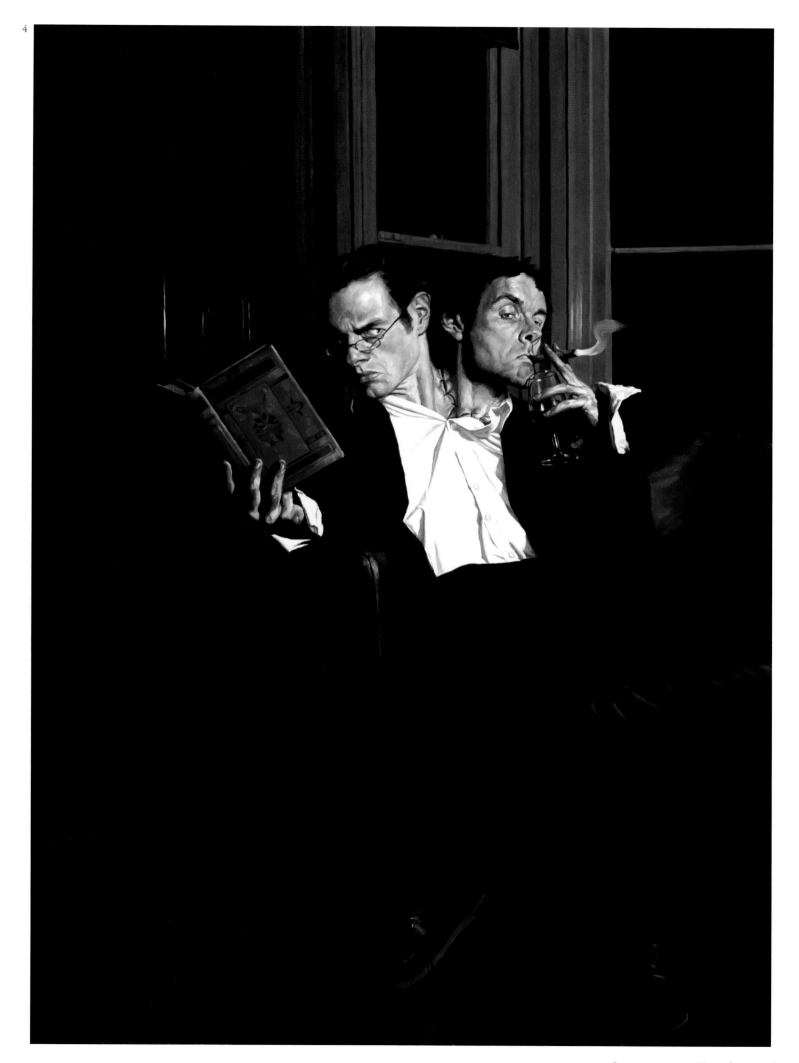

1
artist: **David Bowers**
title: Little Tiny
medium: Oil
size: 11"x11"

2
artist: **Matt Hughes**
title: Judge Not Thy Neighbor
medium: Oil/color pencil
size: 24"x36"

3
artist: **Steven Kenny**
title: The Paper Mantle
medium: Oil on panel
size: 16"x20"

4
artist: **David Bowers**
title: Fall From Grace
medium: Oil
size: 18"x24"

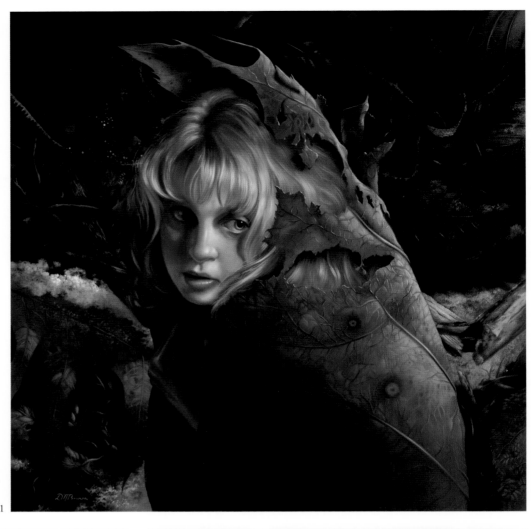

1

2

3

1
artist: **Joe Lacey**
client: Dana Countryman
title: Ragtime For Robots
medium: Digital
size: 18"x18"

2
artist: **Eric Joyner**
client: Brea City Art Gallery
title: The Uninvited
medium: Oil on panel
size: 48"x32"

3
artist: **Chris Young**
title: Found At Last
medium: Digital

4
artist: **Oleg Zatler**
title: Trying To Make It Work
medium: Mixed/digital
size: 10"x14"

5
artist: **Drigz Abrot**
title: Child Benevolent
medium: Oil on panel
size: 24"x30"

1

2

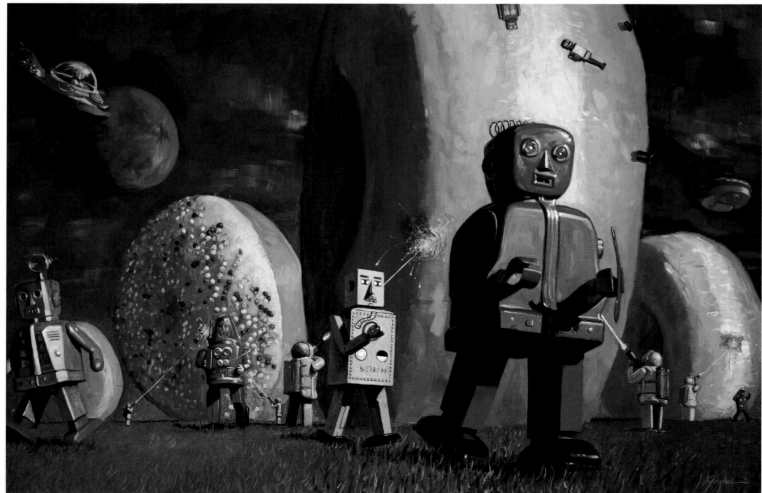

3

5

4

1
artist: **Christian Alzmann**
title: Biased
medium: Mixed/digital
size: 10"x9$\frac{1}{2}$"

2
artist: **Christian Alzmann**
title: Gathering
medium: Mixed/digital
size: 7"x13"

3
artist: **Chantale Arsenault**
title: The Acolyte
medium: Photography/digital
size: 11"x17"

4
artist: **Christian Alzmann**
title: Rabid
medium: Mixed/digital
size: 9"x11$\frac{1}{2}$"

1

2

3

4

1
artist: **Eric Bowman**
title: Griffin's Tomb #2
medium: Oil on canvas
size: 24"x18"

2
artist: **Michael Wm. Kaluta**
title: Faramir and Éowyn
medium: Ink/watercolor
size: 29"x23"

3
artist: **Charles Vess**
title: Companions To the Moon
medium: Colored inks
size: 23"x16"

4
artist: **Lewis Lavoie**
title: Runaway Ben
medium: Oil
size: 48"x24"

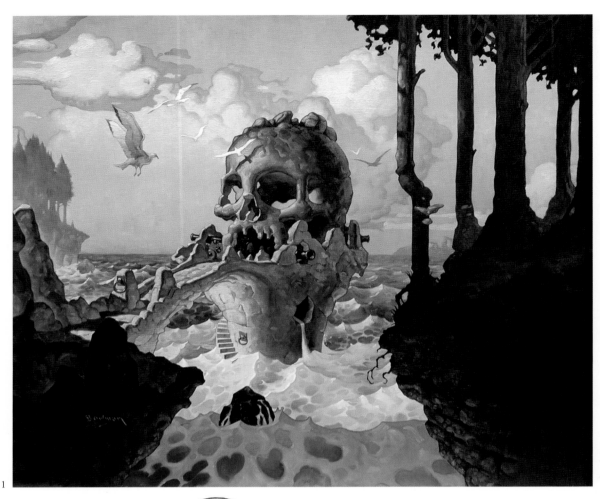

1

2

1
artist: **Charles Keegan**
title: The Trophy
medium: Oil on canvas
size: 20"x24"

2
artist: **David Dorman**
title: A Thousand Angry Teeth
medium: Oil/acrylic
size: 14"x18"

3
artist: **Hubert de Lartigue**
title: Chevaliere
medium: Acrylic on paper
size: 20"x25"

4
artist: **Charles Keegan**
title: The Exile's Return
medium: Oil on canvas
size: 24"x36"

1
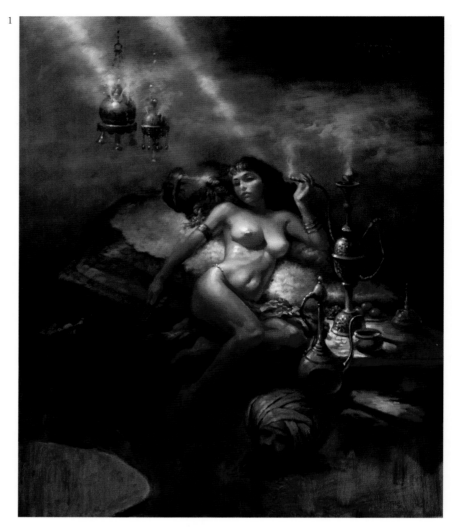

2
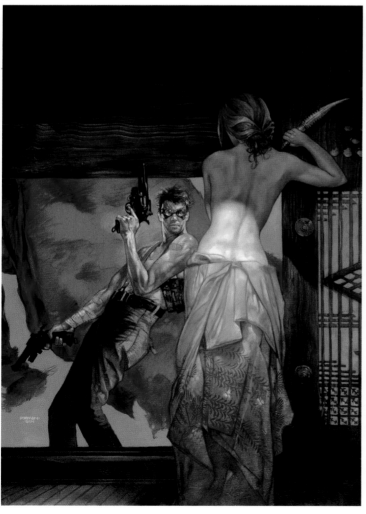

3

4

1
artist: **August Hall**
title: Gold Rush
medium: Mixed
size: 27"x18"

2
artist: **August Hall**
title: The Jester
medium: Mixed
size: 15"x20"

3
artist: **August Hall**
title: Handyman
medium: Mixed
size: 12"x24"

4
artist: **August Hall**
title: Belen
medium: Mixed
size: 24"x36"

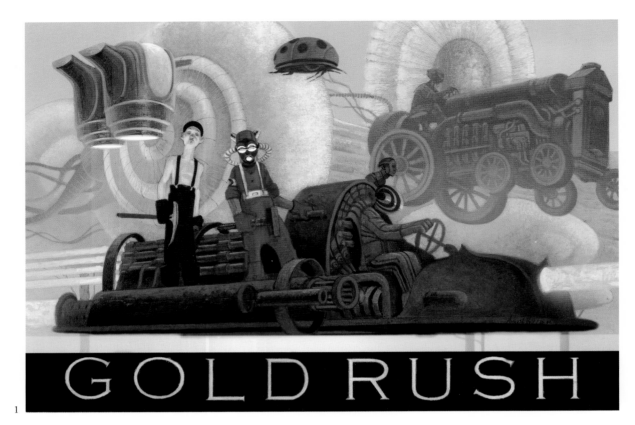

1

2

3

4

1
artist: **Dennis Brown**
title: Lisa & Clay
(The Tooth Fairy
and The Boogieman)
medium: Mixed
size: 22"x36"

2
artist: **Andrew S. Arconti**
title: Platform 7
medium: Digital
size: 8"x12¹/4"

3
artist: **Jeffrey Dickinson**
title: Halo
medium: Oil on canvas
size: 10"x12"

4
artist: **Christopher Brindley**
title: Black Box
medium: Mixed/digital
size: 16"x20"

5
artist: **David Gentry**
title: Greed
medium: Digital
size: 17"x25"

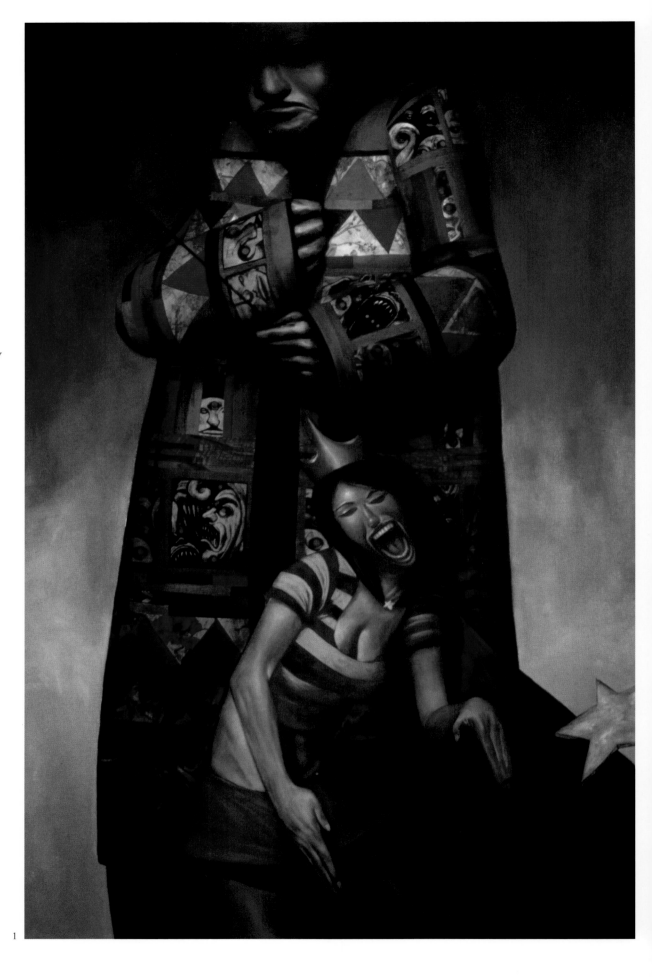

1

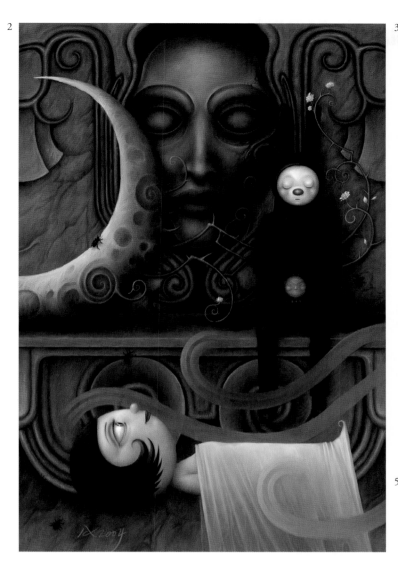

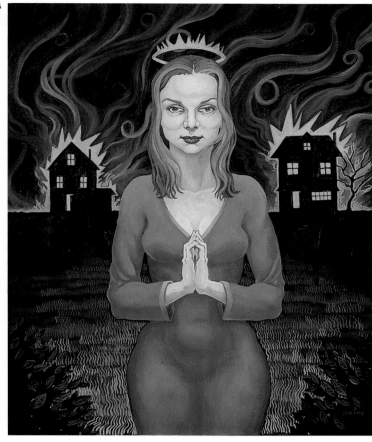

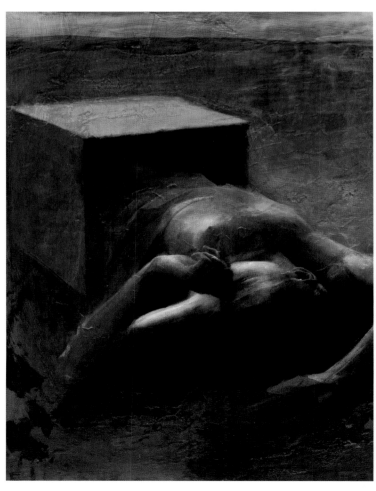

1
artist: **René Milot**
title: Guarded Angel
medium: Oil on canvas
size: 16"x26"

2
artist: **Randy Gallegos**
title: Angelic Songs
medium: Oil
size: 15"x24"

3
artist: **Philip Straub**
title: Dreamcoat
medium: Digital
size: 16"x22"

4
artist: **Stephen Player**
client: Hodder Children's Books
title: Ed and the Devil's Chair
medium: Watercolor
size: 12"x16"

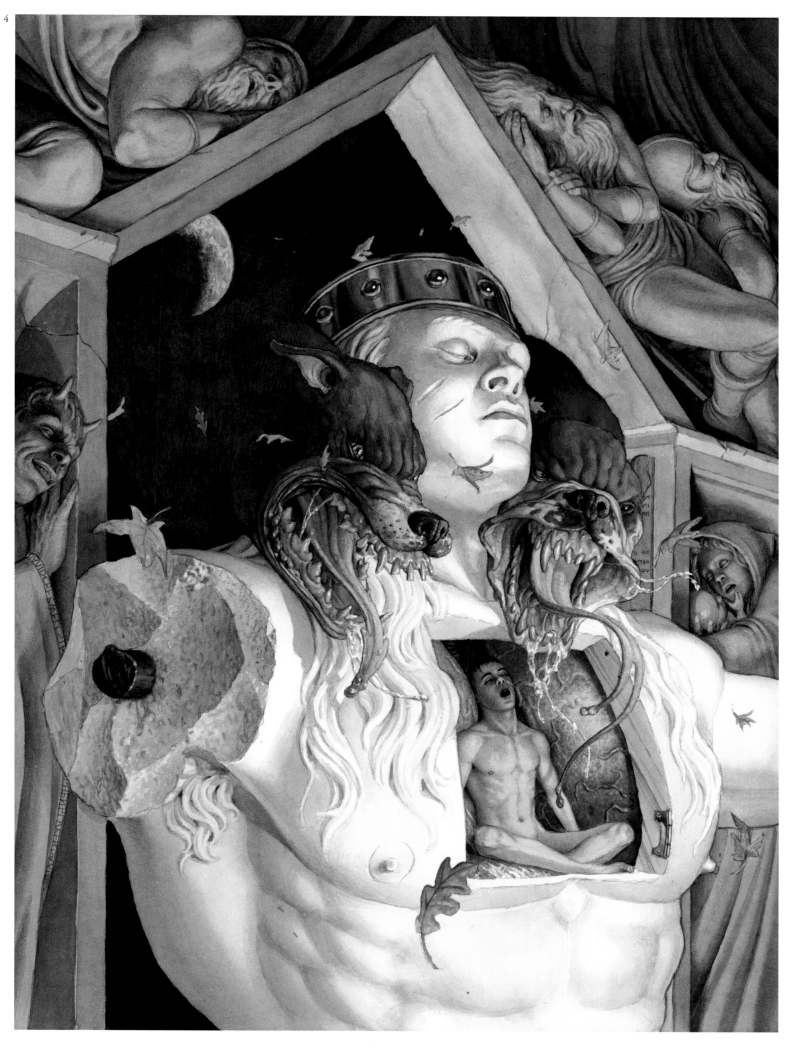

1
artist: **Harvey Chan**
title: Ancient Princess
medium: Mixed
size: 5¹/2"x7"

2
artist: **Keith Thompson**
title: Loper
medium: Mixed
size: 6³/8"x12⁵/8"

3
artist: **Victor Leshyk**
title: Side Effects
medium: Scratchboard/digital
size: 8"x10"

4
artist: **Hoang Nguyen**
title: Mathilda
medium: Digital
size: 8¹/4"x10"

5
artist: **Mark A. Nelson**
title: E2: Earth
medium: Pencil
size: 10"x13"

6
artist: **Kip Omolade**
title: Son
medium: Oil
size: 18"x24"

7
artist: **Gordon Crabb**
title: She Put Down In Writing
 What Was On Her Mind
medium: Digital

4

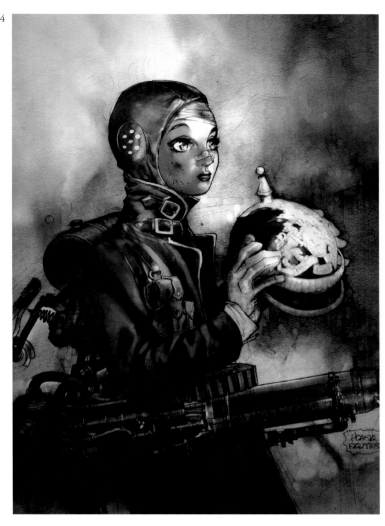

5

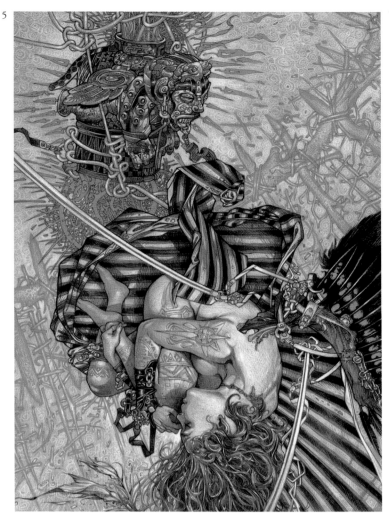

6

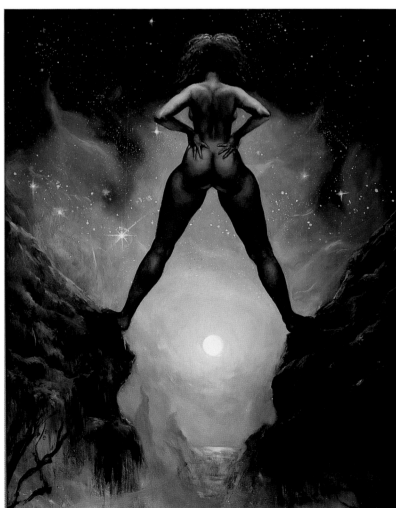

7

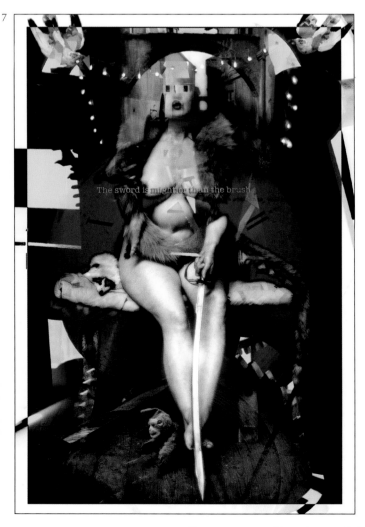

1
artist: **Eric Deschamps**
title: Empress and Her Servant
medium: Digital
size: 8"x10"

2
artist: **Ian Ameling**
title: Stroll
medium: Digital
size: 6"x12"

3
artist: **Eduardo Gonzalez**
title: Ender of All Kings
medium: Mixed

4
artist: **Aaron McBride**
title: Last Stand
medium: Pencil/digital
size: 11"x17"

1
artist: **Thane Gorek**
title: The Juggler
medium: Oil on panel
size: 24"x36"

2
artist: **Eric Bowman**
title: From Out of
 The Ink Well
medium: Oil on board
size: 16"x20"

3
artist: **Owen Richardson**
art director: Amy Parker
title: Ki-Ki-Ri-Ki!
medium: Digital
size: 8"x12"

4
artist: **Hunter Brown**
title: Cheshire Cat
medium: Watercolor/gouache
size: 9³/4"x14"

5
artist: **Claus Brusen**
title: Ladybird Flying to
 The Land of Make-Believe
medium: Oil
size: 15cm x 20cm

6
artist: **Matthew Armstrong**
title: Ol' King Crusty
medium: Watercolor/gouache
size: 13"x22"

7
artist: **Néstor Taylor**
title: The Competition
medium: Acrylic
size: 15"x22"

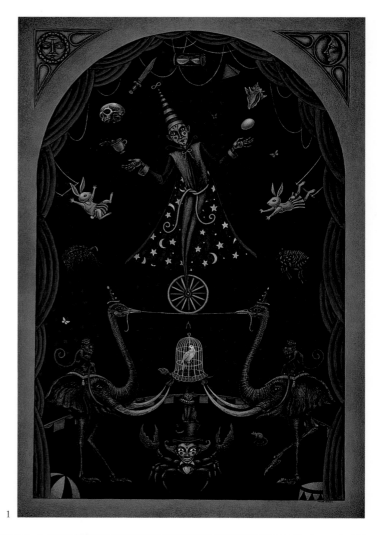

1

2

3

4

5

6

7

1
artist: **Donato Giancola**
client: Jacqueline LeFrak
title: Lancelot and Guinevere
medium: Oil on paper on panel
size: 18"x21"

2
artist: **Gia Manh Luc**
medium: Digital

3
artist: **William Stout**
client: California Art Club
title: Sensuality's Song
medium: Ink & watercolor on board
size: 7"x10"

4
artist: **Luis Royo**
title: Malefic 2004
medium: Acrylic
size: 12"x16"

1
artist: **Emmanuel Bastid**
title: A Fool's Ark
medium: Mixed
size: 10"x8"

2
artist: **Keith Thompson**
title: Patron of Poor Minstrels
medium: Mixed
size: 6^{1}/$_{8}$"x12^{5}/$_{8}$"

3
artist: **Peter Forystek**
client: www.peterforystek.com
title: Ascension
medium: Oil on masonite
size: 7^{1}/$_{2}$"x23"

4
artist: **Caniglia**
title: Her Future's Already Begun
medium: Oil on paper
size: 11"x17"

5
artist: **Nilson**
title: Kranich
medium: Oil/acrylic
size: 21"x29"

6
artist: **Steve Purcell**
title: Ernie & Suda
medium: Acrylic
size: 9"x12"

7
artist: **Lothar W. Speer**
designer: The Renaissance Project
title: Ars Moriendi
medium: White conté on color board
size: 20"x30"

1

2

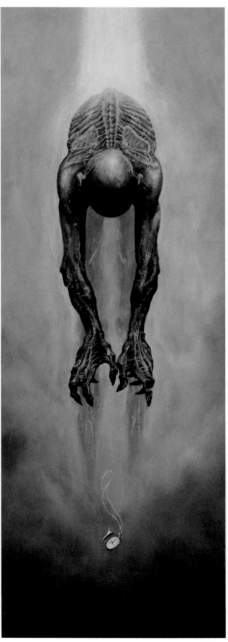

3

4

5

6

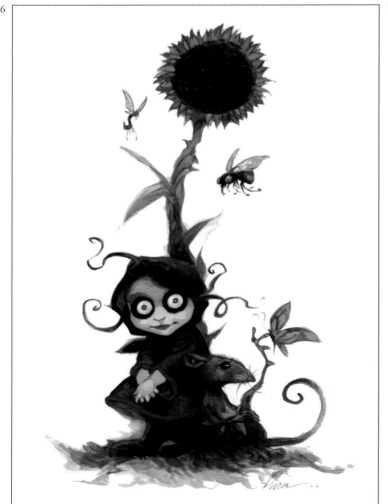

7

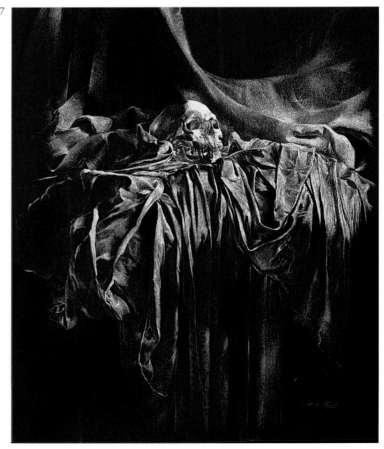

1
artist: **David Christiana**
client: Thornapple Press
title: His Third Arm
medium: Hand-tinted etching
size: 6"x7"

2
artist: **Joe Vaux**
photographer: Artworks 4
title: Dusk
medium: Acrylic
size: 11"x18"

3
artist: **Fabrice Lavollay**
title: Remoros
medium: Mixed
size: 11³/4"x16¹/2"

4
artist: **Brom**
client: Abrams Books
title: Angel Bound
medium: Oil

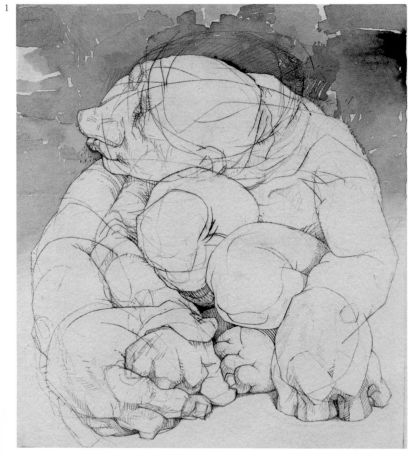

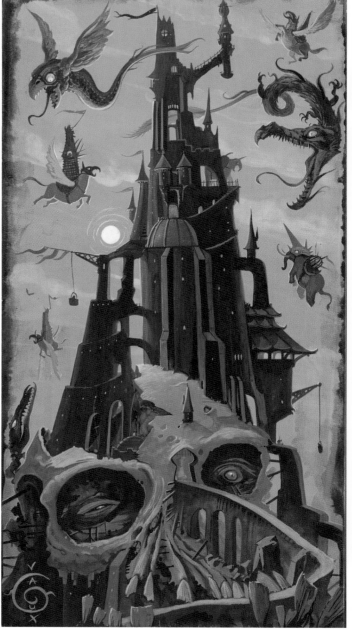

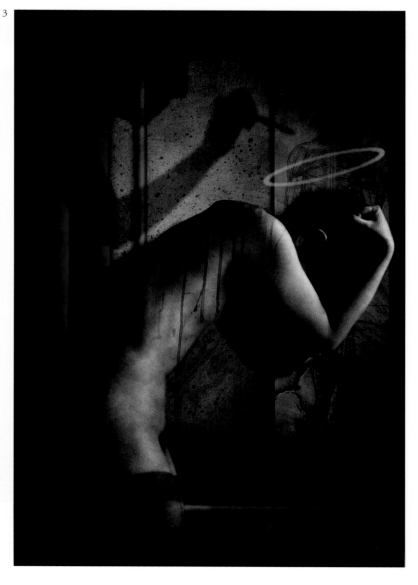

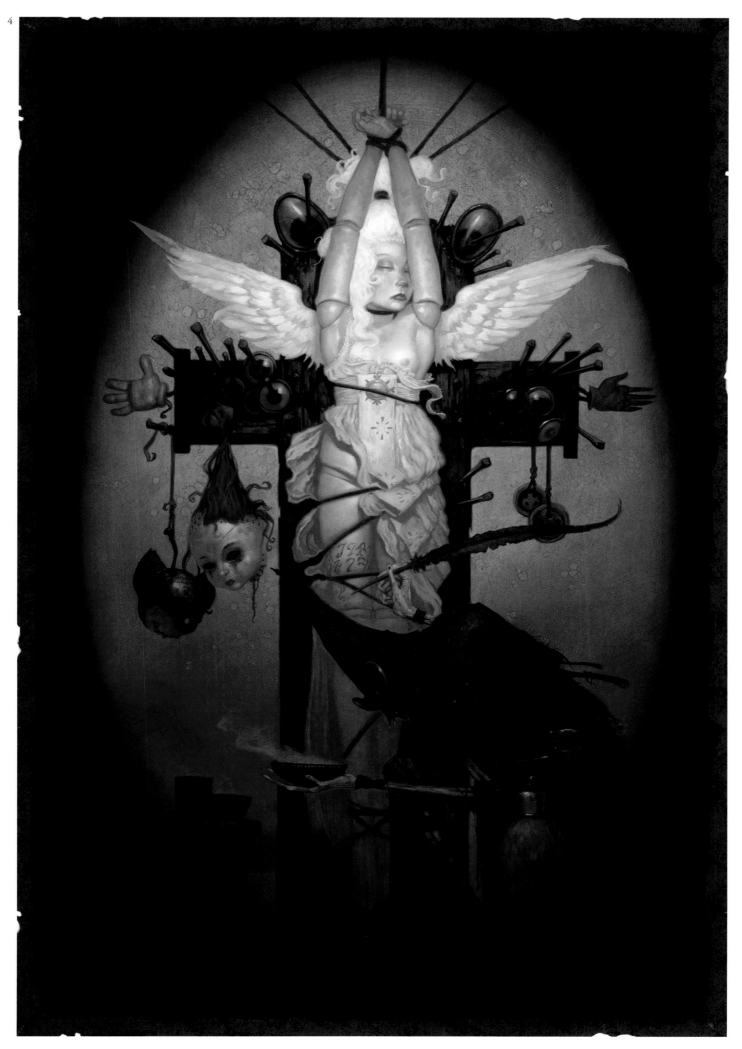

1
artist: **José Roosevelt**
title: The Mirror
medium: Oil on canvas
size: 23¹/₂"x23¹/₂"

2
artist: **Arthur Adams**
title: Atlantean Queen 2
medium: Ink on board
size: 9"x16"

3
artist: **John Pierro**
title: Ambilica
medium: Digital

4
artist: **Cody Kenworthy**
title: Son of Dust
medium: Watercolor/digital
size: 8¹/₂"x11"

5
artist: **Jason Alexander**
title: Scream
medium: Oil
size: 29"x34"

6
artist: **Oleg Zatler**
title: He Arrived By the Sea
medium: Mixed/digital
size: 10"x14"

7
artist: **Andrew S. Arconti**
title: The Flea Bag
medium: Digital
size: 8¹/₂"x12¹/₂"

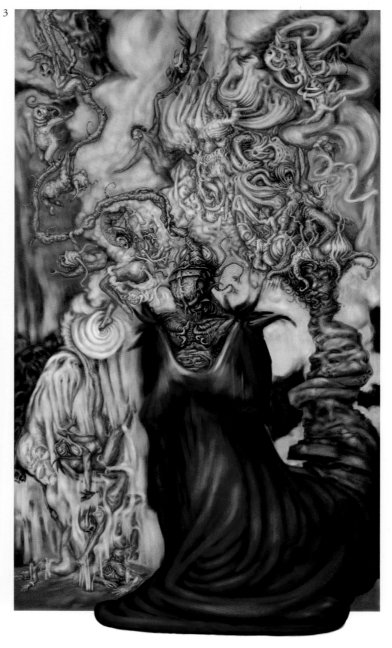

1

2

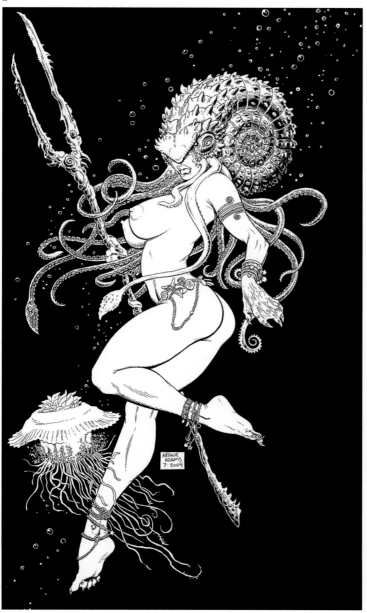

3

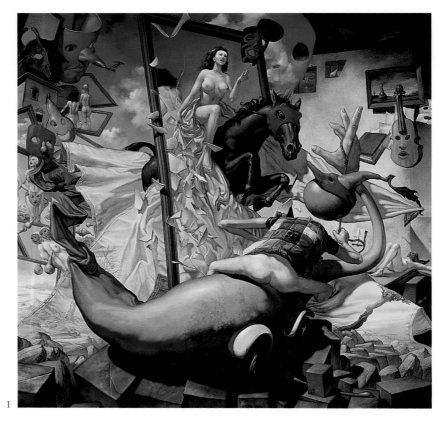

4

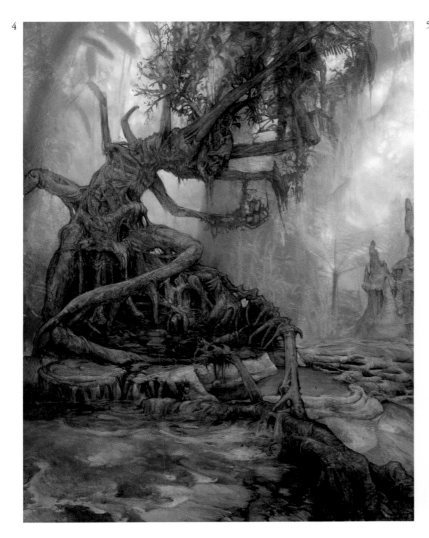

5

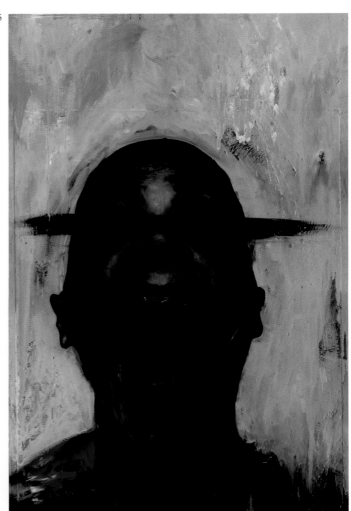

6

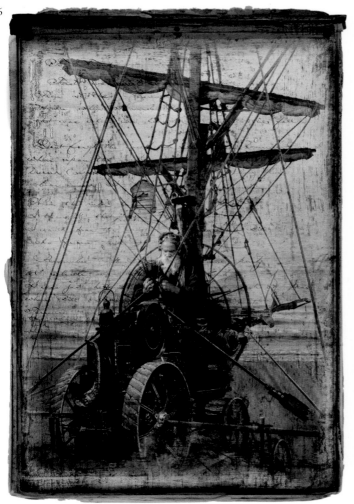

7

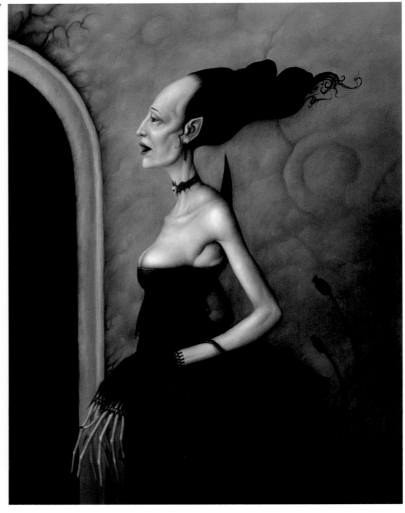

1
artist: **Mark Elliott**
art director: Cheryl Van Ander
client: Baker Bookhouse
title: The Snake Room
medium: Acrylic
size: 11"x13"

2
artist: **Anita Kunz**
title: Twins
medium: Mixed
size: 8 1/2"x11"

3
artist: **Rick Price**
client: Thomas Lu
title: Heavenly Matrimony
medium: Mixed
size: 14"x21"

4
artist: **William Stout**
title: Destiny In the Depths
medium: Oil on canvas
size: 36"x48"

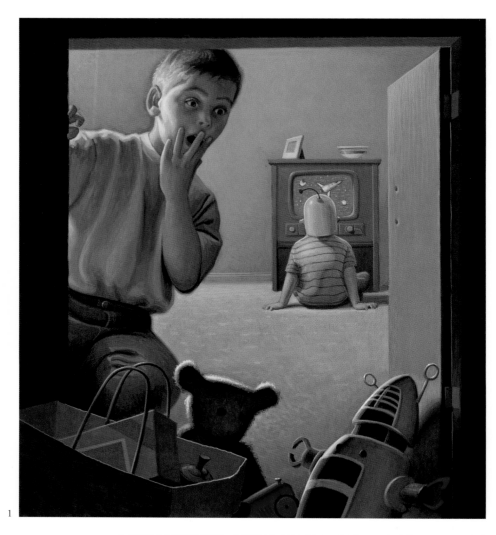

1

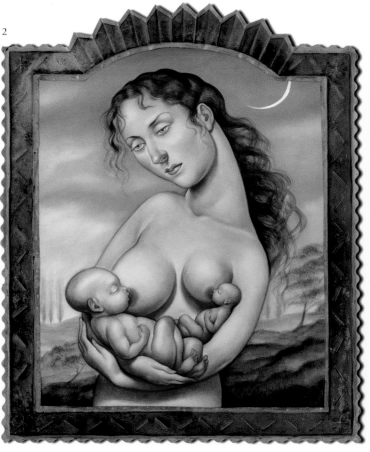

2

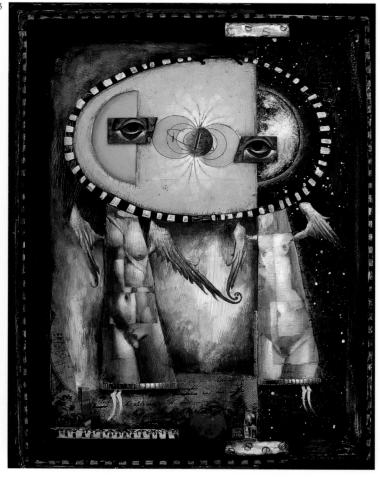

3

4

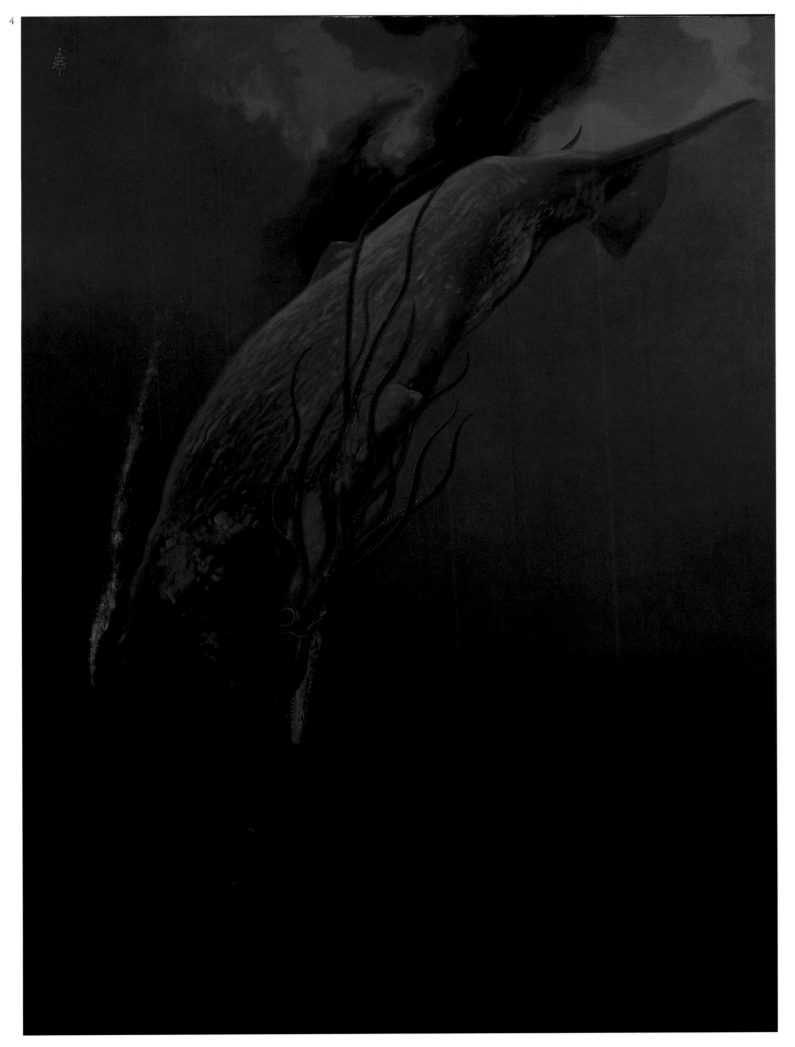

1
artist: **Steven Kenny**
title: Thumbelina
medium: Oil on linen
size: 18"x24"

2
artist: **David Bowers**
title: Thinking of Adam
medium: Oil
size: 24"x22"

3
artist: **Eric Fortune**
client: Columbus AIDS Task Force
title: Self Portrait
medium: Acrylic
size: 15¹/2"x11¹/2"

4
artist: **David Bowers**
title: Artificial Love
medium: Oil
size: 18"x24"

1

2

3

4

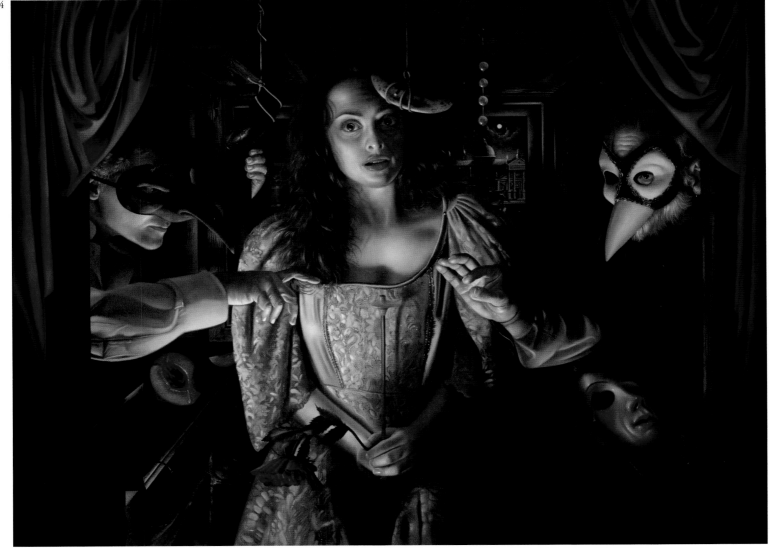

1
artist: **Sandrine Gestin**
title: Sann' Real
medium: Oil on canvas
size: 40"x63"

2
artist: **William O'Connor**
title: Fire & Water
medium: Oil
size: 24"x36"

3
artist: **Terese Nielsen**
client: Nicholas Miller
title: Julsenor & Atticus
medium: Mixed
size: 18"x24"

4
artist: **Cyril Van der Haegen**
title: Al Hazred's Cellar or
 How H.P. Lovecraft Got
 Introduced to the Necronomicon
medium: Oil/digital

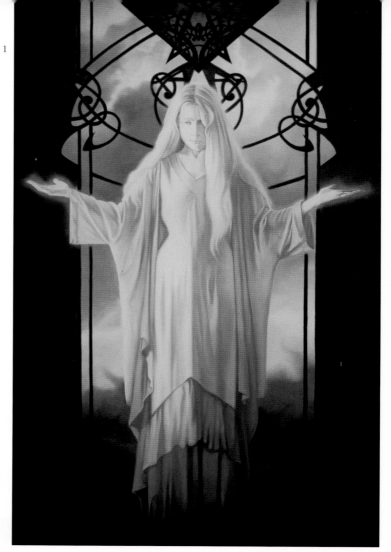

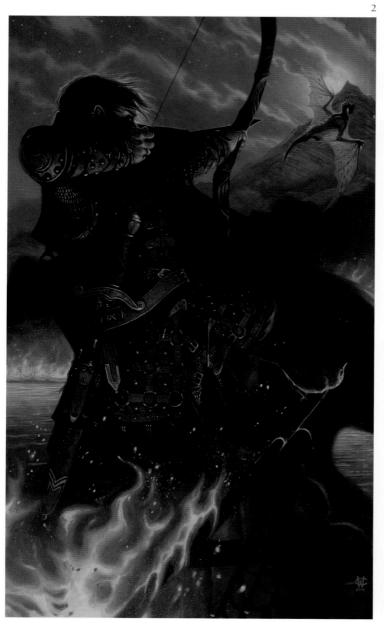

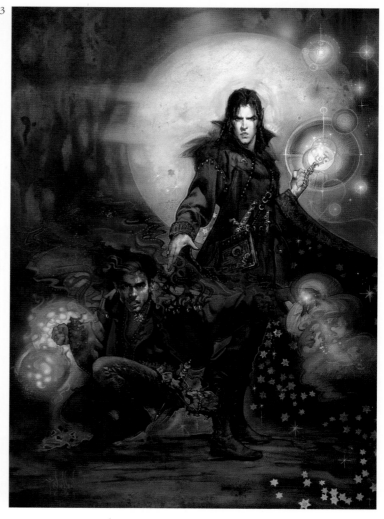

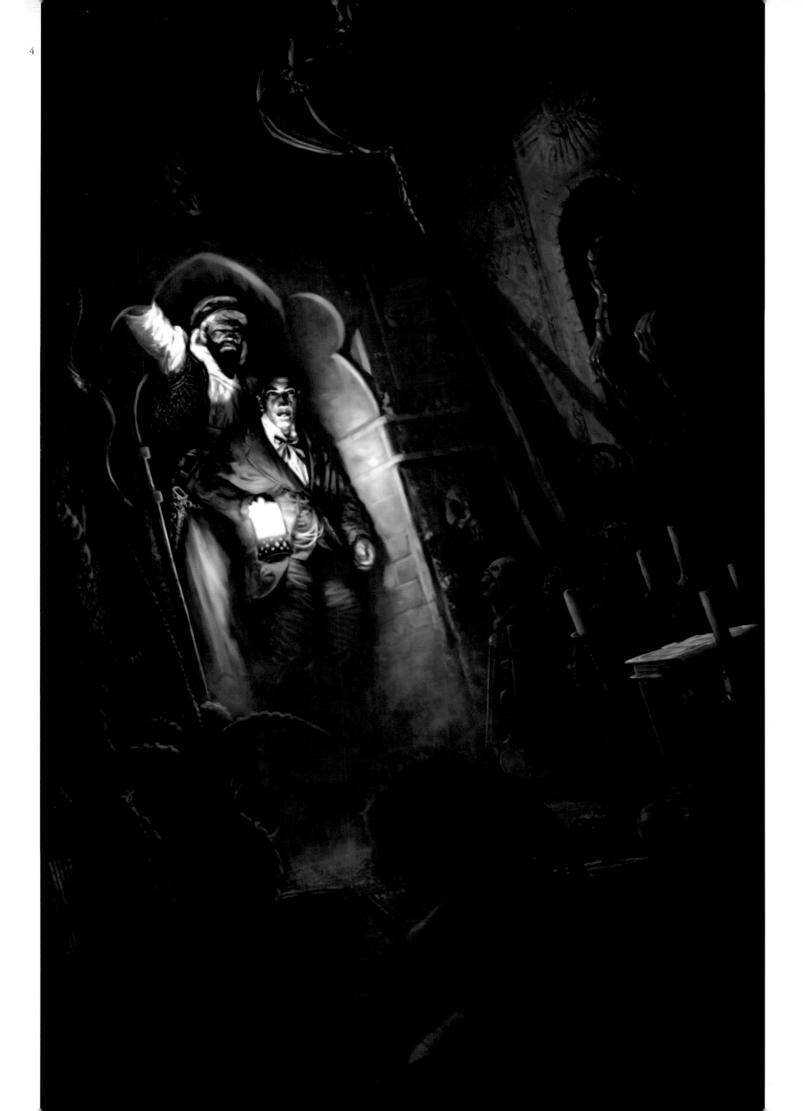

Scott Gustafson 149
4045 N Kostner
Chicago, IL 60641
773-725-8338
scott@scottgustafson.com

Pamelina H 168
P.O. Box 313
TuJunga, CA 91043-0313
818-951-9921
pamelina.h.art@comcast.net

Nathan Hale 116
737 E. 50 South
Provo, UT 84606
801-310-9110
www.shannonassociates.com

August Hall 180, 181
c/o Allen Spiegel Fine Arts
221 Lobos Ave.
Pacific Grove, CA 93950
831-372-4672
asfa@redshift.com

Randy Hand 99
1550 W 28th St Unit #A2
Loveland, CO 80538
970-214-2620
www.randyhand.com

Paul Harding 101
31-32 42nd St. #2
Astoria, NY 11103
718-932-7387
www.hardingdesigns.com

John Harris 46
c/o Alan Lynch
116 Kelvin Pl.
Ithaca, NY 14850
607-257-0330
alartists@aol.com

Jeff Haynie 143
226 Kensington Ave. South
Kent, WA 98030
253-854-5969
www.jeffhaynie.com

Beric Henderson 122
13 Russell Street Riverwood
Sydney, NSW 2210 Australia
beric_henderson@wmi.usyd.edu.au
www.berichenderson.com

Dan L. Henderson 147
197 Chelsea Dr.
Decatur, GA 30030
hendall@mindspring.com
www.mindspring.com/~hendall

Richard Hescox 165
P.O. Box 338
Hobart, WA 98025
triffid@comcast.net
www.richardhescox.com

Paul Hess 64
c/o Alan Lynch
116 Kelvin Pl.
Ithaca, NY 14850
607-257-0330
alartists@aol.com

David Ho 18
3586 Dickenson Common
Fremont, CA 94538
510-656-2468
ho@davidho.com

Brad Holland 27, 33
96 Green St.
New York, NY 10012
212-226-367
brad-holland@erols.com

Chris Hopkins 130
425-347-5613
www.chrishopkinsart.com

Greg Horn 113
561-967-5765
greghornart@yahoo.com

John Howe 55
c/o Alan Lynch
116 Kelvin Pl.
Ithaca, NY 14850
607-257-0330
alartists@aol.com

Philip Howe 144
12425 68th Ave. S.E.
Snohomish, WA 98296
425-385-8426
215-232-6666 [Rep. Deborah Wolfe]

Carlos Huante 34, 125
150 Sanchez Way
Novato, CA 94947
kletosl@yahoo.com

Mike Huddleston 75, 86
4222 Terrace
Kansas City, MO 64111
816-694-0829
mhuddl@hotmail.com

Matt Hughes 170
3716 McGuire St
Kennesaw, GA 30144
770-595-1293
matthughesart@yahoo.com

Jeremy Jarvis 142
437 Moss Trail
Goodlettsville, TN 37072
info@jeremyjarvis.com
www.jeremyjarvis.com

James Jean 44
P.O. Box 5627
Santa Monica, CA 90409
310-903-1681

Bruce Jensen 48
3939 47th St.
Sunnyside, NY 11104
718-937-1887
bruce@brucejensen.com

Katherine Jones 23
9 (GFR) Downfield Place
Edinburgh, Scotland EH11 2EH
+44 (0)131-3133757
katyjonesillustrator@btopenworld.com

Eric Joyner 172
339 3rd Ave.
San Francisco, CA 94118
415-305-3992
eric@ericjoyner.com

Joe Jusko 82, 89
203 Glen Spring Circle
Canonsburg, PA 15317
joejusko@comcast.net

Michael Wm. Kaluta 79, 84, 176
312 W 92nd St. #5A
New York, NY 10025
212-873-7573
kaluta@kaluta.com

Montgomery S. Kane 120
P.O. Box 82654
Pittsburgh, PA 15218
m@montgomerystevenskane.com
www.montgomerystevenskane.com

Charles Keegan 178, 179
P.O. Box 2532
Forest Park, GA 30298
404-366-1490
charles@keeganprints.com

Jim & Ruth Keegan 52
c/o Sampson Advertising
7217 Geyser Ave. Suite #1
Reseda, CA 91335
818-766-8782
fornobulax@aol.com

Steven Kenny 170, 202
130 Fodderstack Rd.
Washington, VA 22747
540-675-2355
www.stevenkenny.com

Cody Kenworthy 199
1160 Haro St. #1505
Vancouver, BC V6E 1E2 Canada
732-299-8069

Tom Kidd [Gnemo] 142
59 Cross Brook Rd.
New Milford, CT 06776
860-355-1781
tkidd@snet.net

Michael Knapp 153
c/o Blue Sky Studios
44 South Broadway/17th Floor
White Plains, NY 10601
914-259-6416
mknapp@blueskystudios.com

Viktor Koen 36
310 E 23rd St. #11J
New York, NY 10010
212-254-3159
www.viktorkoen.com

Michael Komarck 53

Thomas S. Kuebler 92, 93
520 Campground Rd.
Selma, NC 27576
tskuebler@earthlink.net
www.tskuebler.com

Anita Kunz 18, 19, 200
218 Ontario St.
Toronto, ONT M5A 2V5 Canada
416-364-3846
akunz@anitakunz.com

Joe Lacey 172
622 N 23rd St
Allentown, PA 18104
610-432-6140
joe@joelacey.com

Richard Laurent 148
531 S Plymouth Ct. #205
Chicago, IL 60605
312-939-7130
richard@rcn.com

Lewis Lavoie 70, 177
RR#2, St. Albert, ALB
Canada T8N 1M9
www.lavoiestudios.com
lavoie@airsurfer.ca

Fabrice Lavollay 196
rue d'Ecosse, 92
1060 Brussels, Belgium
fabrice@fabricelavollay.com
www.fabricelavollay.com

Virginia Lee 100
4, White St
Brighton, East Sussex
UK BN2 0JH
0044 (0) 1273 603 482
virginialee88@hotmail.com

Victor Leshyk 186
P.O. Box 2775
Flagstaff, AZ 86003-2775
928-606-5551
forestin@northlink.com

Gary A. Lippincott 99
48 Bliss Hill Rd.
Royalston, MA 01368
978-249-9620
gary@garylippincott.com

Sandra Little 99
206-363-5925
needleanddread@yahoo.com

Todd Lockwood 24, 43, 61, 113, 134
20825 SR 410 E #186
Bonney Lake, WA 98390
www.toddlockwood.com
todd@toddlockwood.com

Angela Giovanna Loroux 96
2806 Valley View Dr.
Bath, PA 18014
610-837-0224
www.lorouxgallery.com

Travis Louie 160, 168
18 Echo Valley Rd.
Red Hook, NY 12571
845-758-9460
louieart37@yahoo.com

Howard Lyon 111
1455 North Gaylord Circle
Mesa, AZ 85213
480-330-7728
me@howardlyon.com

Gia Manh Luc 192
44 Station Ave.
Daly City, CA 94014
www.gialucart.com
gluc@email.com

Don Maitz 162
5824 Bee Ridge Rd., MB #106
Sarasota, FL 34233
donmaitz@paravia.com
www.home.paravia.com/DonMaitz/

Gregory Manchess 48, 131
15234 D SW Teal Blvd.
Beaverton, OR 97007
503-590-5447
503-590-6331 [fax]

Manchu 37, 112
6 Allee des Erables
Tours 37000 France
(33) 0247371603
philippe.bouchet7@wanadoo.fr

Stephan Martiniere 37, 47, 88, 122
596 Morgan Ranch Dr.
Grass Valley, CA 95945
530-271-0904
martiniere@neteze.com

John Matson 143
2134 A N. 72nd St
Wauwatosa, WI 53213
414-453-4209
www.johnmatson.com

Jonathan Matthews 94, 102
3435 Riverside Green Dr.
Dublin, OH 43017
614-717-9367
jonlmatthews@columbus.rr.com

Aaron McBride 80, 189
2120 Steiner St. #11
San Francisco, CA 94115
xexahylus@yahoo.com
www.sagania.com

Chris McGrath 66
3526 Wayne Ave.
Bronx, NY 10467
chrismcgrath@mac.com

Dave McKean 109
c/o Allen Spiegel Fine Arts
221 Lobos Ave.
Pacific Grove, CA 93950
831-372-4672
asfa@redshift.com

Petar Meseldzija 66
Kogerwatering 49
1541 XB Koog aan de Zaan
The Netherlands
petarmeseldzija@planet.nl
www.petarmeseldzijaart.com

Ken Meyer, Jr. 78
359 Kelsall Dr.
Richmond Hill, GA 31324
912-727-2637
kenmeyerjr@costalnow.net

Ron Miller 36
5210 Potomac Creek Rd.
King George, VA 22485
www.black-cat-studios.com
spaceart@att.net

René Milot 54, 184
416-425-7726
www.morganaynin.com
renemilot@rogers.com

Matthew Mitchell 32
45 Spaulding St
Amherst, MA 01002
413-253-7999
studio@crocker.com

Christopher Moeller 124
210 Parkside Ave.
Pittsburgh, PA 15228
www.cmoeller.com
moellerc@adelphia.net

Lee Moyer 33
7432 N Kellogg St
Portland, OR 97203
503-737-3344
lee@leemoyer.com

Daniel Lopez Muñuz 157
35 Main St #1
Tarrytown, NY 10591
773-531-5683
munozdesign@yahoo.com

Vince Natale 35
18 Van De Bogart Rd.
Woodstock, NY 12498
845-679-0354
vnatale@hvc.rr.com

Jim Nelson 111
2011 W Byron #2
Chicago, IL 60618
773-868-0803
mothman@sprintmail.com

Mark A. Nelson 153, 187
3738 Coachman Way
Cross Plains, WI 53528
608-798-3783
manelson1@matcmadison.edu

Greg Newbold 52
3724 S 2700 E
Salt Lake City, UT 84109
801-274-2407
www.gregnewbold.com

Hoang Nguyen 187
2202 Duvall Court
Santa Clara, CA 95054
408-727-9431
www.liquidbrush.com

Terese Nielsen 128, 204
9661 Las Tunas Dr. Suite C
Temple City, CA 91780
626-286-5200
hiddenkingdom@earthlink.net

Nilson [Nils Hamm] 79, 195
Flügelstr. 15
40227 Düsseldorf, Germany
049 211 788 62 84
nilshamm@hotmail.com

Dennis Nolan 62
106 Nash Hill Rd
Williamsburg, MA 01096
413-268-3441

Lawrence Northey 90, 102
145 Tyee Drive #197
Point Roberts, WA 98281
www.robotart.net
robotart@hotmail.com

William O'Connor 204
2072 Frand St.
Scotchplains, NJ 07076
908-322-3299
woc@earthlink.net

Kip Omolade 187
62 Meadow Run Rd.
Bordentown, NJ 08505
718-812-2681
www.kipomolade.com

Glen Orbik 62, 79
818-785-7904
glenandlaurel@earthlink.net

John Jude Palencar 28, 54, 55
3435 Hamlin Rd.
Medina, OH 44256
330-722-1859
ninestandingstones@yahoo.com

Joel Parod 22
2412 Las Colinas Ave.
Los Angeles, CA 90041
323-255-4931
www.parod.org/joel

Brandon Peterson 82
327 Tavernier Dr.
Oldsmar, FL 34677
813-843-1011
brandonpeterson@aol.com

Ryan K. Peterson 91
www.ryankpeterson.com
ryankpeterson2003@yahoo.com

John Picacio 57, 113
334 E. Craig PL
San Antonio, TX 78212
210-731-9348
john@johnpicacio.com

John Pierro 198
7133 Burnway Dr.
Orlando, FL 32819
407-226-0314
jpierro@cfl.rr.com

Stephen Player 168, 185
736 Leavenworth St. #5
San Francisco, CA 94109
415-771-4069
www.playergallery.com

R.K. Post 51
12120 204th Ave. Ct E
Sumner, WA 98390
253-862-8013
www.rkpost.net

Painting by Joe DeVito

Artists, art directors, and publishers interested in receiving information for the
SPECTRUM 13 competition should send their name and address to:

Spectrum Design, P.O. Box 4422, Overland Park, KS 66204

Or visit our website for information:
www.spectrumfantasticart.com

Call For Entries posters are mailed out every October.